A Concise History of
French Painting

Edward Lucie-Smith

with 278 illustrations, 32 in colour

Thames and Hudson

Contents

For Masud and Svetlana with love

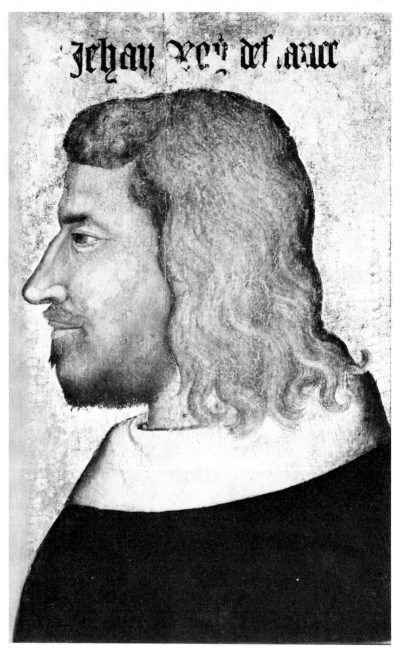

1 ANONYMOUS *Profile of Jean II* (*Jean le Bon*) *c.* 1355

The Middle Ages

This book is a history of French painting in a particular sense. When we speak of 'painting', we use this word to cover a multitude of techniques, used upon a variety of surfaces. The historian of Italian art, for example, must take into account frescoes as well as easel-pictures, because so many of the greatest achievements of Italian artists are to be found on the walls of palaces and churches. Though the historian of French art has to take decorative painting into account (as it was used, for example, at Versailles and Fontainebleau), and though he must occasionally glance at the considerable achievements of French illuminators, many of whom, in the late medieval period, were men who also painted upon panel, easel-painting is his main concern. Essentially, easel-painting is what this book is about, and I intend to tell the story of its development from the late fourteenth century, when we meet the earliest surviving French easel-paintings, to the present day.

The first painting which has come down to us is the profile portrait of the second Valois King of France, Jean II, known as Jean le Bon, which is now in the Louvre. This dates from about 1355. The king is seen in profile, and he is presented simply and without trappings; even the costume is plain. We have here the medieval concept of man, a being naked before God, presenting himself to the Creator's, as well as to the artist's, unsparing scrutiny. We also have the quality which Edouard Manet once told Proust was the very essence of French art – the *sens du vrai*, the feeling for reality, which has characterized French painting throughout the ages. This *sens du vrai* is something which differs from the characteristic realism of Dutch and German artists, just as it differs from the idealism of the Italians. The French artist neither exalts nor caricatures, he observes. French art frequently seems to combine detached observation with an involvement with the very substance of life. The image is presented as an aspect of some-thing much larger and more important, a carefully selected facet of the complexity of human experience. The portrait of Jean II, even

though it is the portrait of a monarch, is a triumph of dispassionate observation, and the unknown artist's conclusions are not entirely favourable to his sitter.

The reign of Jean II was not an easy time for France. From the end of the twelfth century onwards, commerce had been constantly developing, and in consequence the towns had grown. But in the 1270s the economic situation had altered. The growth of prosperity slowed down, stagnated, and then reversed itself. Times became hard for Frenchmen, and the countryside in particular tended to revert to a subsistence economy. Economic decline was accelerated by the outbreak of the Hundred Years War in 1337, its official cause being the change of dynasty from the Capetians to the Valois, and the English monarchy's determination to press its claim to the French throne. The conflict soon established a cycle of war, famine and pestilence. The Black Death ravaged France and the rest of Europe. Jean II was captured by the English at Poitiers in 1356, and an enormous ransom had to be raised for him. Under the stress of war the organization of the royal finances became more efficient but also more oppressive. Feudalism increasingly became an empty show, and the conflict between the classes was sharpened.

Yet the next picture we come to in the story of French painting suggests the degree to which the medieval world retained its original
2 unity. This picture is the *Parement de Narbonne*, painted for Charles V, who was Jean II's son and successor, in the early 1370s. The *Parement* is an altar-frontal, painted in grisaille on silk, and originally intended for use in the royal chapel during Lent, when colourless vestments were also worn. The same workshop no doubt created the copes and mitres too; the painter did not yet claim to be the superior of other craftsmen.

The surviving frontal shows five scenes of the Passion, followed by the *Descent into Limbo* and the *Noli Me Tangere*. The central scene, the *Crucifixion*, is flanked by a pair of allegorical figures: on one side the triumphant Church accompanied by the prophet Isaiah, and on the other the defeated Synagogue, with King David. In panels below these kneel the King and Queen of France, and the King's initial, K for Karolus, appears in the borders.

The scheme is a traditional one, and part of its purpose is to emphasize the traditional medieval view of royalty, with the King as intermediary between God and his people. Every monarch in

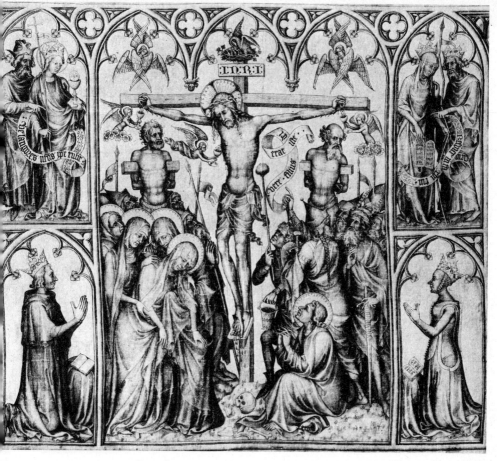

2 ANONYMOUS *Parement de Narbonne c.* 1370

Christian Europe saw himself in this role, and kings, despite the fact that they waged war on one another from time to time, recognized a kind of unity in monarchy which transcended the idea of nationhood. The *Parement* is a French painting, but it comes from a world which was only just discovering what national distinctions were about. In fact, the style employed is what scholars now label 'International Gothic', the mannered, elegant, linear, Late Gothic style which prevailed almost everywhere in Europe except for Italy (and even there it had a firm foothold in the rich cities of the Lombard plain). Other–

wise, International Gothic stretched from Bohemia to Catalonia. At the centre of this stylistic empire lay France, still, despite her troubles, the richest and most powerful state in Europe, and a place where artistic fashions were made.

As the *Parement* shows, the artists of the French Court were conscious of their own sophistication; and, simply because they were sophisticated, they could be affected by influences from outside. The influence one sees here is that of Italy, and especially that of Siena. In the *Parement*, the mannerisms are disciplined and restrained. The figures have mass as well as outline; the limbs are organically articulated.

Looking at the picture, we also catch the first breath of the changes which were to affect the medieval mind in a very much more fundamental sense than the way in which the art of Italy was eventually to alter the art of France. In the thirteenth century, men had rediscovered the philosophers of paganism, and particularly Aristotle. Though many of Aristotle's ideas could be assimilated to the medieval world view, others could not. Now, a hundred years later, the rupture between faith and reason was being universally felt. For many people, reacting against the uncertainties and the questions which the use of reason introduced into their lives, the mystical illumination recommended by some of the Fathers of the Church became the only way of attaining to God. The alternatives were too risky and too suspect. Painters (naturally upon the side of direct illumination) reflected the strains which were imposed upon all the men of their time. Compared to earlier work – the sculptures at Reims, for example – the *Parement* is extreme: extreme in its tenderness and in its violence.

Charles V was himself a new kind of French monarch, partly by temperament, partly thanks to the situation which he inherited. Sickly, but intelligent and tenacious, he made good much of the damage which France had suffered under his father. Unlike his predecessors, he preferred a retired and sedentary life, though he also had a certain taste for luxury: he loved jewels as well as books. To supply the Court, which mostly fixed its residence in Paris, merchants and artists flocked to the city from all over Europe, and it more than ever became the great European mart of styles and ideas. Paris continued to flourish when other towns stagnated or declined.

The following reign, that of Charles VI (1380–1422), administered a check to the predominance of Paris, and was the most humiliating

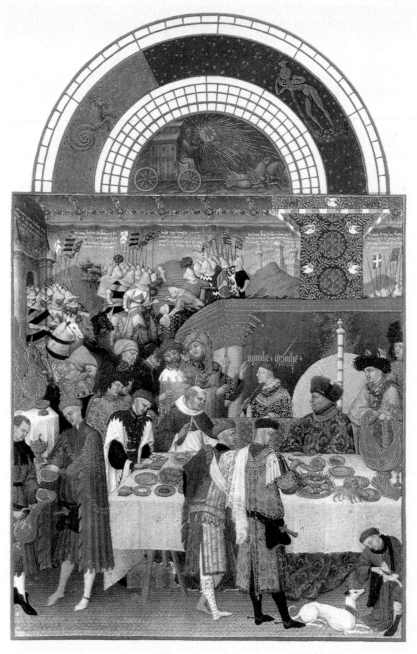

3 LIMBOURG BROTHERS *January, from the 'Très Riches Heures' c.* 1416

that France was ever to experience. All that Charles V had won back was lost. When his father died, Charles VI was left in the charge of his uncles, the Dukes of Anjou, Burgundy and Berry. Anjou, after plundering the royal treasury, left on foreign adventures. The other two remained to quarrel with one another, and, after the King's attack of madness in 1392, with his ambitious young brother, Louis of Orléans. The country drifted towards civil war.

To the arts, the new régime was at first a stimulus. There were now a number of princely patrons, instead of just one. The sheltered Court life created by Charles V protected a small group of privileged people from the horrors of the world outside, and gave them the leisure to cultivate the arts. The greatest of these patrons was Jean, Duke of Berry – no match for his abler brother the Duke of Burgundy in the struggle for political power, but his successful rival in this sphere. Berry attracted to himself the ablest painters of the age, among them many Flemings: André Beauneveu, Jacquemart de Hesdin, Jacques Coëne, the Limbourg brothers. The Duke had a passion for sumptuous illuminated manuscripts, and one can get an idea of the luxury with which he surrounded himself from the miniatures he commissioned.

3 A famous example is the miniature for *January* in the *Très Riches Heures* now at Chantilly. Painted by the Limbourg brothers, it shows us the Duke himself, seated at table and surrounded by his retinue.

At this time it is scarcely possible to make a distinction between the styles employed in manuscript illumination and in painting on panel. The same artists practised in both fields, and some of the most beautiful work of the time is to be found in books. It was only with the invention of printing that the illuminated book gradually lost its importance. The images to be found in books are often more varied and more inventive than those to be found in the few surviving panel-paintings, which tend to be limited in their range of subject-matter.

Typical of the 1390s and 1400s are a series of small panels which are stylistically very close to the manuscript illumination of the same period, a similarity which is emphasized by the similarity of scale. These panels are variously assigned to the school of Paris and the school of Dijon, a meaningless controversy both because Burgundian influence was strong in Paris throughout the period (for political reasons) and because Paris, despite the troubles of the time, continued to be a magnet for artists. Perhaps the most beautiful of these panels,

14

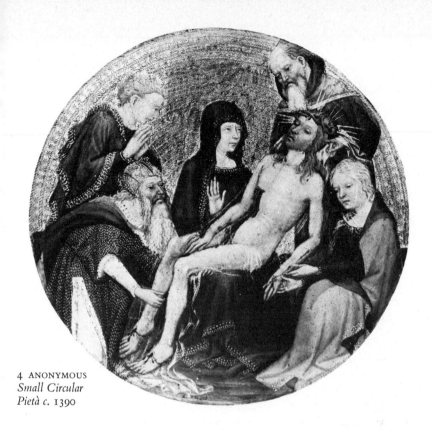

4 ANONYMOUS
*Small Circular
Pietà c.* 1390

and certainly one of the best preserved, is the so-called *Small Circular* 4
Pietà, now in the Louvre. With its delicate forms and flowery colours,
this exemplifies the taste of the time, which inclined towards Christian
mysticism tempered by elegance. We can see a further, indeed a final,
development of this style in the rather later *Large Circular Pietà*. This 5
is often attributed to Jean Malouel, uncle of the Limbourgs, and it has
on the back of the panel the arms of the Duchy of Burgundy. It seems
to have been painted about 1410.

 The Hundred Years War entered a particularly cruel phase for
France in the second decade of the fifteenth century, when England
actively re-entered the conflict. Henry V of England inflicted a
crushing defeat on the French at Agincourt in 1415; and in 1420 the
Treaty of Troyes was signed, under the terms of which the Dauphin
was disinherited and Henry of England was declared the heir to the

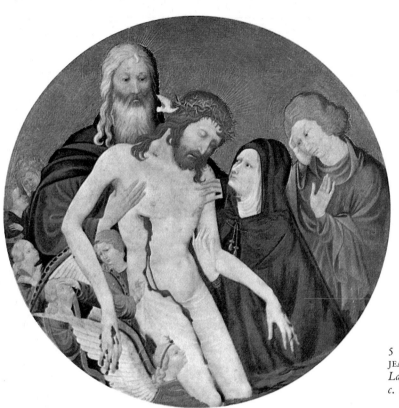

throne. The Dauphin, who two years later was to become Charles VII, withdrew to the valley of the Loire, and set up his Court in Bourges.

The story of Charles's slow recovery of power, and of the part played in it by Joan of Arc, needs no re-telling here. But it is worth pointing out the degree to which Charles's Court differed from that of his father and grandfather. The throne remained the focus of power, but the nobility who had remained faithful were now intermingled with new upstart office-holders, of bourgeois origin. Particularly prominent was Jacques Cœur, Charles's financial adviser until Cœur was ruined in 1453. It was men such as this who were the art patrons of the new reign, and the artist whom they chiefly patronized was Jean Fouquet.

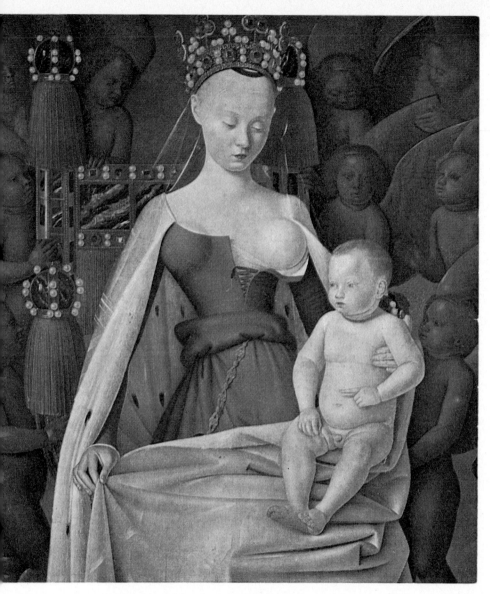

6 JEAN FOUQUET *The Melun Diptych: Virgin and Child c. 1450*

It was Fouquet who painted the superb portrait of Guillaume
7 Jouvenel des Ursins, Chancellor of France under Charles VII and
Louis XI. From the evidence of the hairstyle, it was painted about
1455. There is an instructive comparison to be made between this
1 painting and the portrait of Jean II, which dates from a hundred years
earlier. Where Jean II is seen in profile, Jouvenel des Ursins appears in
three-quarter face – a view which allows for much greater psycho-
logical subtlety. While the presentation of the monarch is simple, the
commoner is shown against an elaborate background which em-
phasizes his wealth and importance. Prominently displayed in the
background is the coat of arms of the princely Roman family of
Orsini, which hints at nobler origins than the sitter in fact possessed.
What one sees in these two portraits is the distance which the medieval
conception of man had shifted in the course of a century. It is no
longer a matter of showing a man naked before God; we have moved
on to the modern notion of man as a kind of synthesis of the spiritual
and the material, of inborn personality and worldly trappings.

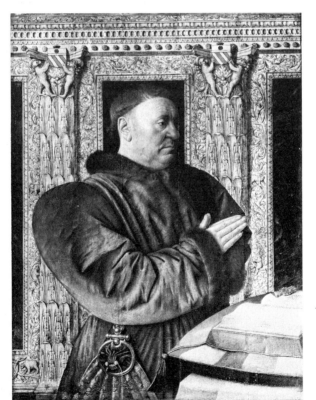

7 JEAN FOUQUET
*Guillaume
Jouvenel des
Ursins c. 1455*

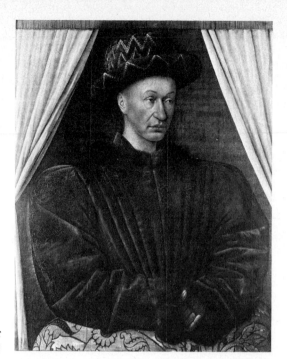

8 JEAN FOUQUET
Charles VII c. 1445

Fouquet's art shows revealing affinities, and also revealing contrasts, with that of his Flemish and Italian contemporaries. The Flemish art of the time is rich in portraits: those of Rogier van der Weyden, Jan van Eyck, and Memling. In contrast to these artists, Fouquet tends to smooth out surface details – folds and wrinkles – and to generalize his forms, while emphasizing their massiveness. But he does not carry the process of generalization as far as does Piero della Francesca, the Italian painter who most clearly influenced him. It seems likely that Fouquet visited Italy between 1443 and 1447, when he is thought to have painted a portrait of Pope Eugenius IV which has now disappeared. Certainly Fouquet knew something of the new Italian science of perspective, and the sculptural grandeur of his figures is in itself Italianate.

Fouquet's work seems to reflect the clash between medieval ideas and the oncoming scepticism of the Renaissance. For example, his portrait of Charles VII shows that Fouquet was capable of pitiless objectivity, even in a work which is clearly earlier than the portrait of 8

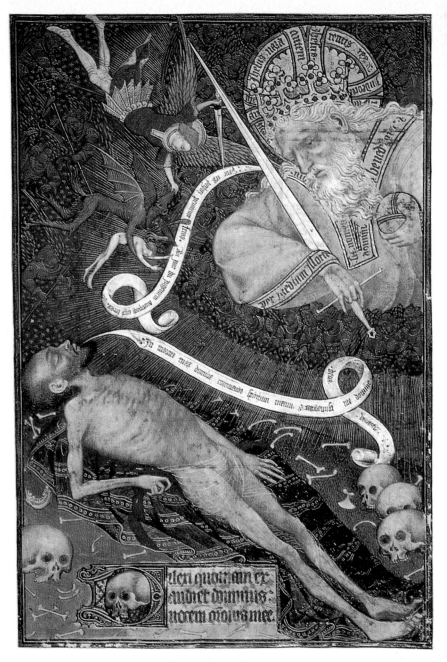

9 ROHAN MASTER *Man before his Judge* 1420–25

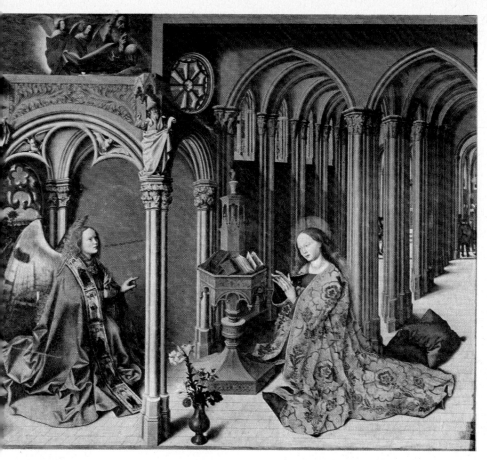

10 Attributed to JEAN CHAPUS *The Altarpiece of Aix: Annunciation* 1445

Jouvenel des Ursins. The composition is less sophisticated; the half-
length figure is cramped between curtains, which make everything
seem fusty and airless. The head itself is subtly but coldly described:
timid, melancholy, secretive, self-doubting. Such an approach to
reality was bound to produce some curious effects when applied to a
religious theme, as it is in the Melun Diptych.

The Melun Diptych was commissioned by another bourgeois 6
functionary of Charles's Court, Etienne Chevalier, Ambassador to
England in 1445, Treasurer of France in 1451, and afterwards Secretary

of State. The left half of the picture, now in Berlin, shows Chevalier with his patron, St Stephen. The right half, now in Antwerp, shows
6 the *Virgin and Child* – perhaps the most secular Virgin ever to appear in a medieval picture. There is a tradition that this is in fact a portrait of Charles VII's mistress, Agnès Sorel, and authenticated likenesses of the lady bear this out. A mid-eighteenth-century inscription on the back of the panel relates that Chevalier had the picture painted in fulfilment of a vow, on Agnès's death – which would make the date about 1450.

The Virgin, with her shaven forehead, high-pushed breasts, narrow waist and out-thrust stomach, conforms to the then fashionable idea of beauty. Her slightly pinched, impassive face and the barbarous glitter of her throne and crown seem designed to put religion out of our minds altogether. One detects in the picture a deliberate with-holding of emotion which chills the spirit.

But perhaps it is not simply the first breath of Renaissance scepticism that is to be detected in Fouquet's work, but also the effects of all those bitter years of war when France sank deeper and deeper into misery. The events of these years would either harden a man's heart or wring it unbearably.

There was one artist who reacted in a different way to contemporary events: the Rohan Master. Among all the gifted book-illuminators of his time, this painter stands out through the power and pathos of his work. His principal masterpieces are some of the large illuminations in the book from which he takes his name, *Les Grandes Heures du duc de Rohan*. The date, the place of origin, and the patron for whom the book was executed, are all in doubt. It seems probable that the date is about 1420 to 1425 (just at the worst point in the war), and that the patron was a member of the House of Anjou. Few images could more vividly symbolize the misery of the times than the miniature of
9 *Man before his Judge*. The visionary pathos of this and other illustrations of tragic themes – the *Pietà* in the same manuscript, for instance – make the greatest possible contrast with the rational art of Fouquet.

The Rohan Master strikes us now as an individualist, someone who stands apart from the main current of development in French painting, which runs through Fouquet and the Master of Moulins. Another individualist, but of a very different kind, also worked under the patronage of the House of Anjou. His connection with them is in fact more firmly established than that of the Rohan Master, as he was the

illustrator of a romance called *Le Livre du Cuer d'Amours espris*, written by no less a person than René of Anjou himself, who was at one stage of his career simultaneously Duke of Anjou, Bar and Lorraine, Count of Provence, and King of Sicily and Naples.

The individuality of the René Master is to be found not so much in the emotional atmosphere of his work, as in its technique. The miniatures which illustrate the romance are startlingly realistic, with a feeling for space, atmosphere and perspective, the state of the light and the time of day, which are quite unlike anything else to be found in the painting of the period. In one scene, Amour comes to the love-sick king as he lies in bed, and takes his heart away. The way in which the incident is treated hints at the romantic realism of an early seventeenth-century painter such as Adam Elsheimer (an impression

11

11 RENÉ MASTER
*Amour Takes Away
the King's Heart*

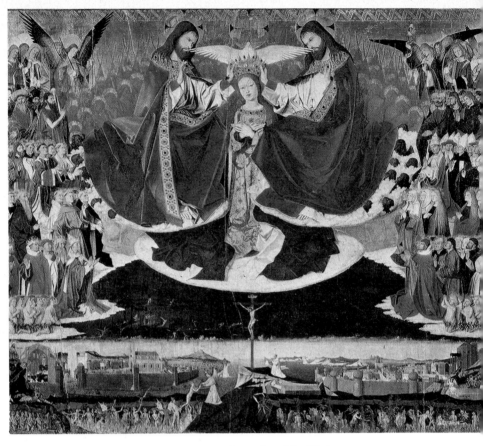

12 ENGUERRAND CHARONTON *Coronation of the Virgin* 1454

reinforced by the fact that it is a night scene, one of Elsheimer's specialities). Compositions such as this are important because they remind us that the French artists of the period were quite capable of dealing with subjects outside the limited repertoire of sacred scenes and portraits to which they mostly confined themselves when working on panel. If we still possessed the wall-paintings and tapestries which are now lost, we should be more keenly aware of this.

The extreme disregard of pictorial convention shown by the René Master has given rise to the suggestion that King René himself illustrated the romance which he had written. The Neapolitan artist

Colantonio is said by one source to have learned 'the art of painting in the manner of Flanders' from King René. Since Colantonio is in turn reputed to have been the master of Antonello da Messina, one of the key figures in the development of Venetian art, this would give René an exceedingly important place in the development of Italian as well as of French painting.

As René of Anjou enters the story, so does the difficult subject of southern French painting. One effect of the closing years of the Hundred Years War was to put an end to the preponderance of Paris. In 1418, the city had gone over to the Burgundians, and for nearly twenty years thereafter found itself in the midst of an area disturbed by warfare. Charles VII continued to live in the Loire valley even after peace was restored. Royal residences outside Paris, such as Tours, acquired a new importance, and so did regional centres such as Dijon, Aix-en-Provence and Moulins. Southern France at this period was a cross-roads of artistic influences. The prolonged residence of the Papal Court at Avignon had already brought with it an influx of Italian artists. Simone Martini worked at Avignon during the pontificate of Benedict XII (1334–41), and Matteo di Giovanetti painted the frescoes that still remain there in the Palais des Papes, under that of Clement VI (1342–52).

Later, with the removal of the Papal Court to Rome, the Popes were replaced by the Angevins as the principal artistic influence in the region, though René did not make Aix his principal residence until 1470. The mixed stylistic character of the famous Altarpiece of Aix, *10* though it dates from considerably earlier (1445), can nevertheless be most satisfactorily accounted for by looking at the extraordinarily varied character of the Angevin domain, as represented in the long roster of René's titles. Attempts have been made to connect the picture both with Flemish art (the Master of Flémalle and the van Eycks), and with Italy (through the stylistic connection with Antonello da Messina). What is Italian about the picture is its sweep and colour; but the forms are Flemish, and the type of the Virgin in the central Annunciation especially so. The likelihood is that the painter was a native of the region. Documentary evidence suggests that he was one Jean Chapus, born at Avignon and resident at Aix. The donor of the altarpiece is definitely known: he was Pierre Corpici, a draper.

Other important works were also commissioned in this region during the fifteenth century by men who were not aristocrats. The

25

13 *Virgin of Mercy*, by Enguerrand Charonton or Quarton (*c.* 1410–
c. 1466) and Pierre Villatte, was commissioned in 1452 by Pierre
12 Cadard, son of a former physician to Charles VII; the *Coronation of the
Virgin*, by Charonton alone, was commissioned in 1454 by a priest
named Jean de Montagnac. Charonton provides another example of
mixed stylistic influences. He came from Laon, but his work is un-
mistakably Italian in feeling; his *Virgin of Mercy* is close to Piero della
Francesca's version of the same subject in Borgo San Sepolcro.
Charonton also felt the influence of his adopted region. The *Coronation
of the Virgin* is bathed in clear, hard, Provençal light, and has for its
background a lovingly painted landscape in which Cézanne's
Montagne Sainte-Victoire is clearly visible.

Charonton's collaborator, Pierre Villatte, is otherwise unknown as
an artist, but he has sometimes been suggested as the possible author of
a painting which is perhaps the greatest masterpiece produced in
France during the fifteenth century: the *Pietà* of Villeneuve-lès-
Avignon. It has also been suggested that the painting is not French at
all, but is the work of a Catalan or even Portuguese master. The
14 Avignon *Pietà* is in some ways a rougher, less sophisticated picture
than the Altarpiece of Aix, or than the work of the Charonton-
Villatte partnership. The gold ground is a feature which was already
archaic in the 1460s. Yet, in its harshness, this is one of the most moving
religious images in French art. The visionary intensity of the Rohan
Master is here revived, and endowed with a new earthiness. Note, for

13 ENGUERRAND CHARONTON AND PIERRE VILLATTE *Virgin of Mercy* 1452

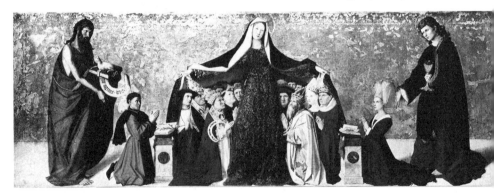

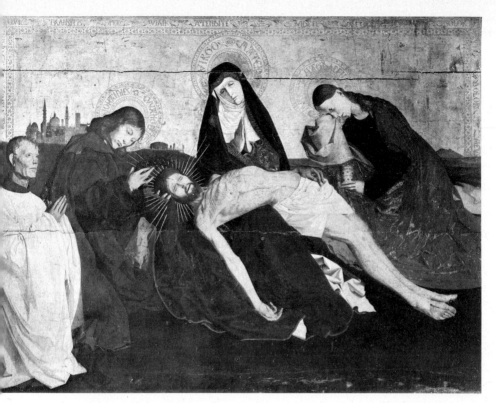

14 SCHOOL OF AVIGNON *Pietà of Villeneuve-lès-Avignon c.* 1460

example, the matter-of-fact air with which the donor attends the sacred event, and the contrast between this and the agonized arc of Christ's body.

The difference in mood between this and the art of the second half of the fifteenth century in other parts of France is extreme. Basically, the art of central and northern France developed little after the departure of Fouquet. The age of Louis XI was one of intellectual stagnation, and painting stagnated also. This is visible in the work of Fouquet's chief heir, the Master of Moulins, who takes his name from a triptych in Moulins Cathedral. *17*

The donors, who appear in this work, which was painted about 1498/9, are Pierre de Bourbon and his masterful wife, Anne de Beaujeu, the daughter of Louis XI and sister of Charles VIII. She had

acted for some years as her brother's regent. By the time the Moulins triptych was painted, Charles had already made an expedition into Italy, the first of several by successive French kings; but the Master of Moulins seems, if anything, less Italian than Fouquet. He still has a good measure of Fouquet's clarity of form, simplicity and dignity, but where Fouquet fell under the spell of Piero, the great foreign influence on the work of the Master of Moulins, as we can see from the types he chooses for some of his figures, is Hugo van der Goes.

It is interesting to see how he reinterprets the style of this great Flemish neurotic. Where Goes's work conveys a feeling of inner tension and anguish, the Master of Moulins is placid and self-assured. But the assurance does not spring from faith; the painter seems to have less genuine religion even than Fouquet. The Fouquet *Virgin* shocks because both trappings and presentation are secular. The Master of 17 Moulins' *Virgin in Glory* is much more conventional – an idealization,

15 MASTER OF MOULINS
Portrait of a Child 1498–99

16 MASTER OF MOULINS
Cardinal Charles de Bourbon

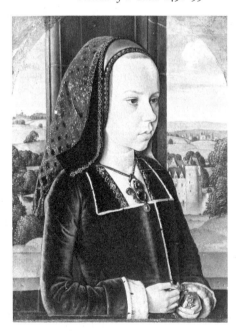

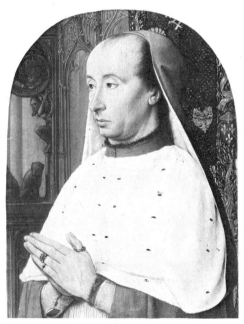

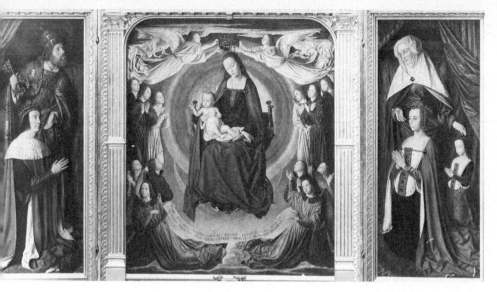

17 MASTER OF MOULINS *The Moulins Triptych* 1498–99

not a portrait – but she is without inner life, and has become a mere symbol which has lost its meaning; the portraits of the donors are much livelier and more convincing.

The Master of Moulins belonged to a world in which the aristocratic principle was successfully reasserting itself. France once more had a strong central government. The troublesome Duchy of Burgundy had been reincorporated into the Kingdom in 1477, and the new men of Charles VII's day were now assimilated into the old nobility. The patrons for whom the Master of Moulins worked were aristocrats, like the patrons of Malouel and the Limbourgs. We see this in his portraits: the *Portrait of a Child* in the Lehman Collection carries us back to the atmosphere of the *Très Riches Heures*. This is especially true of the beautiful castle we glimpse through the window: the Limbourgs show us many such. Equally refined and elegant is his portrait of a handsome young cardinal, now in Munich. In this case we know the sitter to be Charles II de Bourbon, of the royal blood of France.

Despite the influence of Hugo van der Goes, the Master of Moulins is not as 'northern' in style as the other leading French painter of the time. This was Simon Marmion, who was probably born in Amiens

29

18, 19
SIMON MARMION
St Bertin Altarpiece:
Soul of St Bertin
carried up to God;
Choir of Angels

and who spent his working life in Valenciennes: he is said to have lived
in this town from 1458 until his death in 1489. Marmion represents the
closest approach made by French fifteenth-century painting to the art
of the Low Countries, and he reminds us more of Memling than of
Fouquet or the Master of Moulins. He is graceful but superficial. His
pictures are sparklingly bright in colouring, and they show how much
he enjoys the details of everyday life. His principal surviving work is a
18, 19 set of panels depicting the *Life of St Bertin*, which demonstrate the way
in which Flemish religious art was already preparing the way for the
genre painting of the seventeenth century. Marmion's work is not
entirely humdrum: a fragment such as the charming *Soul of St Bertin
Carried up to God* shows that he could strike a vein of poetry. But the
music being played is the swan-song of the departing Middle Ages.

30

Renaissance Fantasy

The sixteenth century marks a turning-point in the political history of France, and in the development of French culture. The first half of the century was an era of foreign wars, a continuation of the adventures which had been embarked upon by Charles VIII. This period comes to an end with the Peace of Le Cateau-Cambrésis in 1559, whose purpose was to adjourn the struggle so that men, both in France and elsewhere, might turn their attention to the religious question.

In painting, the transition from the world of the Middle Ages to that of the Renaissance seems especially abrupt, though one reason for this may be our own lack of information. We know very little, for example, about either Jean Bourdichon (*c.* 1457–1521), or Jean Perréal (d. 1530), who seem to have been the most important French painters in the earliest years of the century. Bourdichon is known to us chiefly thanks to the illuminations of the *Heures d'Anne de Bretagne*; the book was finished in 1508. The pictures make it clear that Bourdichon remained within the Gothic tradition, but they also show a marked Italian influence. Certain architectural details can be traced to the work which Bramante did in Milan, and the figure-types and compositions also tend to have an Italian impress. Perugino, in particular, is one of Bourdichon's sources, and there is a miniature of *St Sebastian* where 20 the pose is copied directly from a design which Perugino had been using some ten years earlier.

Since Bourdichon's sources are large-scale works, sculptures and paintings, rather than other illuminations, his miniatures tend to look like reproductions of bigger originals. The exception is to be found in the naturalistic representations of flowers and insects, which are also included in the book. These have a stereoscopic vividness. The fact that the two styles can coexist in a single volume suggests that the artist himself was a man divided, uncertain which current to follow. We do not find any great power of personality in his work.

Perréal is an even more shadowy figure. We know that he served Charles VIII, Louis XII and François I; that he visited Italy three times;

that, in addition to being a painter, he bore the responsibility for large sculptural undertakings, made designs for festivals, and even designs for the medals which were struck on such occasions (medallic portraits of Charles VIII and Louis XII survive). Yet the only picture *21* attributed to Perréal with any certainty is a portrait of Louis XII which is now at Windsor. This still belongs to the fifteenth-century tradition of French portraiture, but the modelling recalls contemporary Milanese work.

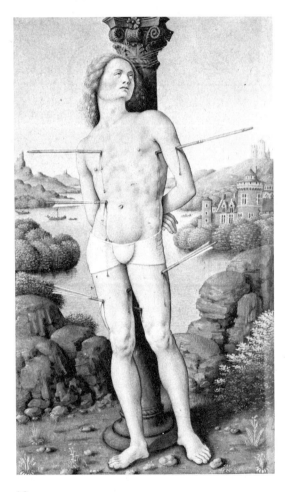

20 JEAN BOURDICHON
St Sebastian 1508

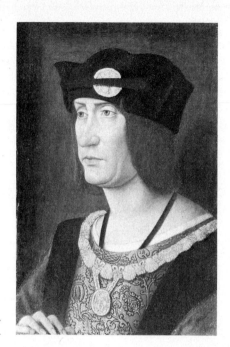

21 JEAN PERRÉAL
Louis XII c. 1514

The man who was to dominate the artistic enterprises of the first half of the century in France was Louis XII's successor, his cousin François I, who came to the throne in 1515, at the age of twenty. Ambitious and high-spirited, François meant to change the way things were done in his kingdom, and, in particular, he meant to revive the arts. His mother was a princess of Savoy, and he already looked towards Italy. He made up his mind to attract the greatest Italian artists to his Court. At first, he was not very successful. He wanted Michelangelo, but failed to get him. Leonardo da Vinci came, and for the last three years of his life (1516–19) resided at the French Court. Andrea del Sarto also came, but stayed for only a year (1518–19). Meanwhile, François involved himself ever more heavily in the wars in Italy. At first he was fortunate; the victory of Marignano marked the first year of his reign. Later, when he found himself at grips with the wily Emperor Charles V, his luck deserted him. François was humiliatingly defeated by the Imperial forces at Pavia in 1525, and taken as a prisoner to Spain.

33

Pavia did not cure François or his Court of their passion for all things Italian, and it was only on the King's release that the real hegemony of Italy over the visual arts in France began. The significant event was the arrival of Rosso in France in 1530, followed by his fellow countryman Primaticcio in 1532. François, after having resided for much of the time in the Loire valley during the earlier years of his reign, now wanted to be closer to Paris, and started to build new palaces and to enlarge and redecorate old ones round the city. One of the buildings to be transformed was the old medieval fortress of Fontainebleau. From Rosso's arrival must be dated the rise of the so-called school of Fontainebleau, which was to dominate decorative painting in France for the rest of the century.

The artists of the school of Fontainebleau abruptly swept away the remains of the medieval tradition. Art was no longer to be primarily religious. Instead, it was to be secular, and pagan allegories in large part replaced the sacred themes of the Master of Moulins and his predecessors. French art moved from the world of the Late Gothic to that of Mannerism, with no intervening phase of High Renaissance classicism. Mannerism, which had only recently begun in Italy, con-

22 IL ROSSO *Pietà* 1530–40

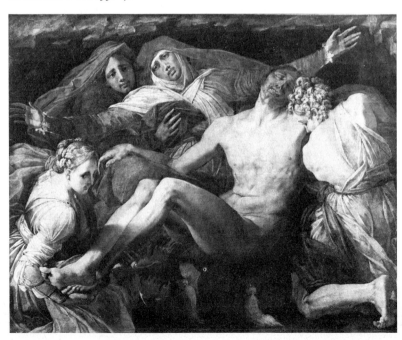

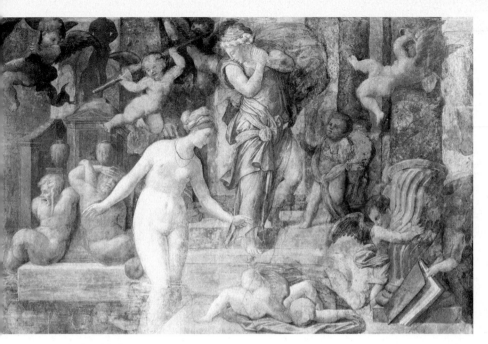

23 IL ROSSO *Venus Chiding Love*

quered France as it was soon to conquer the rest of Europe. It soon be-
came an international style of a kind which had not been seen since
the heyday of International Gothic.

Mannerism and International Gothic had certain qualities in com-
mon, and these were what helped the new style to establish itself so
swiftly. Both were essentially 'Court' styles: fantastic, wilful,
luxurious, amusing. Both were designed to appeal to people with a
sense of the fashionable, an appetite for the new. This was particularly
true of Mannerism and its public; the Renaissance had bred contempt
for what was traditional, and a corresponding respect for 'invention',
for the latest and most unexpected ways of presenting things to the eye.

Il Rosso (Giovanni Battista di Jacopo, 1494–1540) belonged to the *22, 23*
earliest and most vehement phase of the style. A Florentine, he was a
member of the first generation of Mannerists. Pontormo was his exact
contemporary. His early influences were threefold: Andrea del Sarto,
whom he learned from but reacted against; Michelangelo; and the
German engravers who also influenced Pontormo, notably Dürer.

Rosso's early works are religious paintings – moving, tight-strung, neurotic in the fashion of the time. In 1523 he went to Rome, where he was able to see the new style of 'grotesque' ornament, combining animal and vegetable forms and ancient Roman motifs, which Raphael and his workshop had evolved for the Vatican. Rome was sacked in 1527 by Imperial troops, and Rosso fled. He spent three years of increasing financial difficulty, moving from one town to another. Eventually, he arrived in Venice and met the celebrated humanist Aretino, who in turn recommended him to François I.

Rosso's task was to provide a new and more splendid kind of royal environment. Though his work at Fontainebleau has been largely destroyed or overpainted, enough remains to show us the kind of problems he was set, and the ways in which he solved them. His principal work is the Galerie François Premier. A long gallery of this sort was alien to the Italian architectural and decorative tradition. Its chief defect, from the point of view of the decorative artist, was that it could not be looked at as a whole (though, as Rosso, like all Mannerists, tended to shun narrative clarity and indeed anything which disclosed itself simply and at once, this may have seemed an advantage). The solution was to divide the walls into an upper and a lower half. The lower part was filled with panelling, the upper became an enlarged version of the deep frieze already familiar in some Italian decorative schemes. This half was filled with stucco and painting. The stuccos are in exceedingly deep relief, so as to offer variety and interest to the eye as one proceeds down the length of the gallery.

23 The paintings framed by the stuccos were light, elegant, parodistic. The compositions juggle with the notion of space: sometimes they are packed with figures, so that space is tightly compressed or abolished; sometimes the eye is led away to infinity. The colouring – so far as we are able to judge after thorough nineteenth-century overpainting – was unrealistic, with subtle shot-silk effects and clashing hues. The figures are filled with frenetic vitality or with erotic lassitude. The female nudes represent a new type, based on Michelangelo, but elongated, twisted into serpentine poses, with elaborate hairstyles and sudden, fluttering swags of drapery.

Rosso also remained capable of his old religious fervour, as can be
22 seen from his beautiful *Pietà*, now in the Louvre, which was painted for the Constable of France, Anne de Montmorency, and which originally found its place in Montmorency's chapel at Ecouen. But

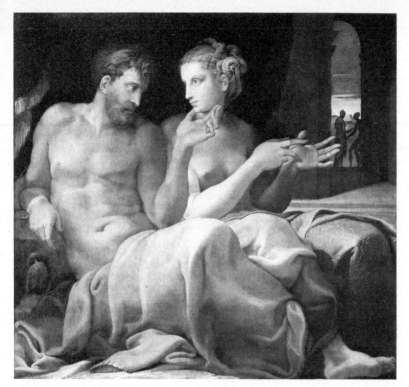

24 FRANCESCO PRIMATICCIO *Ulysses and Penelope c.* 1560

here, too, we find some of the characteristics of the Fontainebleau style: the compression of space, the feverish energy, the startling colours. This eloquent painting is the best preserved of all the works which Rosso left behind him in France, and gives the true measure of his gift. But it was the Fontainebleau compositions which were influential. French artists assimilated them through the medium of prints, and these prints were also much studied abroad.

Rosso's principal collaborator, Francesco Primaticcio, had a more placid talent. He came from Bologna, and worked with Giulio Romano in Mantua, when Giulio was engaged in decorating the Palazzo del Tè. He remained in Giulio's workshop until 1532, when he moved to Fontainebleau. Through Giulio, who had been Raphael's principal assistant, Primaticcio inherited the tradition created by Raphael. In Mantua, Giulio was already combining stucco-work and

37

painted decoration, and it seems likely that, though the over-all responsibility for the decorative scheme in the Galerie François Premier was Rosso's, Primaticcio had much to do with the sculptural part of it. Though Primaticcio's work, like Rosso's, has suffered heavily, one or two pictures survive to give an idea of his manner of *24* painting. The *Ulysses and Penelope* illustrated here is a repetition, probably by the artist himself, of one of the panels in the now-destroyed Galerie d'Ulysse at Fontainebleau. We see from it that Primaticcio was less vehement than his collaborator. The picture demonstrates particularly clearly the debt which Primaticcio owed to another leading Italian Mannerist, Parmigianino.

Rosso died in 1540, a suicide according to Vasari. Primaticcio, who had been buying antiquities for the King in Rome, was recalled to complete the works which Rosso had left unfinished. It was not until about 1552, when François's son Henri II was on the throne, that he acquired another collaborator. This was Niccolò dell'Abbate (*c.* 1512–71), who came from Modena. Primaticcio does not seem to have begun his association with him very enthusiastically, as he wrote: 'If there had been others in Paris who could have done the work as well as he, I should not have engaged him, but there was no one capable.' However, the collaboration was as successful as the previous one.

Niccolò brought the latest ideas in Italian art to France; he reinforced the influence of Parmigianino, and he owed something, too, to Dosso Dossi and to the Venetians. His art is lighter, more painterly, less intellectual, than Rosso's. His most attractive surviving works are two *26* large mythological landscapes, one in the National Gallery, London, and the other in the Louvre. The plunging bird's-eye view is typically Mannerist (we also find it used by Pieter Bruegel the Elder), and so is the glittering, rather tinselly colour. And yet these airy landscapes are the predecessors of some of the most poetic works of Claude Lorrain.

Other artists, Italian and French, clustered round these three *25* principal figures, but their personalities remain shadowy. A fine *Diana* in the Louvre is sometimes attributed to Luca Penni; and Giulio Camillo, Niccolò dell'Abbate's son, has been suggested as the author of some landscapes showing rustic occupations. These look forward not to Claude but to Boucher. A French painter who was apparently influenced by the Italians of the school of Fontainebleau, without becoming completely identified with them, was Jean Cousin the Elder (*c.* 1490–1560), who came from Sens but moved to Paris in 1538 and

38

25 Attributed to LUCA PENNI
Diana c. 1550 (detail)

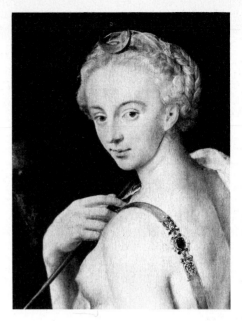

26 NICCOLÒ DELL'ABBATE
Landscape with Eurydice and Aristarchus
c. 1558–60

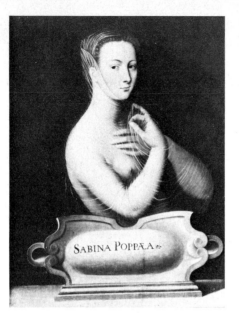

27 SCHOOL OF FONTAINEBLEAU
Sabina Poppaea c. 1570

28 JEAN COUSIN THE ELDER
Eva Prima Pandora c. 1550

29 MASTER OF FLORA
Birth of Cupid c. 1540–60

28 made a successful career for himself. An *Eva Prima Pandora* in the Louvre is traditionally attributed to him. His son and successor, Jean Cousin the Younger (1522–94), is known from engravings and from
32 another picture in the Louvre, a *Last Judgment.*

 A fairly large number of anonymous works continue to be labelled 'school of Fontainebleau' by art historians, and most of these seem to be the work of French artists. The most attractive are those generally
29 grouped together as the work of the so-called Master of Flora, a specialist in erotic mythological scenes. His figures are even more elongated and sinuous than those of Rosso and Primaticcio. The compositions characteristically show a static central figure surrounded by whirling attendants. Flowers are scattered everywhere. The unknown painter offers us a naïve, almost primitive version of Mannerist style: the academic solidity of Primaticcio is nowhere to be seen.

 Another popular type of composition among the anonymous painters of the school was a half-length female figure, nude or transparently draped. The type originated in Leonardo's studio, with the unclothed version of the *Mona Lisa.* Old inventories sometimes describe them as 'courtesans'. One of the most attractive examples of
27 the type is the coolly self-possessed *Sabina Poppaea* which has incongruously found a home in the Puritan city of Geneva.

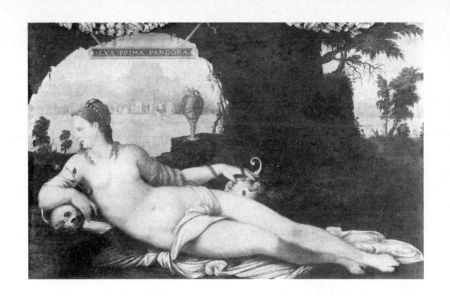

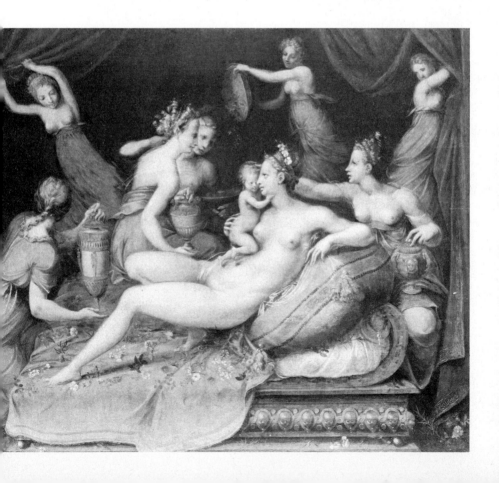

The best known of the identified French painters of the school of Fontainebleau is undoubtedly Antoine Caron (*c.* 1520–*c.* 1600), whose works sums up the atmosphere of the Court of Catherine de Médicis, Henri II's widow, as Rosso's does that of the Court of François I. Caron is first mentioned in the royal accounts in 1540. He becomes more prominent after 1559, just at the time when the Wars of Religion were beginning. Caron was a sympathizer with the Catholic faction,

31 and a remarkable painting of the *Massacres under the Triumvirate* (1566) gives us his reaction to the troubles which were shaking France. It is a strangely heartless work of art. The immensely elongated figures are set against a wide background of fantastic architecture. Their horribly violent actions are swallowed up in the hugeness of surrounding space; the brilliant colour contradicts the sombreness of the theme.

Caron was a skilled designer of the elaborate *fêtes* in which the Valois Court delighted, and his more typical works tend to reflect the festive, irresponsible mood of these occasions. In a few of his pictures, we also find a reflection of Catherine de Médicis's obsessive interest in the occult: one of the most fascinating of Caron's paintings is his

30 *Augustus and the Sibyl*, which is simultaneously naïve and sophisticated,

30 ANTOINE CARON *Augustus and the Sibyl* 1575–80

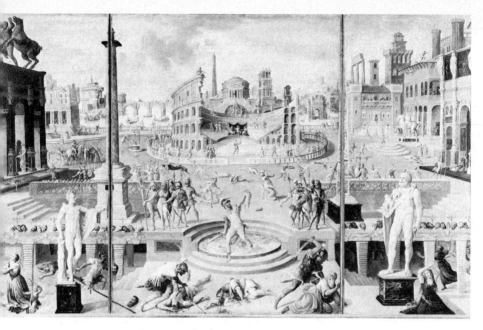

31 ANTOINE CARON *Massacres under the Triumvirate* 1566

32 JEAN COUSIN THE YOUNGER *Last Judgment* 1585

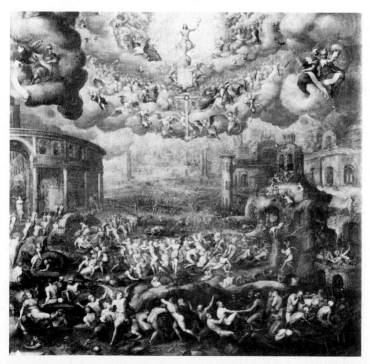

credulous and learned. Caron has some of the primitivism of the Master of Flora, the lack of real amplitude of form, the contempt for realism, the interest in minor details.

The one branch of art which resisted the influence of the Italians and pursued a course of its own was the art of portraiture. Unfortunately, we are here, as elsewhere, bedevilled by the lack of firm attributions.

The leading portrait painter in the early years of the century seems to have been Jean Clouet the Younger, who probably came from the Low Countries. He is mentioned in a poem written in 1509, where his name is coupled with that of Perréal, and his name appears in the royal accounts from 1516 onwards. He seems to have died about 1541. Few works which can certainly be attributed to him survive: one is the *34* portrait of Mme de Canaples which is now in the National Gallery of Scotland. This can be identified because it is based on a drawing now at Chantilly, one of a group connected to Jean Clouet by a chain of circumstantial evidence. These give us the feeling that, despite his Flemish origins, Jean Clouet had been touched by the ideas of the Italian High Renaissance. He is interested in mass rather than in line, in broad effect rather than in details.

Jean Clouet's son François (before 1510–1572) seems to have been the most eminent portraitist of the next generation. In 1541 François I appointed him to succeed his father. The signed portrait of the apothe- *35* cary Pierre Quthe, dated 1562, uses a pattern which was much

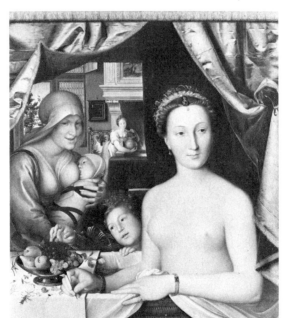

33 FRANÇOIS
CLOUET
Lady in her Bath
c. 1550

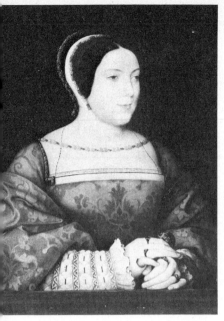

JEAN CLOUET *Mme de Canaples c.* 1523 35 FRANÇOIS CLOUET *Pierre Quthe* 1562

favoured by Italian Mannerist portraitists, such as Bronzino and Salviati. The colouring, warmer and less metallic than theirs, suggests the influence of Domenico Moroni. There is, however, something typically French about the picture, and that is its sobriety; its determined search for the human essence. There is still something here to remind us of Fouquet.

Clouet also felt the attraction of the Italians at Fontainebleau, perhaps more so than any other French portraitist, if we are to judge by the curious (and signed) painting of a *Lady in her Bath*. It has been suggested that it represents Diane de Poitiers, mistress of Henri II, but more probably the subject is Marie Touchet, mistress of his son Charles IX. The basic pattern is one we have met previously: the half-length female nude which originated in the studio of Leonardo da Vinci. Other details show a mixture of Italian and Flemish influences. For example, the woman in the background appears in similar guise in the work of Italian painters as dissimilar as Titian and Giulio Romano, while the old nurse resembles a type used by Quentin Matsys. The whole composition, with figures behind a balustrade,

33

45

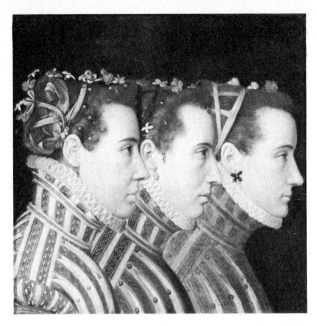

36 SCHOOL OF FONTAINEBLEAU
Three Minions c. 1580–90

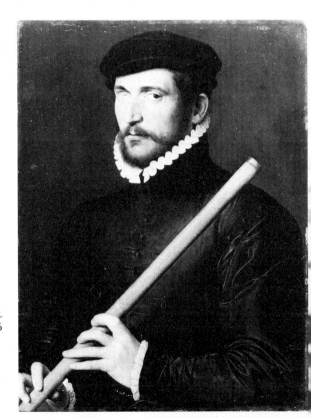

37 Attributed to MARC DUVAL
One-eyed Flautist 1566

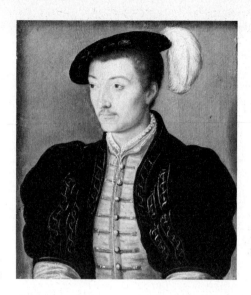

38 CORNEILLE DE LYON
Portrait of a Young Man

may well be a blasphemous echo of a pattern used for Holy Families
by Joos van Cleve. We know that this Flemish painter visited the
French Court to make portraits of François I and his second queen.

If we have some information about the Clouets, including, in the
case of the son, a few signed pictures, we have almost none about
Corneille de Lyon (active 1533–74). A man of this name is recorded as
a portraitist of high reputation, but there is no document to link him
to the group of portraits usually attributed to him. These are smaller
in scale and more naturalistic than those given to Clouet, and less
eclectic. They belong within the sphere of northern painting, but
with a characteristically French simplicity and directness.

Portraiture was as popular in the France of the sixteenth century as
it was among the Elizabethans in England. The age also produced a
small handful of human images by anonymous masters which are
intensely memorable as works of art, so that we find ourselves longing
to know more about the sitters concerned and the circumstances in
which the picture was painted. One of these images is the portrait of a
One-eyed Flautist in the Louvre, dated 1566 and sometimes attributed 37
to a painter called Marc Duval. The sitter holds a transverse, or, as it
was then called, a German flute, and it has been conjectured that he
was a German musician in the service of Charles IX, who was especially
interested in music. Another is the recently discovered *Three Minions*, 36

47

a triple portrait which evidently represents three of the decadent favourites of the homosexual Henri III, last of the Valois kings. These two paintings, especially, tell us much about the state which was ruled by Catherine's sickly children.

Henri III was assassinated in 1589, and his great cousin Henri de Navarre succeeded him, to rule as Henri IV until he too fell victim to an assassin. Henri IV might revive national life in France, but it was beyond his power to revive French painting, which had fallen into the depths of mediocrity we find in the second school of Fontainebleau.

The three principal painters of the school were Ambroise Dubois (1542/3–1614), Toussaint Dubreuil (1561–1602) and Martin Fréminet (1567–1619). Much of their work has been destroyed, but enough remains to show how the feverishness of the earlier Fontainebleau masters became tempered by an inclination towards classicism. Dubreuil's *A Sacrifice* in the Louvre represents the highest level of their talent. Of his two colleagues, Dubois, who was born in Antwerp,

39

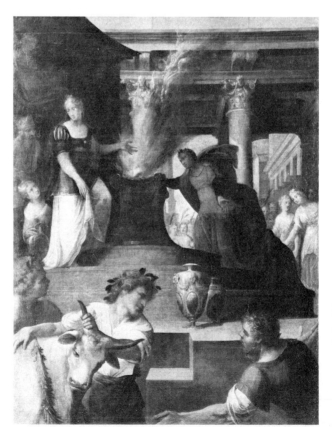

39 TOUSSAINT DUBREUIL
A Sacrifice
c. 1602

40, 41 JACQUES BELLANGE *Virgin Annunciate; Angel of the Annunciation*

showed the influence of Flemish Mannerism, while Fréminet (who returned to France only at Dubreuil's death) was under the spell of Italian painters such as the Cavaliere d'Arpino, dreariest yet most popular of late sixteenth-century artists. Fréminet had been in close contact with him during a long stay in Italy.

Mannerism was livelier and more inventive in the provincial city of Nancy, capital of the Duchy of Lorraine. The leading figures of the school of Nancy are Jacques Callot, Jacques Bellange and Claude Deruet. Callot (1592–1635) was the most celebrated in his own day, and has remained so. But he was a draughtsman and engraver, not a painter. After a period at the Court of Florence, he returned to Lorraine in 1621. Having begun as a pure Mannerist, he now, in this second phase of his career, begun to turn towards an objective realism, a determination to depict life as it really appeared to him. His last work, a set of plates called the *Grandes Misères de la Guerre*, prompted by a French invasion of the Duchy, shows how he mingled compassion with dispassionate observation. Caron had reacted differently to basically similar experiences.

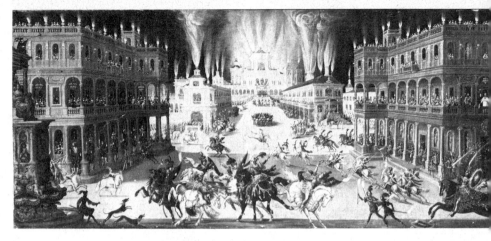

42 CLAUDE DERUET *Fire* 1600

Jacques Bellange (active 1600–17) is again mostly known to us as an engraver, one who seized upon the apparently frivolous tradition of Parmigianino and used its forms to express passionate religious emotion. Mannerism here returns to its beginnings: hypersensitive religious feelings find a voice through exaggerated elegance and formal discontinuity. But Bellange is also documented as a painter, and a

40, 41 signed *Annunciation* diptych by him survives. This is very like the engravings in mood, and shows the same tendency to look towards the past: the diptych is a characteristically medieval format. In addition to this, the *Virgin Annunciate* is an adaptation from Dürer, who was a source of ideas for Bellange just as he was for Pontormo and the young Rosso.

Claude Deruet (1588–1660) was a less interesting artist who has left a much greater number of paintings behind him. A decorative paint-

42 ing, *Fire*, gives some idea of his style.

Deruet must, in his later years, have felt himself to be a survivor from a totally different artistic universe. During the first half of the seventeenth century, French painting was to make another radical change in its assumptions. Mannerism was swept aside, only to return in the following century, in a new and different form, with the artists of the Rococo.

50

Painters of Reality

Italy remained as important to French artists during the seventeenth century as during the sixteenth. But now it was one Italian city in particular that drew them to itself: Rome. Rome was the centre of artistic experiment, the creative melting-pot of the time. It was not only French artists who made their way to Rome (and stayed, sometimes, to create their whole life's work), but artists from all over Europe. So many foreign, and especially northern, painters flocked to the city that they formed a recognizable colony, a community within the city, with its own accepted customs. These customs were free and easy. It was in seventeenth-century Rome that the notion of the Bohemian artist became clearly established for the first time, among painters who were living a long way from home, and who found themselves correspondingly free from social and family responsibilities.

The great revolutionary painter of the time was Michelangelo Merisi da Caravaggio (1573–1610). Caravaggio began his career with pictures of a shocking realism, often scenes of low life or parodies of mythology. For Caravaggio realism was thus at first a Mannerist device, a means of titillating and startling the spectator. Later, he came into contact with the Congregation of the Oratory, which had been founded by St Philip Neri. Neri was a religious reformer; he believed that God should come to men directly and unostentatiously. Caravaggio could never be entirely unostentatious (he was one of the great stormy petrels in the history of European art), but under Oratorian patronage he developed a new and extremely direct style of religious painting. His famous altarpiece of the *Entombment*, painted in 1604 for the Oratorian Church of S. Maria in Vallicella, shows how Caravaggio used realism for religiou: ends. The dramatic chiaroscuro we see in this painting was to influence painters throughout the century, and it was to appeal especially to northern artists. *43*

The alternative to Caravaggio was offered by the Bolognese painter Annibale Carracci (1560–1609), who was summoned to Rome in 1595 to paint frescoes in the Palazzo Farnese. If Caravaggio was a

realist, Carracci has usually been defined as a classicist. But it is impossible to exclude the notion of realism from the new manner which Carracci evolved in revolt against the excesses of Mannerism. Directness was among Carracci's aims, but a cooler, more balanced personality than Caravaggio's informs his work. Carracci, too, was responsible for concepts which were to be very important to European painting, notably that of the 'ideal landscape', which can serve as a setting for either mythological or religious incidents. The *Flight into Egypt*, painted for the Chapel of the Palazzo Aldobrandini between 1600 and 1604, shows that this type of painting was already fully developed in his hands. The frescoes of the Palazzo Farnese were of even more importance. The vigorous, heroically proportioned figures which Carracci invented, and the way in which he deployed them in the spaces at his disposal, moulded the thinking of every Baroque decorative painter. Caravaggio had no pupils, only imitators. Annibale Carracci

44

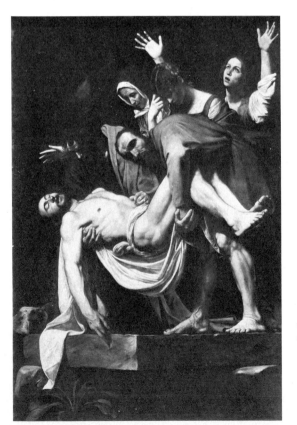

43 CARAVAGGIO
Entombment 1604

44 ANNIBALE CARRACCI *Landscape with the Flight into Egypt* 1600–4

and his brother Agostino created a school which was to dominate painting in Italy for the next century, and which was to have a profound influence on the many French painters who pursued their studies south of the Alps.

The northern painters working in Rome also evolved an influential style of their own, one which owed a little to Caravaggio, but yet remained essentially distinct. They did not create altarpieces and large decorative schemes, and often they did not work directly on commission, but painted instead for a market which was supplied by various professional art dealers. Their speciality was realistic scenes of low life. The man regarded as the pioneer of the style was the Haarlem artist Pieter van Laer (1592–1642), nicknamed 'Il Bamboccio', a word which means 'doll' or 'puppet', and which refers both to Van Laer's dwarfish appearance and to the small size of the paintings he produced. His followers were known as the *bamboccianti*. Van Laer influenced French as well as Dutch artists, among them the young Sébastien Bourdon.

It is possible to relate most of the developments which took place in French art during the first half of the seventeenth century to one or other of the influences I have just described.

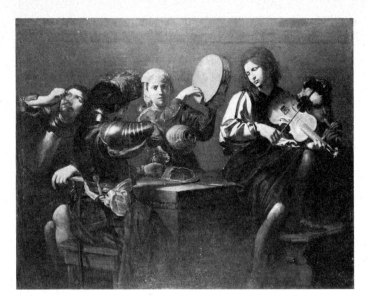

The two French artists who seem first to have felt the impact of
Caravaggio were Simon Vouet (1590–1649) and Claude Vignon
(1593–1670). Vouet was in Rome from about 1615 to 1627. The
46 *Lovers*, of *c.* 1618, shows how close he came to Caravaggio at one
moment in his development. But Vouet soon sheered away towards a
more eclectic style. On his return to France in 1627, he embarked on a
successful career as a decorator, and a discussion of his later work
belongs to a later chapter (p. 92).

Vignon was a less important and even more eclectic artist: he was
subject to Caravaggio's influence, but also to those of Adam Elsheimer,
the Venetian painter Domenico Feti, and (from a completely different
sphere) Rembrandt. Perhaps his leading characteristic, especially when
one compares him to the other French painters of his time, was the
fact that he was anti-classical. A typically tense and crowded picture
47 such as *Death of a Hermit*, painted about 1620 – that is, in the middle of
his period in Rome, which lasted *c.* 1616–24 – shows that basically he
remained a Mannerist, though one whose Mannerism was diluted
with Caravaggesque and northern ideas.

The short-lived Valentin de Boullongne (*c.* 1594–1632), who spent
the whole of his career in Rome, absorbed the lessons of Caravaggio
more thoroughly, but followed them perhaps too slavishly. The
45 *Soldiers and Musicians* now in Strasbourg shows how close he came to

54

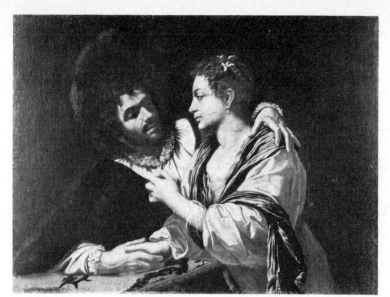

46 SIMON VOUET
Two Lovers c. 1618

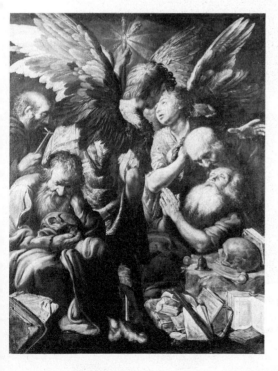

47 CLAUDE VIGNON
Death of a Hermit c. 1620

55

Caravaggio's early manner. But Valentin, because he never returned to France, had little impact on the course of French art.

Another French follower of Caravaggio, but one who did return to his own country, was Nicolas Tournier (1590–1657). Tournier was in Rome at the same time as the three artists I have just mentioned: 1619–26. He, like Valentin, remained faithful to Caravaggio's influence, though his work is altogether more personal. Tournier has a restraint and classicism which seem typically French if we compare him, for example, to the Italian followers of Caravaggio who worked in Naples. His work also has a lingering trace of Mannerism. He, too, like Valentin, remained outside the mainstream of the French painting *48* of his time; he settled in Toulouse. His masterpiece is the *Pietà*, formerly in Toulouse Cathedral, which bears comparison with *43* Caravaggio's *Entombment*.

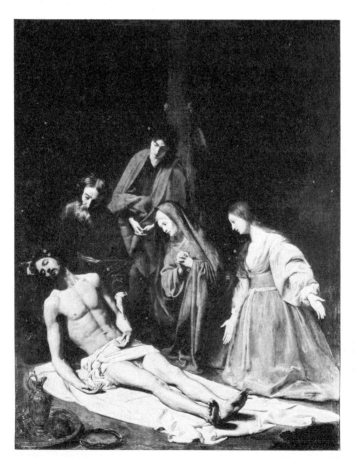

48 NICOLAS
TOURNIER
Pietà
c. 1656–57

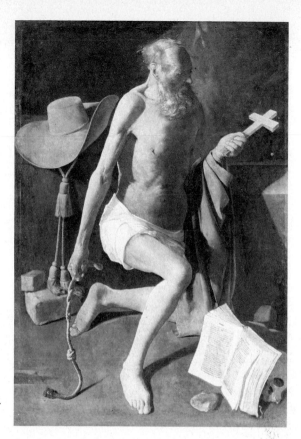

49 GEORGES DE
LA TOUR
*The Penitence of
St Jerome c.* 1620–25

The greatest provincial of them all, and Caravaggio's most gifted disciple in France, was Georges de la Tour (1593–1652). He is as individual as that other artist from Lorraine, Jacques Bellange. Bellange worked for the ducal Court in Nancy; La Tour spent most of his career in Lunéville, where he worked for a prosperous bourgeoisie. It is presumed by art historians that he went either to Italy or to the Low Countries at one point in his life, and on the whole it seems more likely that it was in the north that he came into contact with the ideas of Caravaggio. His early works show the impact of the startling Dutch Caravaggist Hendrik Terbrugghen.

La Tour is mysterious in many senses, and art-historical arguments still rage about his development. The most generally accepted theory is that he moved from descriptive naturalism towards a greater and greater degree of simplicity. *The Penitence of St Jerome,* which exists in 49

57

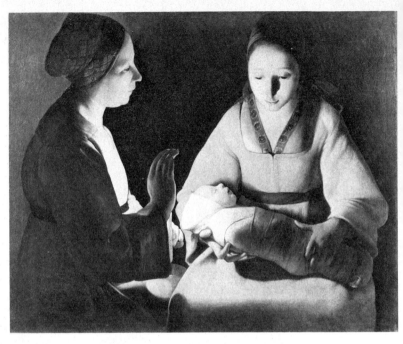

50 GEORGES DE LA TOUR *Nativity*

two versions, shows a degree of naturalistic detail which is still present
51 in parts of *Job Taunted by his Wife*; but this painting is largely resolved
into bold planes of glowing colour and clear-cut, sweeping outlines.
The source of light, and also of shadow, is the candle which the woman
carries: a device which is typical of Caravaggio's Dutch followers, who
liked to provide a common-sense explanation for the violent chiaro-
scuro they preferred. Later, and more simplified, is *St Joseph in the*
53 *Carpenter's Shop*. This painting, it has been pointed out, comes the
closest of all La Tour's works to Caravaggio himself, since the figure
of Joseph seems to be an adaptation of the servant holding the horse in
Caravaggio's *Conversion of St Paul*. The greatest degree of simplicity
52 and monumentality is achieved with paintings such as the *Magdalen*
50 *with the Lamp* in the Louvre, and the *Nativity* in Rennes.

These pictures make it clear that the artist's feeling for composition
was put at the service of genuine religious emotion. Boldly, we may
choose to read the increasing austerity of La Tour's work as an index
of spiritual progress. The time was one of religious revival in France.

58

51 GEORGES DE LA TOUR *Job taunted by his Wife*

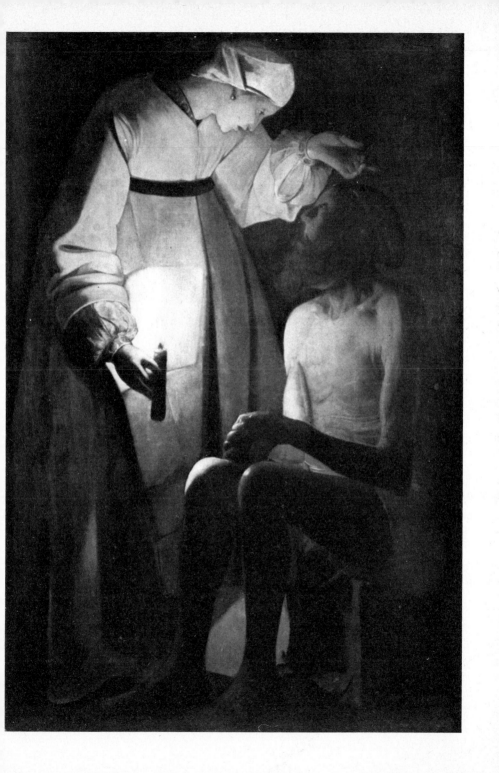

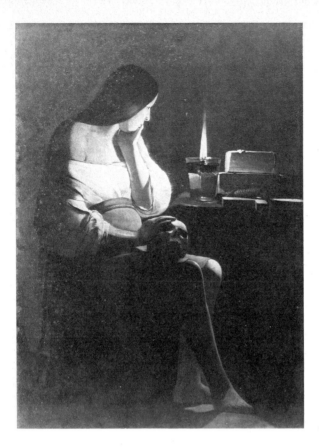

Magdalen with the Lamp

After the Wars of Religion a great intellectual effort was made by French Catholics to rediscover both the essence and the true foundations of the Faith. The situation thus created was similar to that which the Oratorians made for themselves in Rome. Georges de la Tour was a product of the culture which also produced St Francis de Sales. Even today, in a very different cultural situation, it is possible to see his paintings as the product of a heroic and concentrated effort to find a road going straight to God.

Another striking characteristic of La Tour's work is the way in which it joins this concern with the sacred to the ordinary. In quite a number of his paintings it is only the solemnity, the hushed stillness of the figures, that inform us that we are witnessing a sacred event, and not merely an incident taken from life. This is true, for example,

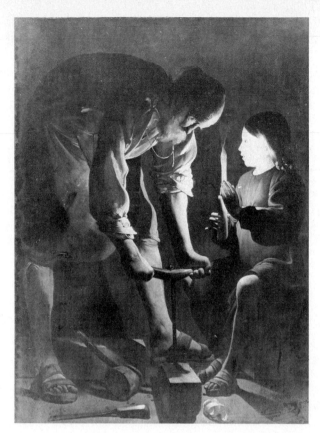

53 GEORGES DE LA TOUR
*St Joseph in the Carpenter's
Shop c.* 1645

of the Rennes *Nativity*, which used to be called simply *The New-born* 50
Child. The picture leads us to see the divinity of the Saviour in all
children, and the tenderness of the Virgin in all mothers.

It is a feeling for the dignity and importance of quotidian events
which links Georges de la Tour's work to that of the Le Nain brothers.
The Le Nains are not in the orbit of Caravaggio, but that of Van Laer;
they give a new and striking interpretation of his *bamboccio* style. There
were three Le Nain brothers, and the exact apportionment of their
work is a matter of controversy. It seems likely that they worked to-
gether on many of the pictures now attributed to one or another of
them – the possibility seems the more likely because the signature on
a signed work tends to be simply 'Le Nain', without the addition of a
forename.

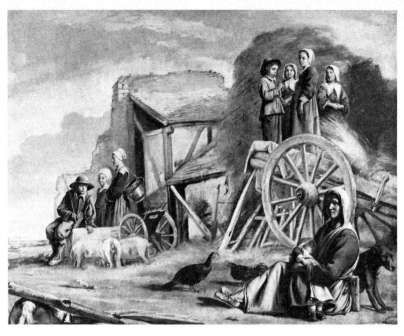

54 LOUIS LE NAIN *The Traveller's Rest*

The Le Nains were born in Laon, and spent most of their careers in
Paris. The eldest brother, Antoine (1588–1648), is now generally re-
garded as a painter of small pictures, rather naïve in composition,
whose subject-matter is usually a bourgeois family group. The
youngest and longest-lived brother, Mathieu (1607–77), is thought to
have come the nearest to Dutch genre-painting of the kind practised
by artists such as Anthonie Palamedesz. His *Reunion of Amateurs* in the
Louvre, generally supposed to have been painted after the deaths of
his two elder brothers, supports this view. Other paintings ascribed to
Mathieu, such as the *Travellers at an Inn* in Minneapolis, show people
who are lower in the social scale than those who figure in the *Reunion*,
and indeed come close to the paintings assigned to the middle brother,
Louis Le Nain (1593–1648), now generally considered to be .the
dominant member of the family partnership.

To Louis, at least three types of composition are assigned. The most
'typical', and the ones from which, because of their striking beauty and
individuality, most experts would like to exclude the possibility of

56

55

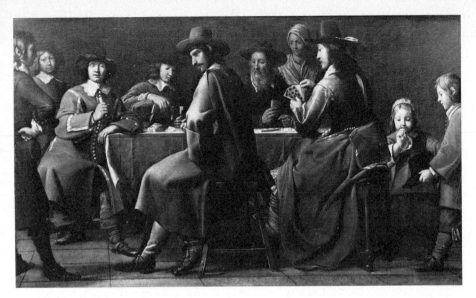

55 MATHIEU LE NAIN *Travellers at an Inn*

56 MATHIEU LE NAIN *Reunion of Amateurs*

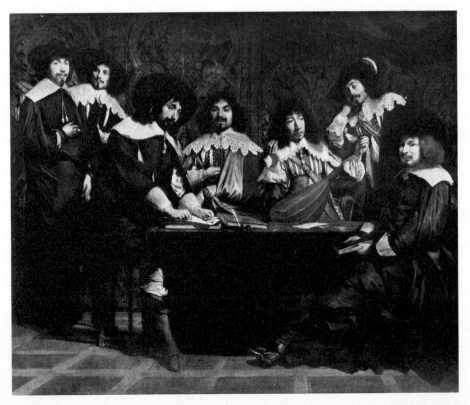

collaboration, are the scenes of peasant life. The grey, quiet tonality and the technique owe something to Van Laer, but the great originality of these pictures is the attitude they adopt towards their subject-matter. The humble people who appear in these pictures are treated with complete objectivity, yet with penetrating sympathy. There is not a trace of exaggeration or caricature. In the most famous, such as *The Traveller's Rest*, we are struck by the air of serenity, the poise of the figures. These are not, as so often happens in Dutch genre scenes, actors upon a stage, performing for the benefit of the spectator. Their self-contained calm reminds us of Greek statues, though there is no overt classicism. Analysis of the compositions reveals how carefully the artist has balanced one figure against another, and how sure his sense of interval is.

The Le Nains also worked on a larger scale, and here they were usually less forceful. Perhaps for this reason, it is customary to treat works of this kind as joint efforts. The mythological pictures, such as *Venus at the Forge of Vulcan*, are usually more successful than the sacred scenes: there is a striking resemblance between this picture and the *Apollo at the Forge of Vulcan* which Velázquez painted in Rome in 1629, and the Le Nains sustain the comparison with their great Spanish contemporary. On the other hand, a picture such as the *Nativity* in London, beautiful though it is, does not benefit from the comparison with Poussin which the composition invites. Set beside Poussin's work, the forms seem uncertain and their arrangement clumsy.

Nevertheless, when they stay within their own limits, the brothers Le Nain produced a number of undoubted masterpieces, and they typify an important aspect of the French national sensibility. The qualities which they possess are those of objectivity and contained emotion, those which we encounter again in the still-lifes of Chardin, in early landscapes by Corot, and even in certain portraits by David.

Historians have often expressed bewilderment about the question of who patronized the Le Nains, as their subject-matter, or rather their treatment of it, seems contrary to the taste of the time. But they were successful enough not only to make a living, but to invite imitation. The closest of their followers appears to have been Jean Michelin (*c.* 1616–70), about whom very little is known. His work has often been confused with that of the Le Nains. Jean Tassel (*c.* 1608–67) was another artist who tried to acclimatize the *bamboccio* style in France. He is known to have visited Rome in 1634, and to have frequented the

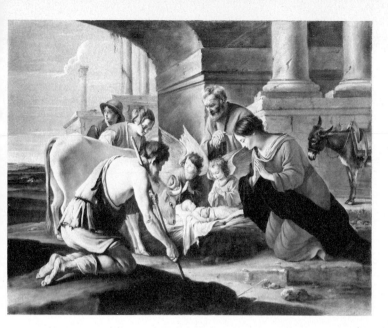

57 LOUIS LE NAIN
AND
ASSISTANT
Nativity

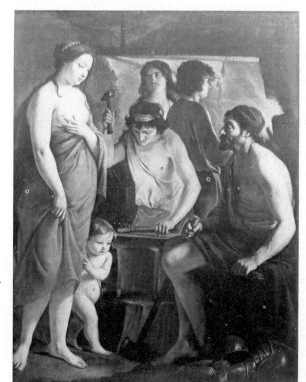

58 LOUIS AND MATHIEU LE NAIN
Venus at the Forge of
Vulcan 1641

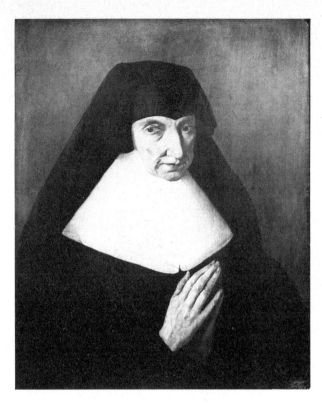

59 JEAN TASSEL
Catherine de Montholon
c. 1648

northern painters who lived there. Like many minor artists, he was uneven and eclectic, but he was capable on occasion of producing a truly memorable painting, such as the terrifying portrait of Catherine
59 de Montholon, who was the foundress of the Ursuline convent in Dijon. This has the dignified but pitiless truthfulness of medieval portraiture.

A special, if humble, place in the history of French painting during the seventeenth century is filled by the painters of still-life. Painting was, theoretically, divided into rigid categories, and the still-life painters ranked lowest of all; theirs was the least-regarded branch of art. Yet their achievements were not neglible. The kind of sensibility which we find expressed in the still-lifes of this period is often recognizably the same as that which appears in the work of the Le Nains.
61 One or two Le Nain-like paintings, such as the *Overturned Wheelbarrow* in the Louvre, exist to prove an actual link. But the genre tended to follow a course of its own.

66

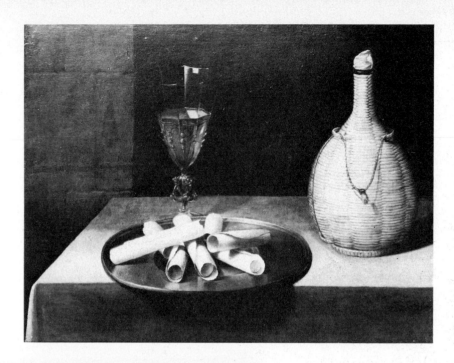

60 LUBIN BAUGIN
The Dessert with Wafers
c. 1630

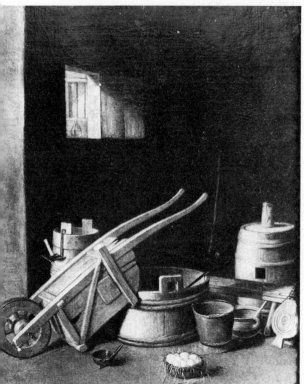

61 SCHOOL OF LE NAIN
Overturned Wheelbarrow
c. 1640–50

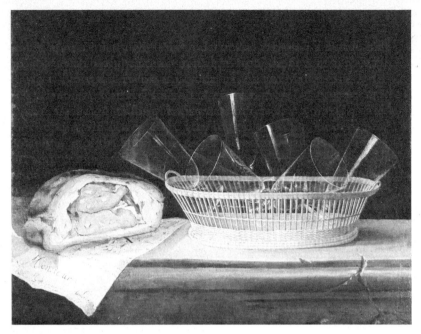

62 SÉBASTIEN STOSKOPFF *Pâté and Basket of Glasses* 1630–40

63 FRANÇOIS GARNIER *Gooseberries and Cherries* 1644

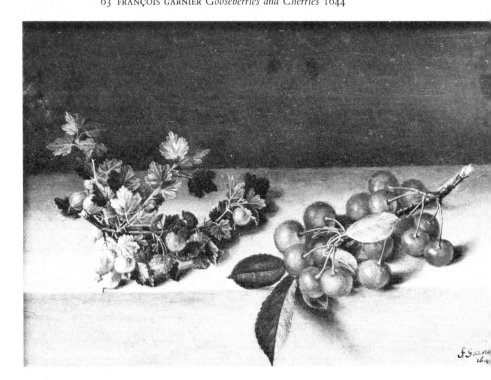

64 LOUISE MOILLON *Nectarines* 1674

A whole colony of Netherlandish artists settled in Paris during the reigns of Henri IV and Louis XIII, and many of them were specialists in the kind of still-life painting which had established itself in the Low Countries at the end of the sixteenth century. Paintings of this kind characteristically have a high viewpoint (rather as in Mannerist land-scape), and clear-cut forms are regularly distributed over the whole picture-surface, with the objects arranged so as not to conceal their neighbours. Often these pictures were allegorical; a common theme was the transience of human life, as symbolized in the genre known as the *Vanitas*.

This style persisted in France even longer than it did elsewhere, per-haps because its clarity appealed to French taste; the picture illustrated here, which was painted by an artist named Baugin somewhere about

60

1630, shows what the French did with the still-life formula they had inherited. They simplified it, reduced the number of objects in the composition, and made their arrangement clearer and more logical. They also paid more attention to subtle transitions of form. The objects shown are thus given an intensified feeling of reality.

Other French still-life painters of the period, who show the same preoccupations as Baugin, include François Garnier (active c. 1627–58), his step-daughter Louise Moillon (1609/10–96), Jacques Linard (c. 1600–45), René Nourrisson (active 1644–50), Pierre Dupuis (1610–82), and Sébastien Stoskopff (1597–1657). Louise Moillon is perhaps the one of these who could most easily be taken for a Fleming. Precise and delicate as she is, her bowls of fruit shimmer under a veil of atmosphere. Since she was the longest-lived of all the painters of the group, her work shows the final stage of development of the kind of painting they practised. A more inventive artist, whose paintings are, unfortunately, much rarer than hers, was her contemporary Stoskopff, who came from Strasbourg and was trained in Hanau. He was thus in direct contact with the Netherlandish tradition. Stoskopff is less archaic than Baugin, but manages to preserve the same reticence and innate classicism within the framework of a more natural looking composition.

63

64

62

70

In Arcadia

The two greatest French painters of the seventeenth century made their careers in Rome. Though their subject-matter is often super-ficially similar, Nicolas Poussin (1593/4–1665) and Claude Lorrain (1600–82) make a curious contrast. Poussin's career was that of an artist who increasingly aimed to make his work both more con-centrated and more rational; Claude, on the other hand, tended to abandon solidity in favour of the illogical and the magical. Neither painter is in any sense a realist: each invents an apparatus and a pictorial grammar to suit himself, and uses it as a vehicle for the expression of personal ideas and feelings. That is, each of them has a vision of the world which is projected outwards, and imposed upon the everyday experience which is shared by artist and spectator alike. With Poussin, this vision has an internal consistency which is missing in Claude. Poussin takes a theme or subject and examines its implications pictorially, while Claude tries to embody sensations. Sir Anthony Blunt has defined the difference between them as that between an artist (Poussin) who was interested in the *subject-matter* of his pictures, and one (Claude) who was more interested in their *content*.

Poussin came from Normandy, from a family which reckoned itself as noble, but which the civil wars had reduced almost to the level of the peasantry. He seems to have decided to become an artist when he came into contact with a minor Late Mannerist painter named Quentin Varin, who came to the nearest town, Les Andelys, to paint a series of altarpieces. This took place in 1611. In 1612 Poussin left home, apparently against the will of his family, to pursue his chosen career. The years between 1612 and 1624 he seems to have spent mostly in Paris, working under various masters. He also seems to have made a profitable study of the paintings and antique marbles in the royal collection, and particularly of the prints after Raphael and Giulio Romano in the royal library. He worked on the decorations being done at the Palais du Luxembourg for the Queen Mother, Marie de Médicis, and the young Philippe de Champaigne was one of his com-

panions in the task. Eventually he attracted the attention of the Italian poet Giambattista Marino, who was at that time enjoying a great success in Paris. Poussin had made two previous attempts to go to Rome; Marino now encouraged him to make a third. We first hear of Poussin's presence in Rome in March 1624.

At this time, the kind of work he was doing was still heavily influenced by the painters of the second school of Fontainebleau. The *Dido and Aeneas*, now in Toledo, Ohio, which is clearly a very early picture, looks like a work from the hand of Toussaint Dubreuil. The long, slim nudes are of the accepted Fontainebleau type.

Once established in Rome, Poussin lost no time in freeing himself from these old-fashioned influences. He began to purify his style; and he came under the influence of Raphael, whom he was now able to study at first hand, and of his own Italian contemporary Domenichino (1581–1641), one of the most important heirs of the classicist tradition established by Annibale Carracci. The *Parnassus* now in the Prado gives us an idea of the effect which these influences had upon Poussin during his first years in Rome. The picture seems to date from 1626–27.

65 NICOLAS POUSSIN *Dido and Aeneas c.* 1634

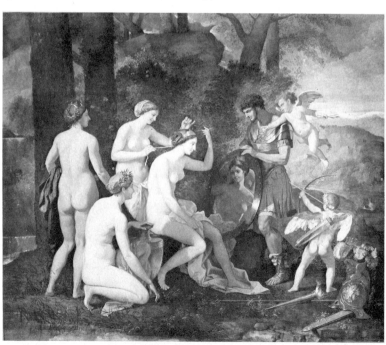

66 NICOLAS POUSSIN *Parnassus* 1626–27

Marino introduced Poussin into the circle of the powerful Barberini family. In 1628 Cardinal Francesco Barberini, nephew of the reigning Pope Urban VIII, got Poussin the kind of commission which most artists then longed for. He was asked to paint a large altarpiece for St Peter's. The result was the *Martyrdom of St Erasmus*. We can now 67 admire its grandiose design, but the picture met with a somewhat cool reception from the contemporary public. Poussin himself may have sensed that his future did not lie with these great Baroque show-pieces, which his Italian competitors were so skilful at producing. On the other hand, he did not, by temperament, belong among the *bamboccianti*.

He began to produce a new kind of picture for what was, relatively speaking, a new kind of patron. One of the finest works created at this time, just at the end of the 1620s, is the first version of the *Shepherds* 68 *of Arcady*. The principal figures are, as the title suggests, two shepherds in classical dress, who press forward to read the inscription on a tomb. This reads ET IN ARCADIA EGO, which is generally translated to mean:

73

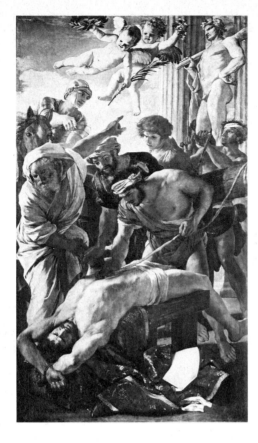

67 NICOLAS POUSSIN
Martyrdom of St Erasmus
1628–29

'And I too lived in Arcadia'. Though the subject is slightly mysterious, the general meaning is plain: death obtrudes, even in the happiest of existences.

The kind of clientèle likely to appreciate a painting such as this had to be a reasonably well-educated one. Those who belonged to it would not be solely 'public men'; they would have the leisure and the taste for reading and meditation. One of the most steadfast of Poussin's patrons henceforth was Cardinal Francesco Barberini's secretary, Cassiano del Pozzo. Cassiano del Pozzo was intensely interested both in contemporary art (Lanfranco and Pietro da Cortona were his friends), and in antiquarian study. A team of artists made drawings for him of ancient sculpture and architecture, in order to make as complete a picture as possible of ancient Rome.

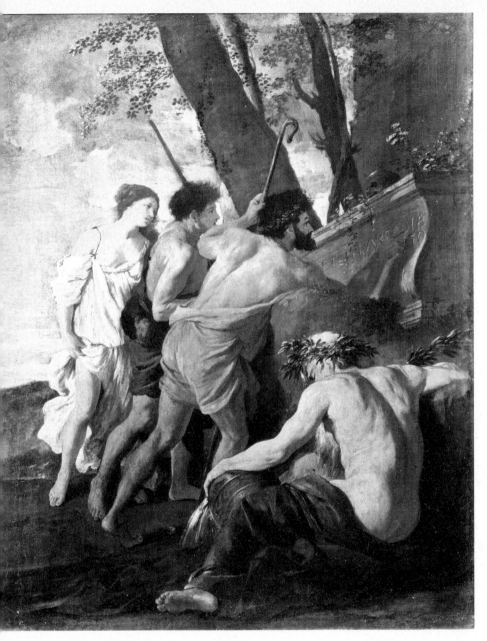

68 NICOLAS POUSSIN *Shepherds of Arcady c.* 1630

At this time, Poussin was under the spell of the Venetians, and in particular Titian and Giovanni Bellini: he copied the latter's *Feast of the Gods*. Gradually, as the decade wore on, his colouring became cooler, his modelling more precise, the equilibrium of the composition more carefully worked out. The *Childhood of Jupiter* at Dulwich is an example of this shift of emphasis. The picture dates from about 1637. Though the picture is demonstrably different from what he had been doing earlier, the artist remained faithful to some of his earliest influences. The figure of the child Jupiter being suckled by a goat is borrowed from an engraving after Giulio Romano.

During this period, Poussin's reputation established itself firmly. By 1635 he was dispatching paintings far and wide: to Turin, to Naples, and to France and Spain. That year, Louis XIII's all-powerful minister Cardinal Richelieu ordered five important paintings from him. Soon efforts were being made to lure him back to his own country, and in 1640 Poussin succumbed to these blandishments and set out for Paris. He had been offered an excellent salary, an extremely honourable position, lodgings in the Louvre – everything, so it seemed, that he could wish for.

To start with, things went well for him in France. By January 1641 he was hard at work. He was to decorate the Grande Galerie in the Louvre, make cartoons for tapestries, paint altarpieces, design frontispieces for books. Furiously jealous, all his colleagues in Paris began to intrigue against him. Poussin disliked not only this, but the coldness of the climate, the pressure which was put upon him by his eminent patrons, the waste of his gifts upon what he considered to be trivial tasks. He thought his assistants were of poor quality, and it is also clear that he discovered that Baroque schemes of decoration were not his forte, any more than Baroque altarpieces had been. On the pretext of fetching his wife, he slipped away from Paris. By November 1642, he was once more in Rome, secretly determined never to leave it again.

Paris had had one good effect upon his career, however. It confirmed the friendships which he had already made with a number of French patrons, and he made new friends and new patrons in the same circle. They continued to support him after his return to Rome. For the most part they were neither very rich nor very aristocratic: they were solid merchants, well-established but not plutocratic bankers, and civil servants.

69 NICOLAS POUSSIN *Childhood of Jupiter c.* 1637

During the ten years after his return, Poussin's art deepened and became more concentrated and more serious. He still painted classical scenes, but now they were not illustrations of Ovid but allusions to Stoical philosophy: incidents which showed the will triumphant over the passions. Scholars have pointed out the resemblance to the themes which Pierre Corneille was using in his tragedies at the same time.

Poussin also returned to the central themes of the Christian myth. He had already painted a series of *Seven Sacraments* for Cassiano del Pozzo; now he painted a second series on the same theme for his Parisian patron Paul Fréart de Chantelou. These paintings have an extraordinary concentration; the artist leaves only the essential.

70, 71

77

70 NICOLAS POUSSIN *The Eucharist* 1647

In some of the works in the series (*The Eucharist* and *Penitence*), Poussin treats the composition as a kind of bas-relief. The extremely restricted range of colour contributes to the sculptural effect. In *The*
70 *Eucharist*, the figures seem to be compressed into a narrow space just behind the frontal plane: the curtain which hangs behind the main group contributes to this effect. In the remaining compositions, Poussin treats the area of action as a kind of box, a definite, three-dimensional space occupied and articulated by the three-dimensional solids of the figures and the buildings in front of which they move.
71 A painting such as *Ordination* reflects Poussin's laborious method of work. First, a sketch. Then a peepshow with a painted backcloth and miniature figures modelled in wax. Then another sketch, followed, perhaps, by alterations in the model. Finally, lay figures on a larger scale. We can see this logical, orderly process at work even in the pictures where the figures take a secondary place, such as the *Diogenes*
72 *Throwing down his Bowl*, painted in 1648.

78

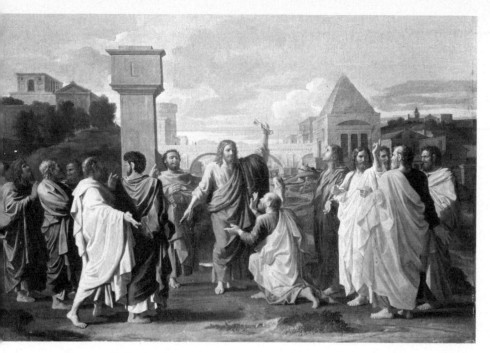

71 NICOLAS POUSSIN *Ordination* 1647

Poussin had by this time come to believe in the absolute power of reason, at least where his art was concerned. He wished his work to be the rational expression of ideas which were both serious and elevating. Since it was to be a means of intellectual communication, the seductions of colour and atmosphere were to be eschewed. Poussin leaves nothing to chance; every detail is made to contribute to the final effect. The subject dictates the stylistic treatment: solemn subjects must have a proper solemnity. Ideas of this kind were to have a persistent influence on the painter who succeeded him.

In his last phase, Poussin became less and less interested in gesture or expression. The paintings take on a marble stillness. The Baroque spiral finally disappears; the underlying design is basically rectilinear. Strangely, this severity can transform itself into a kind of expressionism. At the very end of his career, Poussin painted a series of landscapes representing *The Four Seasons*. They occupied him from 1660 to 1664. *Winter*, or *The Deluge*, is painted in a manner that suits the *73*

subject: rough, coldly monochrome, deliberately awkward. Despite its strangeness, the painting has always been admired. Diderot, the great eighteenth-century critic, was moved by it; and so were Romantics such as Turner and Delacroix. Indeed, it has an odd affinity with some of the most extreme of Turner's landscape visions. One idea is taken and projected with manic force. The stylistic extremes are linked.

Claude Gellée, usually called Le Lorrain in French and Claude Lorrain in English, was born in a village not far from Nancy. According to legend, he went to Rome as a pastry-cook, and took service in the household of the landscape painter Agostino Tassi (1581–1644). Tassi headed a team of artists who produced decorative landscape frescoes for Roman palaces. His style derived from Annibale Carracci via the landscapes of the northerner Paul Bril (d. 1626). Though we find in Tassi's fanciful, insubstantial work the full repertoire of subjects which Claude was afterwards to use, Claude's early work comes closer to Bril, from whom he clearly learned a great deal. Other

72 NICOLAS POUSSIN *Diogenes Throwing down his Bowl* 1648

73 NICOLAS POUSSIN *Winter,* or *The Deluge* 1660–64

artists who influenced Claude were Adam Elsheimer and, later, Domenichino.

Claude seems to have been in Tassi's service about 1620–25. In April 1625 he left Rome and went back to Lorraine, where he was taken on as an assistant by Claude Deruet. He returned to Rome in October 1627, and stayed there for the rest of his life.

He first emerges as a considerable artist in the 1630s. By the end of the decade he was already well known. From 1636 onwards we have an exceptionally complete view of his work, thanks to the so-called *Liber Veritatis,* a book containing a drawing of every painting he did.

Claude is an artist who does not change, in any essential respect, in the course of a long career. His paintings concern his reaction to one particular tract of landscape: the countryside around Rome. Often there are figures. In many cases there is no ostensible subject, but sometimes these figures will act out an incident from mythology or

81

Scripture. The pictures where this is the case are the most complex and highly charged that the artist produced. The function of these incidents is to intensify the mood of the landscape which surrounds them, and to bring it into focus for the spectator. In his later years, at least, Claude chose his incidents very carefully, both for their relationship to the patron who had commissioned the painting, and for their appropriateness to the mood which he himself wanted to convey. Thus, it is clear that the poetry of Virgil meant a great deal to him; in the last ten years of his life he painted six canvases showing incidents from the story of Aeneas. But not one of these illustrates a scene which was used by another artist, even though the *Aeneid* was a popular source of subject-matter for the painters of the time.

74 CLAUDE
LORRAIN
Pastoral Landscape
c. 1636

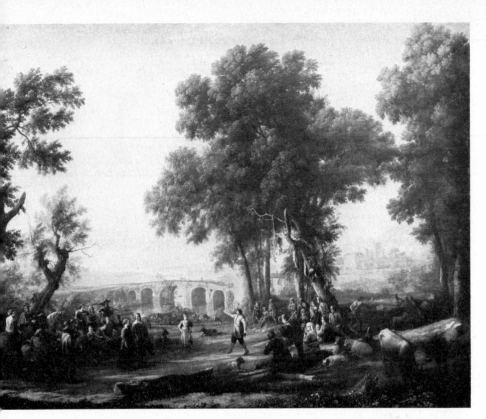

75 CLAUDE LORRAIN *Landscape with a Rustic Dance* 1639

Space is a large part of Claude's concern, and his attitude towards
the depiction of space is very different from Poussin's. Claude's
space is not enclosed and finite; it stretches out, it escapes from the
confines of the picture. He works by means of a series of receding
planes, one linked to another. Often the composition is not logically
constructed: the artist juggles with the relative proportions of trees,
figures and architecture, contracts space or expands it to suit himself,
violates the laws of perspective. But these departures from strict
naturalism are never forced upon the spectator's attention. Claude
lacks both Mannerist unease and Mannerist self-consciousness.

A *Pastoral Landscape* in the National Gallery, London, which dates 74
from about 1636, is representative of Claude's first phase. The classical
note contributed by the figure is very discreet, and the trees are

83

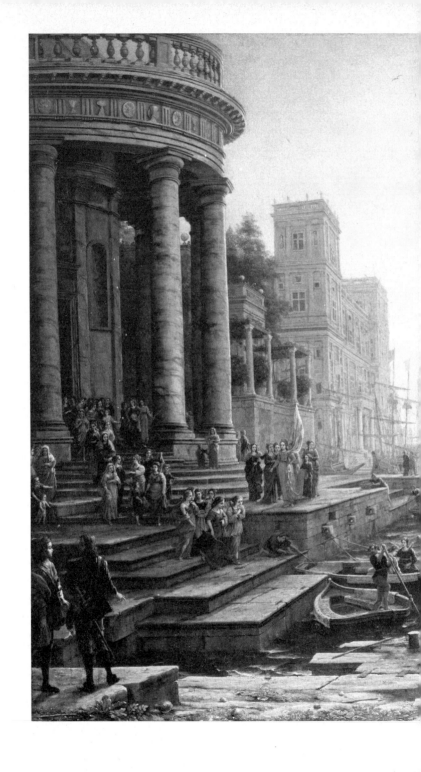

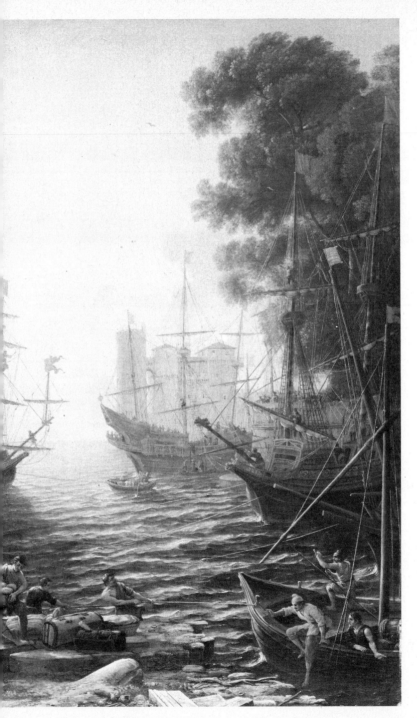

76 CLAUDE LORRAIN *Seaport with the Embarkation of St Ursula* 1641

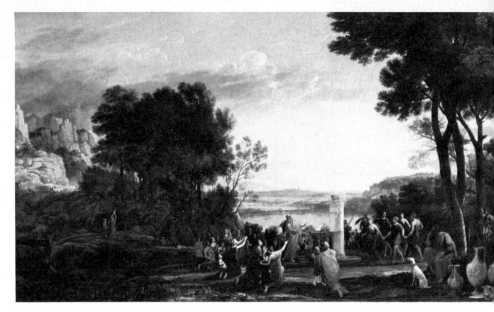

77 CLAUDE LORRAIN *Landscape with the Adoration of the Golden Calf* 1653

observed from nature. Taken as a whole, the picture creates a model
which was to be very influential in English art; early Gainsborough
and John Crome both come to mind. A slightly later painting, the
75 *Landscape with a Rustic Dance* in the Louvre, which is dated 1639,
represents a rather more ambitious sort of composition, but the way
the figures are grouped is not yet as subtle and assured as it was to be
later on. In type, the figures owe something to the *bamboccio* style of
painting.

76 Richer and more assured in composition and handling is the *Seaport
with the Embarkation of St Ursula*, which dates from 1641. Claude had
painted harbour scenes of this type before this one, but this is both
more complex and more festive than its predecessors. The handling of
the passage on the right, where the masts of a ship are shown against
the branches of a tree, is especially notable.

By this time, Claude had little to learn about his craft. During the
rest of his career he was to concentrate on giving a deeper and more
77 poetic meaning to his work. The large and impressive *Landscape with
the Adoration of the Golden Calf*, dated 1653, shows a consummate skill

86

79 CLAUDE LORRAIN *The Landing of Aeneas at Pallanteum* 1675

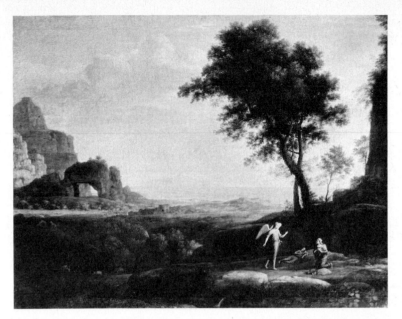

78 CLAUDE LORRAIN *Landscape with the Angel Appearing to Hagar* 1668

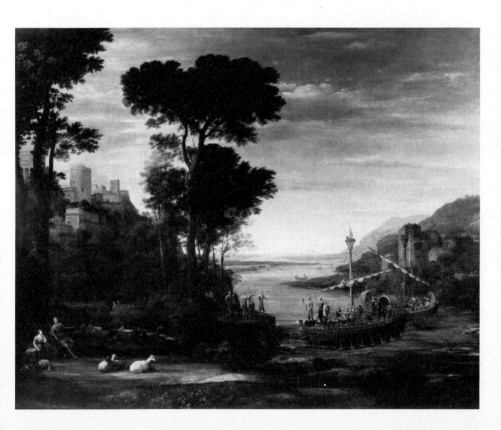

in the handling of the figures – they include Moses, who is about to destroy the tablets, and Aaron sacrificing to the new idol. The figures surrounding the calf are the most elaborately orchestrated group in the whole of Claude's work. Claude was later able to unify the figures still more thoroughly with their surroundings, as we see in the *Landscape with the Angel Appearing to Hagar* of fifteen years afterwards. Two trees are used to set off the group of Hagar, her son, and the angel: the more prominent of these is twisted to echo both Hagar's posture and the intensity of her suffering. The rugged rocks on the left also help to express the nature of the story.

The artist's last phase can be represented here with two paintings on classical themes. The more elaborate and earlier is *The Landing of Aeneas at Pallanteum*. Aeneas stands on the prow of his ship, carrying a palm-leaf as a sign that he comes in peace, and is addressed by Prince Pallas, who stands on the shore. The elongation of the figures is typical

78

79

80 CLAUDE LORRAIN *Landscape with Ascanius Shooting the Stag of Sylvia*

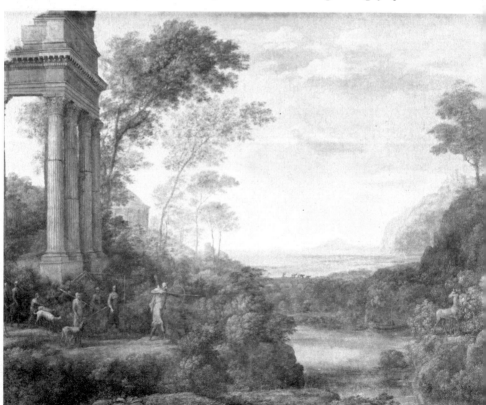

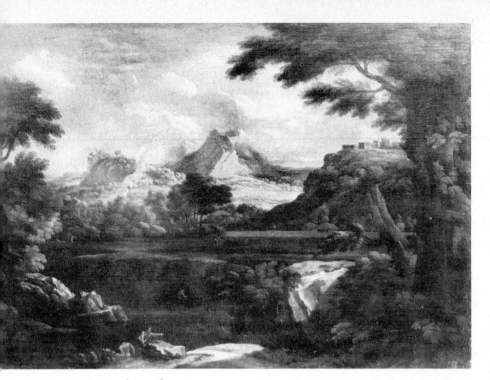

81 GASPARD DUGHET *Landscape* after 1650

of Claude's larger works at this time: we see it again in the artist's last picture, *Landscape with Ascanius Shooting the Stag of Sylvia*. In these late *80* works Claude achieves an unusual combination of force and serenity. The handling is refined; the atmosphere clear, silvery and serene; but the compositions tend to be bold and unconventional. The trees and rocks are as eloquent as the figures, if not more so. The artist has long ago absorbed everything his surroundings have to teach him, and is able to create an imaginary world of exceptional completeness. *Ascanius* embodies features which are characteristic: the trees on the left bend in an ominous wind; the great gap which sunders the landscape (with Ascanius on one side of it and the stag on the other) creates a feeling of tension which corresponds to the tension of the story, where the shooting of the stag brings disaster.

 Claude's imaginative world, like Poussin's, was self-referring; but, also like Poussin's, it was fruitful for other artists. The classical land-

scape, which Claude created upon the foundations provided for him by Annibale Carracci and Paul Bril, was to form part of the stock-in-trade of European painting for the next century.

One talented early practitioner of the genre was Nicolas Poussin's *81* brother-in-law, Gaspard Dughet, otherwise known as Gaspard Poussin (1615–75), whose work combines elements taken from Claude and Poussin with others drawn from the romantic landscapes of Salvator Rosa. Dughet is a direct and masculine artist, more prosaic and less subtle than Claude, and, perhaps for this reason, he proved easier for other painters to absorb and imitate directly.

Another French classical landscape painter of the same period was *82* Pierre Patel the Elder (*c.* 1605–76). Patel never went to Rome, and therefore did not know the landscape of the Campagna at first hand, as Claude and Dughet did. In his hands, classical landscape again became conventional and decorative: that is, it returned to the state of affairs which the young Claude had discovered in the studio of Agostino Tassi. Patel participated in the decorative schemes which will form part of the subject-matter of the next chapter, just as Tassi had plied his trade as a decorator in the princely palaces of Rome.

82 PIERRE PATEL THE ELDER *Landscape with a Goatherd*

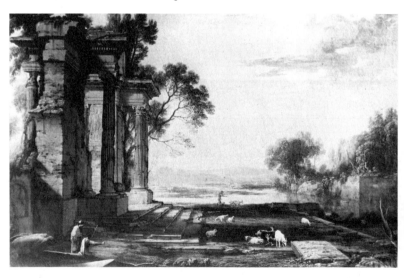

The Sun King

Up to this point we have barely touched upon what the men of the seventeenth century would have considered to be the main line of development in French painting: the work done for the Court and the great men who surrounded the King – altarpieces, paintings with historical and mythological subjects, and, in particular, decorative schemes. The reigns of Louis XIII (1610–43) and Louis XIV (1643–1715) span an authoritarian age of Court patronage and official art.

The first great cycle of decorative paintings done in France after the second school of Fontainebleau had flickered out was the work of a foreigner, Peter Paul Rubens (1577–1640). This was the so-called Marie de Médicis cycle, created in 1622–25 for the Palais du Luxembourg. These paintings form one of the most impressive schemes of Baroque decoration in existence, and they were to have a great impact upon artists of a later period, from Watteau to Delacroix; but at the time they had curiously little effect.

The story of the official painting of the French seventeenth century really begins with the return of Simon Vouet to Paris in 1627. He quickly established himself as the leading decorative painter in France. Though Vouet's talent was by no means comparable with that of Rubens, he has perhaps been underestimated by art historians. The first version of *Time Vanquished by Hope, Love and Beauty*, painted *83* just before the artist left Rome, shows how accomplished he was at this period. Caravaggio has been almost entirely abandoned; what we see, instead, is an amalgam of Baroque influences – those of Guido Reni and Guercino, in particular. Vouet imbues the figures with a typical elegance: the spirit of Fontainebleau survives, without its forms.

Contemporary French taste, however, seems to have imposed a certain constraint upon his development. The *Allegory of Wealth* in the *85* Louvre, apparently painted in the early 1630s as one of a series of allegorical paintings for the royal Château Neuf at Saint-Germain-en-Laye, is a cooler, more linear picture altogether. This development

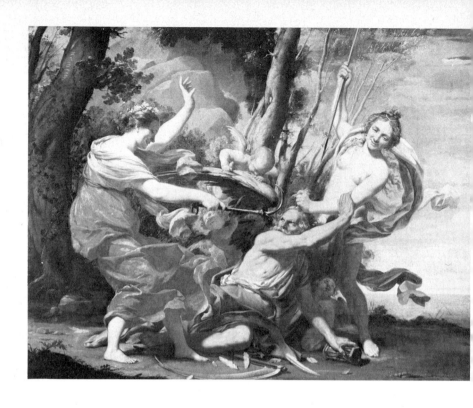

84 continues, and the second version of *Time Vanquished by Hope, Love and Beauty*, painted in the late 1630s or early 1640s, is a striking contrast with the first. The colour is pale and transparent, the forms are flattened, with the figures pressed forward into a shallow space by the classical architecture of the setting.

 Exactly the same pattern of development is to be found in Vouet's
86 religious works. The *Lot and his Daughters* in Strasbourg, which dates from 1633, shows the feeling for female beauty through which, while remaining unquestionably a Baroque artist, he links the Mannerism of Fontainebleau to the Rococo of Fragonard and Boucher. By contrast,
87 the very late *Assumption of the Virgin* is Vouet at his chilliest and least atmospheric.

 Nevertheless, Vouet dominates official painting during the first half of the seventeenth century, just as Charles Le Brun was to dominate it during the second. Even Poussin's arrival in France in

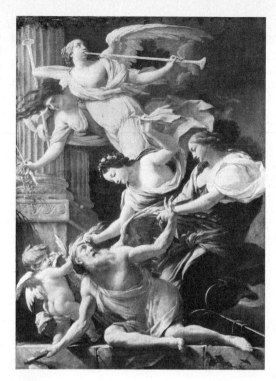

84 SIMON VOUET
*Time Vanquished by Hope, Love
and Beauty c.* 1640

83 SIMON VOUET
*Time Vanquished by Hope, Love
and Beauty* 1627

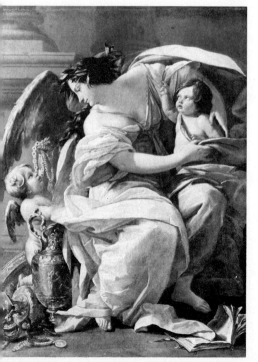

85 SIMON VOUET
Allegory of Wealth
1630–35

93

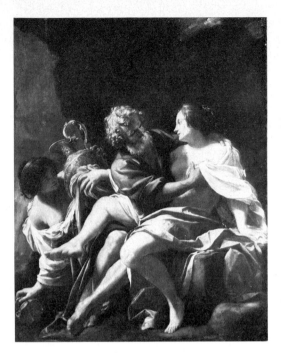

86 SIMON VOUET
Lot and his Daughters 1633

87 SIMON VOUET
Assumption of the Virgin 1644

1640 did not shatter Vouet's position, despite Louis XIII's malicious remark: 'Voilà Vouet bien attrapé!' ('Poor Vouet's had it!'). The leading artists of the next reign studied in Vouet's studio, among them Le Brun himself, Eustache Le Sueur, and Le Brun's rival Mignard.

It was not Poussin's visit, nor the death of Louis XIII in 1643, but the founding of the new Academy of Painting and Sculpture in 1648 that marked the real end of Vouet's influence. The Academy was joined by Le Brun, Le Sueur, and even by Vouet's old associate François Perrier. Vouet did not join, but became, instead, the 'Prince' of the rival Academy of St Luke; he died shortly afterwards.

Other artists worthy of attention were at work in Paris during Vouet's heyday. The most considerable of these, the Fleming Philippe de Champaigne, will be discussed later (p. 102). Among the others were Jacques Blanchard (1600–38), François Perrier (1590–1650), Jacques Stella (1596–1657), and Laurent de la Hyre (1606–56). All except La Hyre studied in Italy. Blanchard was influenced by

88 JACQUES BLANCHARD *Holy Family*

Titian, Perrier by Lanfranco and Pietro da Cortona; while Stella was among the first to be influenced by Poussin, with whom he was on terms of friendship.

Blanchard was and is especially celebrated for his paintings of the *Holy Family* (sometimes this becomes a *Charity*), which have a delicate *88* individuality and sentiment. Perrier's *œuvre* defines itself less easily, but his mythological compositions are among the most Italianate of the time, as can be seen from his animated if rather disorganized *Acis and Galatea* in the Louvre.

Stella and La Hyre are alike in showing the impact of Poussin, but La Hyre is much the more original artist. The *Death of the Children* *89* *of Bethel* shows the extreme point of his development: it was painted in 1653. More attractive is the less complex painting recently acquired by the National Gallery, London. This allegory of *Grammar* shows *90* a curious blend of extreme classicism and naturalism: the effect is almost Surrealist (it recalls the deadpan manner of René Magritte).

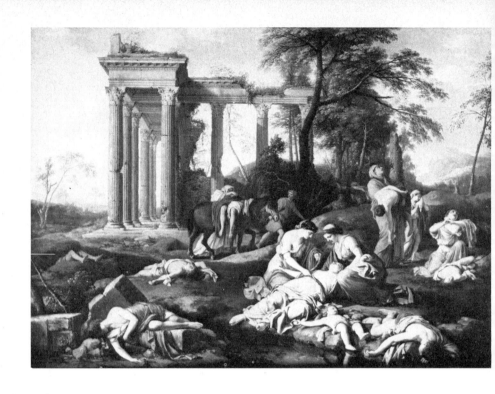

The artist who was to dominate the second half of the century was only slightly younger than La Hyre. He was Charles Le Brun (1619–90). Le Brun was precociously gifted. He studied first with Perrier, later with Vouet. He accompanied Poussin to Rome in 1642, and returned to France in 1646. Though his stay in Italy was comparatively short, the encounter with Poussin was decisive, and set the pattern for Le Brun's subsequent development; as it turned out, he was to be successful at those very tasks which had defeated Poussin himself.

Le Brun was a man of violent temperament, as can be seen from the early *Hercules and the Horses of Diomedes*, painted just before he left for Italy. *The Brazen Serpent*, painted in about 1649–50, shows the extent to which he renounced his earlier manner, and adopted the classicism learned from Poussin. But he retained his energy. In 1657, the powerful Minister, Fouquet, began to build, at Vaux-le-Vicomte, the palace which Louis XIV was to consider 'too good for a subject'. Le Brun was called in to undertake the decoration. For the bedroom

91
93

96

89 LAURENT DE LA HYRE
*The Death of the Children
of Bethel* 1653

90 LAURENT DE LA HYRE
Grammar 1650

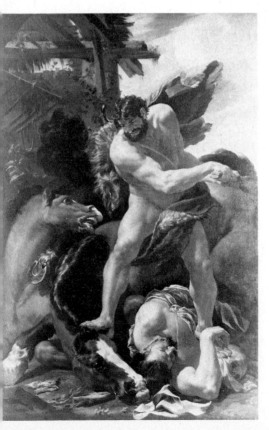

91 CHARLES LE BRUN
*Hercules and the Horses
of Diomedes* 1638–39

97

set aside for the King at Vaux, Le Brun devised a style of decoration which owed much to the work which Pietro da Cortona had been doing in Italy, yet remained, after a fashion, faithful to classical principles. Painting and stucco are combined, but there is no confusion between what is painted and what is three-dimensional. Startling perspective effects are avoided.

When Fouquet showed the splendours of Vaux to the King, he was disgraced. His successor Colbert had already made up his mind that Le Brun was the man he needed in order to impose a unified policy in the visual arts. Le Brun's major efforts were henceforth reserved for the royal service, and his pre-eminence was unchallenged until Colbert's death in 1683. The Academy (with which he had quarrelled) now became his complaisant instrument.

The painting which established him with Louis XIV was the so-called *Tent of Darius*, with its implied (and flattering) comparison between Alexander the Great and the King himself. The style shows a loosened classicism, more picturesque and more colourful than that of Poussin. The various personages are extremely carefully differen-tiated: each has a gesture and an expression suited to his role in the drama which is being enacted. The painting, in fact, is an example of emotion imposed from without, systematically and as the result of rational study. The Academy, under Le Brun's direction, was to preach just such a method.

Le Brun himself was a more varied and indeed a more personal artist than the doctrines which he professed might suggest; he imposed them on his contemporaries and juniors, but not always on his own work. In the years after 1683, when he was struggling to maintain his position against the intrigues mounted by Mignard, and the hostility of Mignard's protector Louvois, he had more time to devote to easel-painting. Among the paintings which the artist presented to the King was his *Moses Defending the Daughters of Jethro*, which was brought to Versailles in 1686. The picture is composed according to the theory of modes, which Le Brun had learned from Poussin: since the subject is violent the rhythms too are violent, the composition is based upon a sequence of obliques and curves. The artist has taken great care over the details: palm-trees and dromedaries; in the sky two ibises pursuing a winged serpent. Yet these details contribute to an emotional as well as a theoretical unity; the forcefulness which appeared in the early *Hercules* here breaks out again.

98

92 CHARLES LE BRUN *Tent of Darius* 1660–61

93 CHARLES LE BRUN *The Brazen Serpent c.* 1649–50

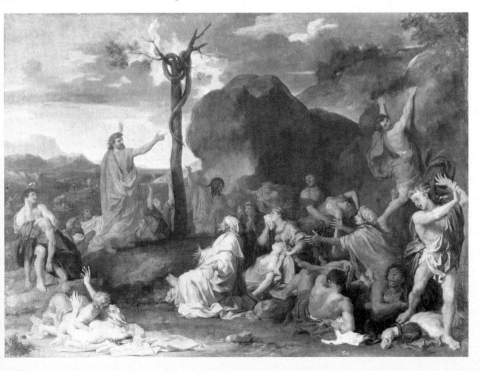

It is particularly difficult to do justice to Le Brun the painter because, in his most active years, Le Brun was so much more than most painters aspire or wish to be. His two instruments were the Academy and the Gobelins; and the latter was perhaps even more effective than the former. This tapestry factory was turned by Colbert into a place which produced all the necessities for the furnishing and decoration of the King's palaces. Le Brun was made director in 1663, and supplied designs for every aspect of the establishment's activities. At the same time, under his direction, the Gobelins served as a school for training designers and craftsmen. His major decorative project was the Galerie des Glaces at Versailles (finished 1684). In large measure, Le Brun was the progenitor of the 'Louis XIV style', and this is the achievement by which we must judge him.

The other painters of the time found their glory much dimmed by Le Brun. Sébastien Bourdon (1616–71) has already been mentioned in a Roman context (p. 53). After his return from Italy in 1637, Bourdon

94 CHARLES LE BRUN *Moses defending the Daughters of Jethro* 1686–87

95 SÉBASTIEN BOURDON *Sacrifice of Noah c.* 1635–40

worked in a variety of styles: the *bamboccio* manner, then a more
ambitious north Italian Baroque. Gradually he was drawn into the
orbit of Poussin, and at the end of his life, after a visit to Sweden in
1652–54, he was producing a delicate but rather devitalized variant 95
of Poussin's classicism.

Eustache Le Sueur (1616–55) was a more considerable figure.
According to tradition, Le Brun exclaimed that Le Sueur's premature
death had 'removed a great thorn from his flesh'. Le Sueur was among
the few important French painters of the period who never visited
Rome. Having received his training in Vouet's studio, he established
himself as an independent artist in the 1640s. He seems to have come
into personal contact with Poussin during the latter's visit to Paris, and
was certainly much influenced by Poussin's way of thinking. The
decorations painted for the Hôtel Lambert in Paris between 1646 and
1649, and especially the later compositions in the series, show how
Le Sueur moved away from Vouet towards Poussin and Raphael,
without losing Vouet's sense of elegance. The charming *Clio,* 96
Euterpe and Thalia is representative of this aspect of the artist's work.

But there was another side to Le Sueur's art: he was a gifted painter
of religious subjects, as is demonstrated by the series of paintings 97

96 EUSTACHE LE SUEUR
Clio, Euterpe and Thalia
c. 1647–49

97 EUSTACHE LE SUEUR
Death of St Bruno
c. 1648

98 PHILIPPE
DE CHAMPAIGNE
Crucifixion c. 1674

illustrating the life of St Bruno, done for the Charterhouse of Paris
about 1648. These have the withdrawn, introspective, contemplative
quality which we find in Spanish religious painting of the same period,
and most notably in Zurbarán, who also numbered the Carthusians
among his patrons.

The religious aspect of Le Sueur also prompts a comparison with
his elder contemporary Philippe de Champaigne (1602–74). (One
98 thinks, for example, of Champaigne's last picture, the *Crucifixion*.)
Champaigne was born in Brussels, trained chiefly as a landscape
painter, and came to Paris in 1621. Soon after this he met the young
Poussin. Champaigne was soon being patronized by both Louis XIII
and Richelieu. His style at this period derives from Rubens, but it is
Rubens robbed of warmth, modified in the direction of a chilly
classicism. About 1643 a significant event occurred: Champaigne
came into contact with the religious community of Port-Royal, and
became a convert to the austere doctrines of Jansenism.

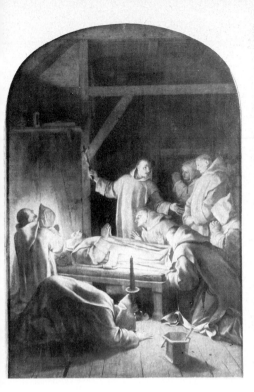

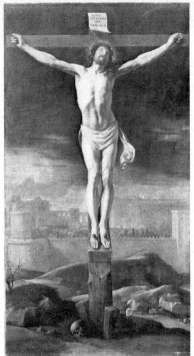

Jansenism was seventeenth-century Catholicism in its purest and most heroic form. For the Jansenist, the faithful soul must humble itself before God, be swallowed up by God and realize its own nothingness. The doctrines which evolved from this attitude came close to the ideas about grace and predestination put forward by Calvinism; Jansenists believed that good must be chosen, not in the hope of a reward on earth or in heaven, but gratuitously, for its own sake. Such an attitude was in itself an implicit challenge to royal absolutism, and the Jansenists soon found themselves in conflict not only with the Society of Jesus (against whom their great champion Blaise Pascal wrote his *Lettres Provinciales*) but with the Crown.

Philippe de Champaigne thus found himself in the opposite camp to Le Brun. Where Le Brun painted for Versailles and the King, Champaigne painted for Port-Royal and the greater glory of God. The most personal of his Jansenist pictures, and the most memorable, is the *Ex Voto* which Champaigne painted in 1662 to commemorate 99

99 PHILIPPE DE CHAMPAIGNE *Ex Voto* 1662

the miraculous recovery of his daughter Catherine, who was a nun at the convent. She had been suffering from progressive paralysis, but recovered swiftly and completely when the Prioress, Mère Catherine-Agnès Arnauld, declared a *novena* in the hope of an improvement. The *Ex Voto* contains no vestige of the sacred apparatus which we expect to find in Baroque religious pictures. There are two figures only: the sick nun reclines on a chair, and the Prioress kneels beside her. A ray of light falling between them symbolizes the miracle.

The two nuns show Champaigne's power as a portraitist: he is able to cut through to the very essence of a personality. The *Unknown Man* in the Louvre, with its dignity, simplicity and unsparing observation, is typical of the way in which he worked.

Not surprisingly, Champaigne far outdistanced in his portraits such professional rivals as the cousins Henri Beaubrun (1603–77) and Charles Beaubrun (1604–92), and Louis Elle (1612–89). These specialists in portraiture continue the Mannerist tradition until a comparatively late date.

100

100 PHILIPPE DE CHAMPAIGNE *Unknown Man* 1650

The history painters, however, were capable of producing impressive portraits occasionally. Bourdon painted a good number, among

103 them a memorable image of Queen Christina of Sweden, and few likenesses could be livelier or more eloquent than Le Brun's sketch-

102 portrait of Marshal Turenne, painted in preparation for a tapestry showing *The Meeting of Louis XIV and Philip IV of Spain*, or more

101 ingenious than his processional portrait of Chancellor Séguier on horseback. In this, the sitter, surrounded by pages, becomes the principal unit in a new interpretation of the classical frieze.

One painter practised a totally different kind of portraiture, less admirable, perhaps, but of some significance for the future. This was Le Brun's rival Pierre Mignard (1612–95). Mignard spent twenty-one years in Rome; he was summoned back to France by royal command in 1657. Once arrived, he found himself unable to make a real success as a decorative painter because Le Brun shut him out. Such commissions of this kind as he received came from the Queen Mother,

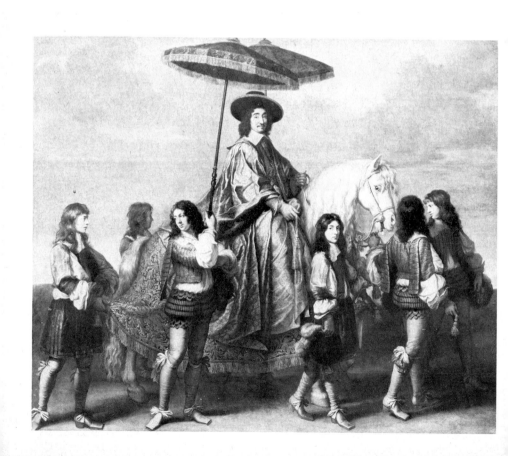

101 CHARLES LE BRUN
Chancellor Séguier 1661

102 CHARLES LE BRUN
Marshal Turenne 1663–65

103 SÉBASTIEN BOURDON
Queen Christina of Sweden 1652–53

104 PIERRE MIGNARD
*Marquise de Seignelay
and her Children* 1691

Anne of Austria, and from the King's frivolous and homosexual brother, Monsieur. In fact, Mignard became the chosen painter of an opposition party at Court, and his work reflects their tastes as well as his own frustrated allegorical ambitions. An example is the group 104 portrait of the Marquise de Seignelay and her children, a curious attempt to reconcile the demands of fashionable portraiture with those of history painting, which was a more prestigious and indeed 'respectable' department of artistic endeavour. The picture was intended as a kind of memorial to the lady's dead husband, Jean-Baptiste Colbert, eldest son of the 'great' Colbert, who had at one

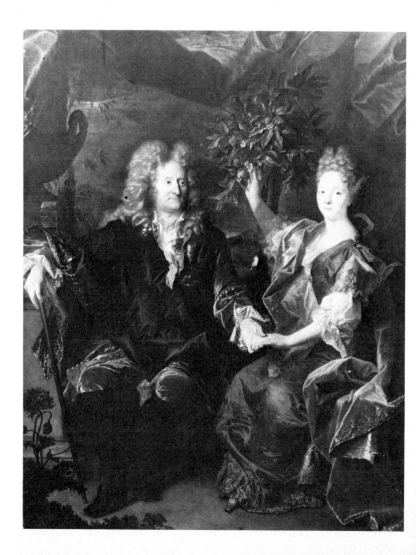

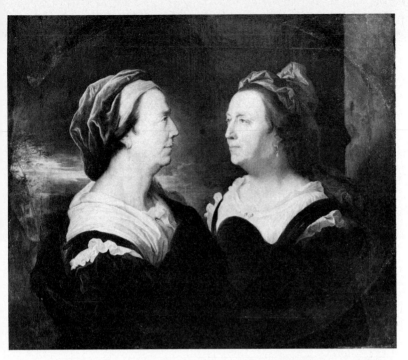

106 HYACINTHE RIGAUD *Double Portrait of the Artist's Mother* 1695

time been Minister of Marine. This explains her costume and attributes: the lady, holding aloft a miniature portrait which represents her husband, is the sea-nymph Thetis, mourning a departed hero; her son is the infant Achilles.

Portraiture of this kind looks back towards Mannerism. But it appealed to the courtiers of the ageing Louis XIV, men and women who were beginning to tire of the public routine which the monarch imposed upon them, who were ceasing to relish the formal splendours of Versailles, and to long for a way of life which was more relaxed, more informal, and, above all, more amusing.

Mignard's formula found favour with other clients and other painters, as we can tell from Hyacinthe Rigaud's portrait of Jan Andrzej Morsztyn and his daughter. Here it is the daughter's forthcoming marriage which is the subject of the allegory. Rigaud (1659–1743) was a Court painter, and on the whole formality prevails in his work. Yet he can be intimate and informal in paintings which are not

105

109

106 official; an example is the double portrait of his mother, which is influenced by Rembrandt. He survived successfully into the next reign; after Louis XIV's death in 1715 he was official painter to the Regent, and later still to Louis XV.

The other leading portrait painters of the time pursued much the same course. Rigaud's principal rivals were François de Troy (1645–1730), and Nicolas de Largillière (1656–1746). Largillière had a vast practice among the new bourgeoisie, who were now beginning to challenge the standards imposed by Versailles; and we can see the new world coming to birth in his work long before Louis XIV died. It is *107* already present in *The Artist with his Wife and Daughter*, which was painted about 1700.

Largillière's openness to new trends can to some extent be explained by his slightly unorthodox background. Though he was born in Paris, he received his early training in Antwerp, and later joined the workshop of Sir Peter Lely in England. The rich colour and fluent brushwork of the Flemish school continued to influence him even after he settled in Paris. Part of the secret of Largillière's success as a portraitist

107 NICOLAS DE LARGILLIÈRE *The Artist with his Wife and Daughter c.* 1700

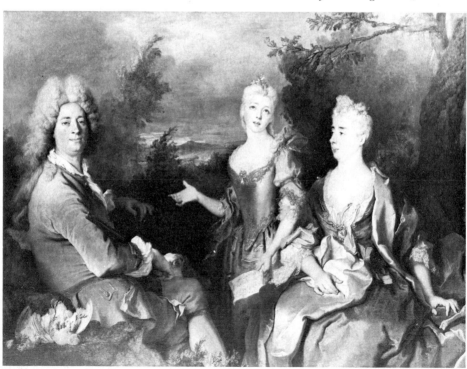

108 NICOLAS DE
LARGILLIÈRE
Elizabeth Throckmorton
as a Dominican Nun
1729

clearly lay in his adaptability. He painted the flattering, frivolous and silly mythological portraits which Mignard had pioneered, and which were to become even sillier in the next generation, in the hands of Jean-Marc Nattier. But he was also capable of simplicity when the occasion seemed to require it. His portrait of *Elizabeth Throckmorton* *108* *as a Dominican Nun* dates from 1729, well into the next reign. Watteau was already eight years dead when it was painted. It is a likeness of a recusant nun settled in Paris, intended for her friends in England. It has the directness and truthfulness the occasion called for, and a vigour worthy of Rubens.

If portraiture changed, so did decorative and historical painting. During the last decade of the seventeenth century taste began to swing towards the full Baroque style which had made its irruption into France with Rubens and the early work of Vouet, and had then been suppressed by the admiration for Poussin, and by the rules imposed by Poussin's followers in the Academy. Charles de la Fosse (1636–1716) worked under Le Brun, but by the 1680s escaped from Le Brun's tutelage and became the pioneer of a new style which led towards the

Rococo. The King, sad and elderly though he was, did not resist the
new current, as can be seen from the *Bacchus and Ariadne* which La
Fosse was commissioned to paint for Marly, the most informal of all
the Court's residences. The picture was paid for in 1699, and hung in
the Grand Salon of the Château.

Other artists who helped to prepare the way for a change of
artistic climate were Jean Jouvenet (1644–1717), Bon de Boullongne
(1649–1717), and Antoine Coypel (1661–1722). Jouvenet evolved a
form of Baroque art which was ultimately based upon Le Brun, but,
just as Le Brun had loosened Poussin's compositions, so Jouvenet
loosened Le Brun's. A more distant ancestor is Raphael, whose large
late compositions, such as the *School of Athens*, continued to fascinate
French painters. What gives Jouvenet's work its particular interest,

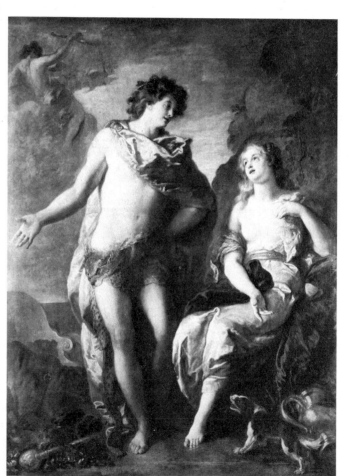

109 CHARLES DE
LA FOSSE
Bacchus and Ariadne
c. 1699

110 JEAN JOUVENET *The Raising of Lazarus* 1706

however, is the naturalism of many of the details: the large *Raising of Lazarus* in the Louvre has quite a different flavour from Le Brun's *110* large-scale works, simply for this reason. Jouvenet provided a starting-point for much of the religious painting done during the next century. This is not a high distinction, if one considers its almost universal emptiness.

Coypel offers us an example of the fact that a pioneer need not necessarily be a genius. A highly eclectic artist, his reputation with his contemporaries was based upon large and vapid mythological and Biblical compositions. In many ways the antithesis of the true 'Louis XIV style', he painted the ceiling of the Chapel at Versailles in imitation of that painted by Giovanni Battista Gaulli for the Gesù in Rome; its exuberant Baroque illusionism was something quite new in a country which had always resisted what was considered the 'irrationality' of the Italian art of the period. It is significant for the future that Coypel's most attractive works look like Venetian Rococo painting in its early phase. In this mood he has been compared to Gianantonio Pellegrini; the *Girl Stroking a Dog* in the Louvre is *114* characteristically full of life.

113

III ALEXANDRE-FRANÇOIS
DESPORTES *Landscape*

112 JOSEPH PARROCEL
Cavalry Officer Resting
c. 1685–88

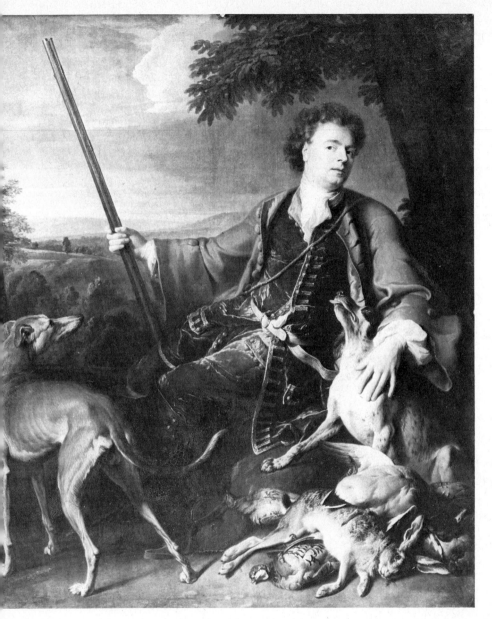

113 ALEXANDRE-FRANÇOIS DESPORTES *Portrait of the Artist as a Huntsman c.* 1699

114 ANTOINE COYPEL
Girl stroking a Dog

As the artistic climate changed in France, a number of other artists started producing work which departed from the expected norm. Often these mavericks were specialists, such as the battle painter Joseph Parrocel (1646–1704), whose loose handling and strong colour seem to anticipate Delacroix and the Romantics. It is a surprising fact that his contemporaries made little comment on his unorthodoxy: the painting illustrated here is one of a group of eleven, executed between 1685 and 1688 for the King's own apartments in Versailles. The yet more unexpected character of some of the paintings of Alexandre-François Desportes (1661–1743) is more easily accounted for: these informal landscapes are sketches made in preparation for the hunting scenes in which the artist specialized. They were therefore never intended for public exhibition.

Nevertheless, Desportes is a forerunner even in his finished work. Trained by a pupil of Snyders, he brought French art into contact with an important aspect of Flemish painting, and prepared the way for Oudry and Chardin.

116

Fêtes Champêtres

The eighteenth century is perhaps the most complex in the whole history of French painting: one reason, perhaps, why it has been so imperfectly charted. Painting was still subject to the centralized organization which had been created during the reign of Louis XIV. The Premier Peintre du Roi remained the spokesman of the Academy, and advised the Directeur-Général des Bâtiments du Roi, who oversaw the work of such organizations as the French Academy in Rome, and the Gobelins. Painters still looked towards Rome as the most important source of knowledge, and most of the leading painters of the French eighteenth century made at least one journey to Italy. At the same time the rigid categorization of painting into various genres was tending to break down. An artist such as François Boucher could now practise his art over a very wide range: landscapes, portraiture, genre scenes, decorative painting. In theory history painting was granted pre-eminence. Although the best artists had abandoned it, or no longer treated it seriously, the prejudice in its favour remained, particularly in the minds of the new class of *philosophes* who were revitalizing intellectual life in France. David's eventual triumph was the easier because of it.

Though the King remained a very important patron of painting, he was not the only patron by any means. The small class of officials and financiers who had supported Poussin had now swollen beyond all recognition: a numerous, rich and pleasure-loving bourgeoisie supplied the painters with their opportunities, and the aristocracy assimilated themselves to the manners and tastes of this new class. The retreat from Versailles was an accomplished fact; people found their pleasures in Paris, and the Court tended to be thought of as a bore.

A new style of living created a demand for a different kind of picture: small rooms meant smaller paintings; a more informal way of behaving was reflected in the works of art which provided part of the setting for the lives which moneyed people now chose to lead.

Very important events in the lives of most artists were the Salons where they displayed their wares. The first official public exhibition (artists had sometimes previously shown at fairs) took place at the Palais-Royal in 1673. The second was held in 1699 in the Louvre, and the third in 1704. In 1699 only fifty portraits were shown; by 1704 there were more than two hundred. This fact is in itself an index of changing social conditions. After this there was a lapse of a further thirty-three years, until the Academy revived the Salons in 1737, now inviting artists to participate who were not members. There was an annual exhibition until 1746, then the Salons were held every two years. Besides this exhibition organized by the Academy, other Salons existed, such as that of the Academy of St Luke.

The existence of the Salons led naturally to the creation of a new function: that of the art critic. In 1746 Lafont de Saint-Yenne published a little book entitled *Réflexions sur quelques causes de l'état présent de la peinture en France*. This contained an account of the work shown in the Salon of 1746. When, in 1753, Melchior Grimm began his *Correspondance littéraire* for the benefit of foreign princes, such as the King of Poland and the Empress of Russia, who wanted information about the intellectual and artistic life of France, he was careful to give information about the Salons. Denis Diderot, one of the key figures of the philosophical Enlightenment, was Grimm's collaborator, and in 1759 he took over the job of writing about painting. Diderot's arrival on the scene may be taken to be one of the key moments in the history of French art; his application of moral and social standards to art criticism was enormously influential.

Nevertheless, great though the changes were in the years following Louis XIV's death, one of the principal agents of the change survived the old King by very few years.

This was Jean-Antoine Watteau (1684–1721). Watteau is one of the miraculous figures in French art. He stands for nothing and nobody except himself; he is important in terms of taste and atmosphere, rather than of style. And yet he is a painter, like Georges de La Tour and the Le Nains, whose work seizes our attention instantly, and compels it in a way that more ambitious painters fail to do.

Watteau was born in Valenciennes, a town which had only become officially French in 1678, by the Treaty of Nijmwegen. His father was a master tiler. Watteau began to study painting about 1696. He left home for Paris in 1702. His first contacts there were with members of

115 CLAUDE GILLOT *Quarrel of the Cabmen*

the Flemish colony (it will be remembered that some of the still-life painters of the early seventeenth century had belonged to this). At first he had a hard time earning a living: he was employed as an apprentice by a manufacturer of daubs. But in 1704 he joined the studio of Claude Gillot (1673–1722). Gillot was a painter who continually changed style and subject, but one subject which interested him particularly was the theatre. His *Quarrel of the Cabmen* in the Louvre demonstrates what he made of it: the picture is an updating of the grotesqueries of the engraver Jacques Callot. Yet, in the terms of the day, Gillot was indisputably a modern painter; he stood for the new, light, informal taste.

115

In 1707, Watteau quarrelled with Gillot, and left his studio for that of Claude Audran III (1658–1734). Audran was a member of a well-known family of decorators, with a successful practice; among his patrons were the younger members of the royal family – the Dauphin at Meudon, the Duchesse de Bourgogne at the Ménagerie. He was a pioneer of the new taste for what was light, fanciful, luxurious.

Audran taught Watteau the art of decorative painting in this style, which made much use of arabesques and of figures in exotic costume.

But it was not only in this respect that Audran was important to Watteau. He was *concierge*, or conservator, of the Palais du Luxembourg, and Watteau was thus given access to Rubens's Marie de Médicis cycle. He seems to have been overwhelmed by their impact; he copied them, and he worshipped Rubens for the rest of his life. At this time, too, he seems to have been interested by the Dutch genre painting which was becoming a passion with leading French collectors. Some of his earliest paintings show the influence of Teniers.

Watteau's fortunes as an artist were to be made by the collectors, and by the dealers who supplied them. But first, he had a brush with official art. In 1709, he won second prize in the competition for the Prix de Rome, a scholarship awarded to young artists to allow them to study at the French Academy in Rome. Having failed so narrowly, he decided to return to Valenciennes. He is said to have paid for the journey by selling a picture of a *Recruit Going to Join his Regiment* to the picture-dealer Sirois.

His characteristic method seems already to have been established. He made numerous drawings of whatever he saw about him, whether soldiers in Valenciennes, or fashionable ladies in Paris, or actors in some scene from the Italian Comedy. Later, he would combine these figures into a composition. He did not rely entirely on his own observation, but borrowed from the artists of the past; Watteau's method is thus very different from Poussin's. Because of the way in which he worked, his pictures have no set 'subject'; their purpose is simply to convey a mood. The pictures showing fashionable people amusing themselves in the open air – the *fêtes galantes* with which Watteau's name will always be associated – seem to follow quite naturally in sequence from those which show soldiers taking their ease, leading their lives with no thought for the morrow.

116, 119 But the *fêtes galantes* have their roots in the painting of the past. Their sources are to be found in Venetian painting – notably Giorgione's *Concert champêtre* in the Louvre, which was already in Paris in the early eighteenth century – in his friend Crozat's collection of Titian and Campagnola landscape drawings, and in Rubens's *Garden of Love*, one version of which belonged to a celebrated Parisian collector of the time, the Comtesse de Verrue. *The Garden of Love* shows fashionable couples in a garden, which is adorned with a

116 JEAN-ANTOINE WATTEAU *Assembly in a Park* 1717

fountain dominated by a statue of Venus. But, despite its mythological apparatus of cupids, the Rubens is much more earthy and realistic than most of the paintings of Watteau. The latter did not care to depict how fashionable society actually behaved; he created instead a dream world where characters from the Italian Comedy mingle with men and women in masquerade costume and in ordinary fashionable dress. Watteau's friends often appear in these pictures. The attractions of the Italian Comedy, so far as Watteau was concerned, seem to have been its atmosphere of dalliance and amorous intrigue, and its atmosphere of improvisation. The Italian comedians based their entertainments on characters with fixed identities – Pierrot, Columbine, Harlequin, Mezzetin, Scaramouche – acting in unscripted variations on a number of stock situations. By using these familiar figures, Watteau could

121

often hint at a story without actually telling it. In turning to the theatre for material, he began a tradition in French painting which lasted until the time of Toulouse-Lautrec.

By 1712 he was a painter of established reputation. He presented himself to the Academy on 30 July and was accepted (his sponsor was Charles de la Fosse). He was also in poor health, showing signs of the consumption which was eventually to kill him. Contemporaries speak of his restlessness and irritability, and his disease has been taken by subsequent historians as the reason for the atmosphere of melancholy which seems to pervade so much of his work.

The means by which Watteau obtains an atmosphere of solitude, loneliness and withdrawal are interesting. In a picture which contains a number of figures, many will be turned away from us, looking into the depths of the landscape: this is conspicuous in the *Assembly in a Park* now in the Louvre. A serenader, such as the solitary figure in *Le Mezzetin*, will play to someone who is not present. But the mood

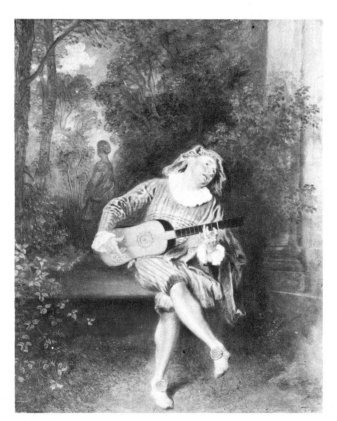

117
JEAN-ANTOINE
WATTEAU
Le Mezzetin
1717–19

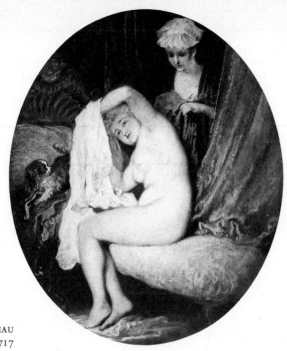

118 JEAN-ANTOINE WATTEAU
Lady at her Toilet 1717

prevails even in unexpected circumstances. The *Lady at Her Toilet* *118*
in the Wallace Collection is perhaps the nearest that Watteau came to
painting the licentious subjects which were on occasion favoured by
Boucher and Fragonard. But even here we are conscious of the
woman's languorous melancholy.

Three paintings in particular have helped to confirm Watteau's
reputation as a great artist. These are the *Departure from the Island of
Cythera* in the Louvre, the *Gilles*, also in the Louvre, and the *Enseigne
de Gersaint* in Berlin. Only one of these can be regarded as entirely
typical. The *Departure* was Watteau's long-delayed reception piece *119*
for the Academy. He presented it in August 1717. It is the apotheosis
of the *fête galante*, the most authoritative statement to have been made
in the genre.

The picture seems to have been long in gestation. It is based upon,
or alludes to, a comedy by Florent Dancourt called *Les Trois Cousines*,
which was first performed in 1700. It is probable that Watteau saw a
revival of it in 1709. The play contains songs and dances, and there is
one song in the final scene which seems to have haunted the artist. Two

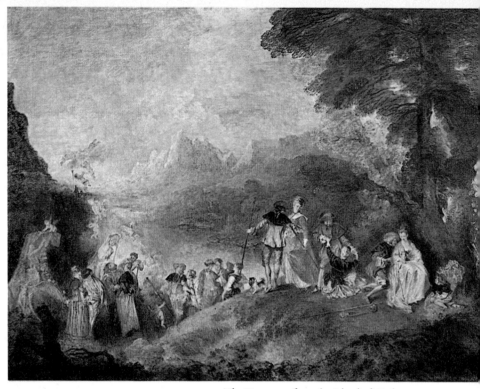

lovers have decided to make a pilgrimage to Cythera, accompanied by their friends. They sing the following verse:

Venez dans l'île de Cythère
En pèlerinage avec nous,
Jeune fille n'en revient guère,
Ou sans amant ou sans epoux;
Et l'on y fait sa grande affaire
Des amusements les plus doux.

'Come to the island of Cythera
In pilgrimage with us,
No young girl returns from there
Without a lover or a spouse;
And the business of the place
Is the most charming kind of pleasure.'

124

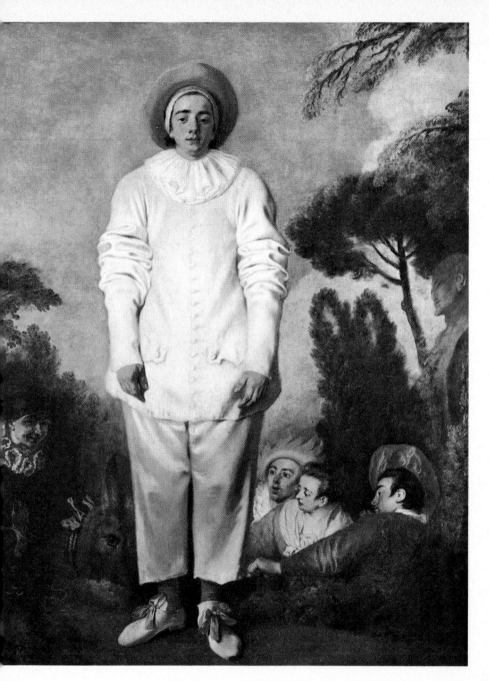

120 JEAN-ANTOINE WATTEAU *Gilles c.* 1721

Watteau made several earlier attempts at the theme: one, known from an engraving, shows the lovers, as we might expect, departing on their pilgrimage. But the picture in the Louvre (despite its traditional title of the *Embarkation for Cythera*) shows the band of pilgrims already there, and making ready to leave again. The figures form a sinuous chain of linked groups moving from right to left of the picture, from the term of Venus at one side to the gilded barge awaiting them on the other. Rubens's *amoretti* make their reappearance in the composition, and hover in the air or mingle with the lovers. The main burden of meaning is carried by the three pairs on the right, often, and I think correctly, interpreted as aspects of a single couple. Those nearest the term are the most completely beneath the spell of the goddess. A cupid tugs at the woman's skirt, but she pays him no heed. The next couple are rising to their feet, ready for departure. The third couple, on the crest of the slope leading down to the shore, look back regretfully. The relationship between figures and landscape is extraordinarily successful. The sinuous movement of the figures is echoed by the shapes of trees and mountains; the distance fades away into a symbolic sunset. Watteau here seems to be the heir, not only of Rubens and of Giorgione, but of Claude.

In their wholly different ways *Gilles* and the *Enseigne de Gersaint* remind us of another aspect of French seventeenth-century art: the Le Nains. *Gilles* may have been painted at about the same time as the *Departure*. The picture is unique in Watteau's work because of the large scale of the central figure; the painting of the white costume is a technical *tour de force*. The relationship of this central figure to the others in the background is a wonderful piece of psychology. He is seen full length, and he stares out of the canvas at us in the way that some Le Nain peasants do: the woman on the right in *The Cart*, for example. The subsidiary figures, on the other hand, are on lower ground, so that we only see their heads and shoulders. The melancholy Gilles, passive where they are active, towers above their merriment as they drag the clown along on his donkey.

Recently, when the Grande Galerie of the Louvre was rehung, and paintings of the French school replaced the Italian works which had hitherto been shown there, Watteau's *Gilles* was given the place which had formerly belonged to the *Mona Lisa*. One can understand the decision: *Gilles* has the same poetry, the same mystery, the same melancholy as the Leonardo. Mystery, perhaps, above all: it is a

120

comment on the degree to which human beings can hope to know and understand one another.

The *Enseigne de Gersaint* is one of Watteau's last works, painted in *122* 1721 after his return from a disastrous visit to London which had undermined further his already failing health. The circumstances in which it was painted were afterwards related by Gersaint himself. Edme-François Gersaint was a picture-dealer, and one of Watteau's friends. The artist asked permission to create a sign for the dealer's shop, and the *Enseigne de Gersaint* was the result.

Watteau's starting-point seems to have been the notion of making an illustrated catalogue of the wares to be found in the shop, a subject treated by painters such as Teniers and Gonzales Cocques. Since Gersaint was only just beginning his career as a dealer, the painter probably imagined the shop as it would look when his friend had had some success in his business. The figures who animate the scene are divided into two groups: on one side those who discuss matters at the counter; on the other, those who surround an assistant who, perhaps symbolically, is packing away a portrait of Louis XIV.

In this instance, it is the way in which the figures are made to balance one another within the general framework of the composition

121 NICOLAS LANCRET *Mlle Camargo Dancing*

which prompts a comparison with the Le Nains. Those who look inward are carefully set against those who look outward; figures seen from the back are set against those seen from the front, so that the two halves of the painting balance one another perfectly. Of course, the compositional arrangement is more sinuous and flexible than anything we would find in a seventeenth-century painting. It reflects the new suppleness of manners, the growing liking for what was informal. Yet the quiet realism of the scene preserves some of the best characteristics of the century which had passed.

Watteau's work had a great impact on his contemporaries, both through personal contact and through the engravings which were made after his paintings. His two closest imitators were Jean-Baptiste

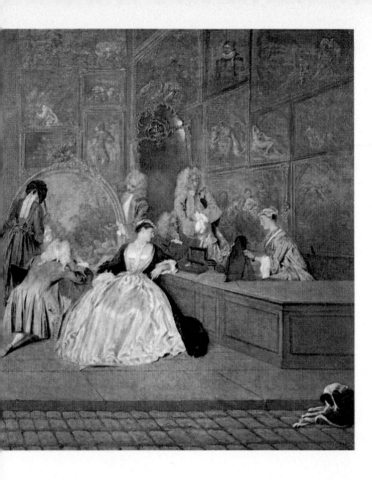

Pater (1695–1736) and Nicolas Lancret (1690–1743). Both of these knew Watteau personally. Pater was from Valenciennes, and was taught by Watteau; Lancret, like Watteau, worked under Gillot and Audran. Of the two, Pater has the less personality; his imitations of the master are close enough to be deceptive, but they lack, in particular, the substructure of wonderful drawing which distinguishes Watteau's work from those who attempted to copy him.

Lancret, who is known to have excited Watteau's jealousy, is a slightly more individual painter. His theatrical scenes in particular, such as *Mlle Camargo Dancing*, are not so much evocations of a mood, 121 in the manner of Watteau, as factual records. As such, they are charming enough.

Philippe Mercier (1689–1760), who was trained by the French-born Antoine Pesne (1683–1757) in Berlin, and afterwards settled in England, seems to have met Watteau in London during the latter's disastrous visit there: he afterwards made many imitations of Watteau's

123 compositions, such as the *Conjurer* now in the Louvre, which was at one time attributed to Watteau himself. Watteau also seems to have influenced the early work of William Hogarth.

Yet there is a paradox about Watteau's relationship to the subsequent history of French art. All over Europe it was accepted that his work gave an unrivalled image of French elegance and grace; that it held the mirror up to French civilization and the French sensibility. Frederick II of Prussia was only one among many foreign collectors who sought out Watteau's work. Meanwhile, his imitators found employment all over Europe: Mercier in England, Pierre-Antoine Quillard (1701–33) in Portugal, others elsewhere. On the eve of the French Revolution, the expatriate French artist Jean-Pierre Norblin de la Gourdaine (1745–1830) was at work in Poland, producing *fêtes champêtres* for a member of the princely Czartoryski family. And yet

123 PHILIPPE MERCIER *Conjurer c.* 1720–25

124
JEAN-FRANÇOIS
DE TROY
The Hunt Breakfast
1737

in France Watteau soon went out of fashion. The great collectors
turned from his work to indulge their passion for Dutch genre
painting, and the intellectuals echoed this verdict. Diderot said that he
preferred Teniers to Watteau.

Of course, painting which was so original could not be wholly
without its effect on other artists. We find distinct traces of Watteau's
influence in the work of Jean-François de Troy (1679–1752), for
example, who began as a painter of allegorical compositions, but
afterwards switched to genre scenes. De Troy has a robustness and a
vigour which give his work a different atmosphere from that of
Watteau. *The Hunt Breakfast* in the Wallace Collection demonstrates *124*
the appetite with which this painter tackled scenes of contemporary
life. A similar gusto and versatility are to be found in the paintings of
Boucher and Fragonard, both of whom undoubtedly owed some-
thing to Watteau, though they turned what they borrowed to very
different uses.

125 FRANÇOIS BOUCHER *The Setting of the Sun* 1753

The Feast of Pleasure

If Watteau gives a certain pervasive flavour to the French art of the eighteenth century, most of all because he colours our response to other painters, the main line of art-historical descent does not run through him. Instead, we can trace it in the work of a lesser artist, though one greatly respected in his own day: François Le Moyne (1688–1737).

Le Moyne marks the real moment of transition from the style of the seventeenth century to that of the eighteenth, the point at which the Baroque becomes the Rococo. From the seventeenth century he takes his classicism and liking for allegory, and his love of working on a huge scale; but he is eighteenth-century in his preference for what is light, elegant, clear in colour. Many of his characteristics can be found again in the work of his pupil François Boucher, and his mythological pictures, in particular, provided the foundation upon which Boucher's style as a decorator was built.

Le Moyne arrived on the scene early enough to receive important commissions for Versailles, just as Le Brun had done before him: he was responsible for decorations in the Salon de la Paix and for the vast ceiling of the Salon d'Hercule. But he approached these tasks in a somewhat different spirit from that of Le Brun. He responded readily to the change in taste which was taking place in France: like Watteau, he was an enthusiast for Rubens and for the Venetians of the sixteenth century, particularly Veronese. He was aware of the activities of Veronese's heirs, the contemporary Venetian decorators whose work was being acclaimed throughout Europe, and he undoubtedly saw himself as competing with such artists as Sebastiano Ricci and Gian Antonio Pellegrini. When, in 1730, Pellegrini painted the ceiling of the Banque Royale, Le Moyne, incensed that so important a commission should have been given to a foreigner, produced a sketch to show what he would have done with the job.

His contemporaries responded to him as a man who was extremely competent in their terms, and eventually they killed him with over-

133

work. Le Moyne committed suicide in 1737. The painting which he
126 finished only a few hours before his death, *Time Revealing Truth*, tells
us much about his talent. Not only the subject, but even the com-
position are Tiepolesque, but without Tiepolo's soaring grandeur.

Le Moyne was not an isolated figure. Other artists of the period
showed much the same tendencies, often, indeed, in a more advanced
127 form. The playful *Alliance of Bacchus and Venus*, by Noël-Nicolas
Coypel (1690–1734), half-brother of Antoine Coypel, is signed and
dated 1726, and is thoroughly representative of its time.

It is necessary to keep this background in mind when discussing the
work of François Boucher (1703–70) who, far more than Watteau,
is the representative French painter of the first half of the eighteenth
century. Boucher was far more various than Le Moyne: omnicom-

126 FRANÇOIS LE MOYNE
Time Revealing Truth 1737

127 NOËL-NICOLAS COYPEL
Alliance of Bacchus and Venus 1726

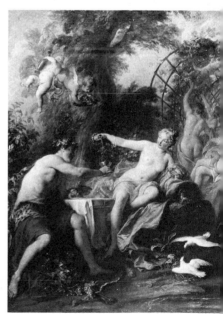

134

petent, he painted mythological pictures, landscapes, portraits, erotic scenes, religious pictures, indeed anything that was required of him. Only the religious paintings can be dismissed as consistent failures, though there is about all of Boucher's *œuvre* a kind of airless artificiality which eventually proves wearisome.

He increasingly became identified with the Court at a time when, under the unimpressive Louis XV, the Court was becoming more and more unpopular; it is therefore not surprising to find that Boucher, at the end of his life, was often the target of Diderot's strictures. Writing about the Salon of 1765 (the year in which Boucher was appointed Premier Peintre du Roi), Diderot said:

'I do not know what to say of this man. The degradation of taste, of composition, of characters, of expression, of drawing, has step by step followed the depravation of morals. What do you want this artist to throw upon his canvas? What he has in his imagination; and what can a man have in his imagination when he passes his days with prostitutes of the lowest sort? . . . I defy you to discover in a whole countryside one blade of grass from his landscapes. And then a confusion of objects heaped one upon another, so out of place, so disparate, that it is less a picture created by a man of sense than a madman's dream. . . . I dare not say that this man truly does not know what grace is, but I do dare to say that ideas of delicacy, of honesty, of innocence, of simplicity, have become almost foreign to him; I do dare to say that he has never for one moment looked at nature, at least of a kind created to engage my soul, or yours, or that of a child of good family or a woman of feeling; I do dare to say that he is without taste.'

How far did Boucher deserve these strictures? So far as his mythological pictures go, he shows greater confidence and lightness than Le Moyne. We see him working at full stretch in the two large paintings of *The Rising of the Sun* and *The Setting of the Sun*, painted in 1753 *125* as designs for tapestries. The relationship with Rubens's Marie de Médicis cycle is obvious. But despite their energy, they do not have the pictorial weight and density of Rubens; they are essentially exercises in virtuosity.

On a smaller scale, Boucher is more pleasing. Like Renoir after him, he was pre-eminently a painter of women, and in his work mythology was turned to this purpose. The figures in *Diana after the Hunt* are *128* women before they are a goddess and her nymphs, but (as Diderot

135

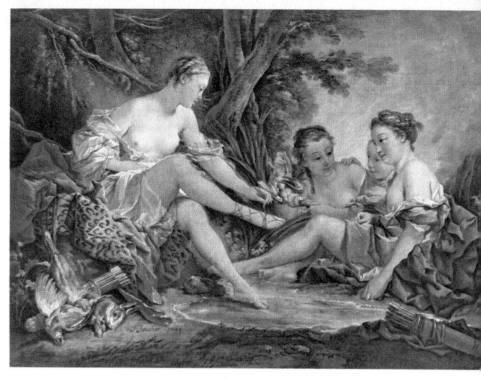

128 FRANÇOIS BOUCHER *Diana after the Hunt* 1745

sensed) the women of an erotic dream, rather than those we meet in real life: it might be said that Boucher invented the pin-up.

At those times when reality impinges on his obsession with the feminine, Boucher is at his best. His relaxed, easy portraits of his patroness, the King's favourite Madame de Pompadour, well reward her interest in him. Even the openly salacious *Reclining Girl* (supposed to be a portrait of Louisa O'Murphy, one of the minor mistresses of Louis XV) has an air of keen enjoyment and observation – it is a real enough girl who displays herself so flagrantly before us.

Boucher is also extremely skilful at conjuring up a wholly fantastic dream world. It is difficult not to be captivated by the charm of his pastorals and *chinoiseries*, but one must also admit that a world where all painting looked like this would soon prove boring.

129
130

131

136

129
FRANÇOIS BOUCHER
Madame de Pompadour
1758

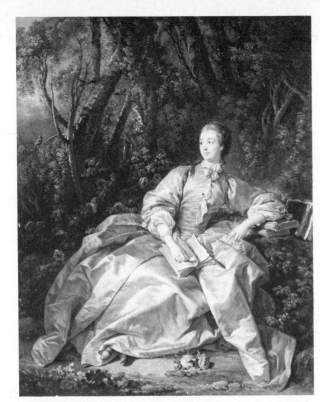

130 FRANÇOIS BOUCHER
Reclining Girl
(Mademoiselle O'Murphy)
1751

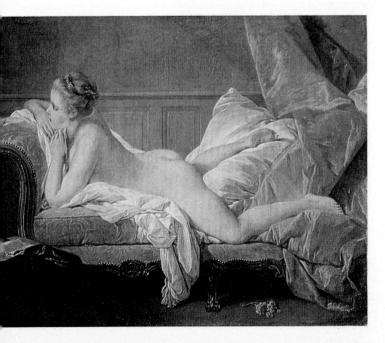

131 FRANÇOIS BOUCHER *Chinaman Fishing* 1742

132 CARLE VAN LOO *The Grand Turk giving a Concert to his Mistress* 1737

133 JEAN-HONORÉ FRAGONARD *Corœsus sacrificing himself to save Callirhoe* 1765

None of Boucher's rivals has anything like his skill and versatility. He far outshines contemporaries such as Carle van Loo (1705–65), who was, like the Coypels, a member of a whole dynasty of artists. Van Loo, who had a reputation with his contemporaries for personal stupidity and vulgarity, was nevertheless capable of producing pleasing pictures, as his exotic genre scene, *The Grand Turk Giving a Concert to* *132* *his Mistress*, is sufficient to prove.

The painter who was to continue the tradition of Boucher and Van Loo until the *ancien régime* itself passed away was the pupil of them both, and also, surprisingly, of Chardin. Jean-Honoré Fragonard (1732–1806) came from Grasse in Provence. He won the Prix de Rome in 1752, and journeyed to Italy in 1756. He travelled extensively in Italy, in the company of the landscape painter Hubert Robert and their mutual patron the Abbé de Saint-Non, returning to France in 1761.

134 JEAN-HONORÉ FRAGONARD *The Gardens of the Villa d'Este, Tivoli* 1760

Italy made a great impact·on the sensibility of the young artist, as his beautiful early landscapes prove. The small painting in the Wallace
134 Collection, *The Gardens of the Villa d'Este, Tivoli* (Fragonard and his companions spent the summer of 1760 at Tivoli), presents us with a fresh interpretation of the same countryside which Claude had loved so well. Claude's influence is certainly present, but his vision is transformed: Tivoli becomes a romantic dreamland, a place for lovers to walk in, rather than a place which evokes the legends of the past.

When Fragonard returned to France, the neoclassical vogue was just beginning, under the influence of Madame de Pompadour's brother, the Marquis de Marigny, then occupying the post of Directeur-Général des Bâtiments du Roi. Fragonard scored a great

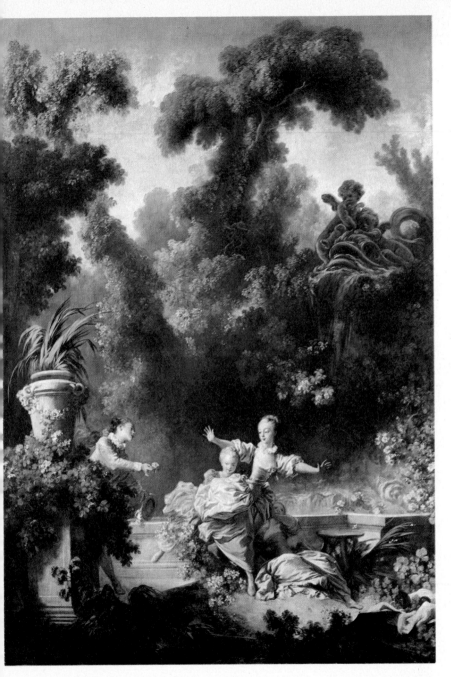

135 JEAN-HONORÉ FRAGONARD *The Pursuit c.* 1771–73

133 success at the Salon of 1765 with a large history picture, *Coroesu.* *Sacrificing himself to Save Callirhoe.* But, despite the expectations thus raised among connoisseurs, he then abandoned history painting, to become an artist of the salon and the boudoir. There could hardly be a greater contrast than between *Coroesus* and the painting which Fragonard produced for an eager client only three or four years later. This *137* was *The Swing,* which for so many people sums up the licentious gallantres of the eighteenth century. The painter showed what he was instructed to show: the client's mistress flies high in the air on a swing which is propelled by a bishop; the client himself reclines on the ground and looks at her admiringly as her skirts fly up. But how deliciously the incident is treated! The light and colour which bathe the scene are those which Fragonard had brought with him from Italy; the elegance of the figures is purely Parisian. Love is a game; no offence can be taken at a lover's caprices.

136 JEAN-HONORÉ FRAGONARD
The Souvenir c. 1787

137 JEAN-HONORÉ FRAGONARD
The Swing c. 1766

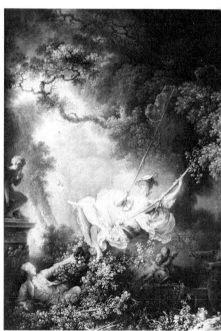

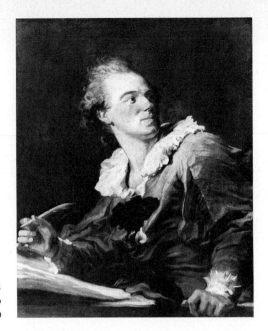

138
JEAN-HONORÉ FRAGONARD
Inspiration c. 1769

Some clients, of course, did tend to take fright at Fragonard's daring.
A notable instance was Madame du Barry, the Pompadour's successor,
who in 1771 commissioned him to do a series of decorative paintings
for her villa at Louveciennes. The subject of the panels is the *Progress of
Love*, and it may be that she thought they made too obvious an allusion
to her relationship with the King. At any rate, she rejected them (and
commissioned a new series of paintings from Vien). The last painting
in the series remained unfinished. These decorations are nevertheless
one of the great landmarks of eighteenth-century French painting;
their lack of intellectual content ceases to matter in the face of sheer *135*
exuberance, beauty of colour and vitality of brushwork.

Fragonard's handling of paint is one of the key things about his
work. His chief influences were 'painterly' painters: Rubens, whom
he (like Watteau) studied at the Palais du Luxembourg, and Giovanni
Battista Tiepolo, whom he discovered in Italy. Rembrandt, too,
played a part in creating the freedom of Fragonard's style: not surpris-
ingly, as the great Dutchman was much admired by the leading French
collectors of the second half of the eighteenth century. One sees Rem-
brandt's influence at work in the numerous half-length fancy figures
that Fragonard painted: the so-called *Inspiration* in the Louvre is a *138*

139 JEAN–BAPTISTE OUDRY *The White Duck* 1753

140
JEAN-BAPTISTE OUDRY
Count Tessin's Dachshund
1740

typical example. Here the brushwork is so direct and the impasto so heavy that the painting reminds us of Van Gogh as well as Rembrandt.

Nor did Fragonard remain entirely isolated from what was going on around him in France. Pictures such as *The Souvenir*, which dates *136* from about 1787, show him essaying the vogue for sentiment, which had been pioneered by Greuze. Eventually, however, Fragonard found himself out of fashion, and almost entirely forgotten. His lightness and brio, his eclecticism and what the new generation saw as his lack of correctness, were alien to the times. During the Revolution he was protected by Jacques-Louis David, in all respects his antithesis as a painter. Through David's influence, Fragonard, though the least academic of artists, was made a member of the Commission du Musée, the body responsible for the creation of the Louvre and other museums. He seems to have discharged his functions well.

Boucher and Fragonard, who were basically decorators but who attempted a wide variety of different tasks, were surrounded by artists who contented themselves with narrower specializations. One who is not as specialized as he first appears is Jean-Baptiste Oudry (1686–1755). Oudry began as a history painter, but later turned to painting

145

subjects connected with the chase, and to designing tapestries (often with animals or hunting subjects) for Beauvais. Oudry was trained by Largillière, and was therefore an inheritor of the Flemish tradition. Later, he was influenced by Boucher. Oudry painted animals with great sympathy, as can be seen from his delightful portrait *Count* *Tessin's Dachshund*, and he was a master of subtle technical effects, which are shown at their most dazzling in his famous still-life *The White Duck*. From the historical point of view, however, his chief contribution was to the development of landscape, where he offered an alternative to the tradition of Poussin.

140
139

Landscape painting in the eighteenth century was in any case in a state of flux, and, during the second half of the century, there were a number of painters at work who foreshadowed the Romantic movement. This, with its emphasis on 'nature' and the 'natural', was to find landscape painting an especially congenial and flexible means of artistic expression.

Prominent among these pre-Romantic landscapists was Fragonard's companion in Italy, Hubert Robert (1733–1808). During his time there, Robert was influenced by the work of Giovanni Paolo Pannini (1691–1765). Pannini is an important figure in the history of European art because he was chiefly responsible for the invention of a new subdivision of landscape painting, the 'ideal view' or *capriccio*, in his case usually furnished with ruins. This was a development of the ideal classical landscape which had begun with Annibale Carracci. By taking real and imagined buildings, and combining and transposing them in different ways, Pannini was able to create a world which existed parallel to the real one. People often seem to have experienced antiquity more intensely through Pannini's work than through their visits to ancient buildings as they actually existed. One reason for this was that Pannini was familiar with the work of the great theatrical designers of the time, such as the Bibienas, and well knew how to paint for effect. His work can be compared to that of the Dutch seventeenth-century flower painters, who combine the blooms of all seasons into a single glorious bouquet.

141

Under the spell of Pannini's work, Robert evolved a new vision of Italian landscape. His paintings, despite their apparent precision of detail, became statements of mood rather than statements of fact: the mood is all-important even in those canvases which present more or less 'real' views.

146

141 HUBERT ROBERT *Architectural Composition with Temple and Obelisk* 1768

When Robert's paintings in this style were first exhibited in France, in the Salon of 1767, they attracted high praise from Diderot: 'Oh beautiful, sublime ruins! What firmness and at the same time what lightness, sureness and facility with the brush. What an effect! what grandeur! what nobility!'

Later, however, Diderot was to draw back a little from his first enthusiasm. His comment upon two paintings shown by Robert in the Salon of 1771 is far cooler and more judicious: 'M. Robert visibly demonstrates how much more difficult it is to paint landscape after nature than it is to paint stones and columns in the studio, after drawings, and to colour them.'

147

That is, the critic has already begun to feel that Robert fails, measured against ideal standards, because he has not achieved the fusion of all the elements in the picture which would please a sensibility full attuned to nature. 'Nature' is already a key word in Diderot's writings about art, just as it is in the philosophy of Jean-Jacques Rousseau.

Other forerunners of Romanticism were Claude-Joseph Vernet (1714–89), and his pupil Charles-François Lacroix, usually called Lacroix de Marseille (c. 1700–82). Both came from the South of France, both studied in Italy (Vernet was taught by Pannini and Locatelli), both made a speciality of seascapes and harbour views. Vernet's *A Storm with a Shipwreck* in the Wallace Collection is signed and dated 1754, and provides an interesting link between the storms painted during the seventeenth century by Dutch marine painters such as the Van de Veldes, and those to be painted later on by artists such as J. M. W. Turner. The more tranquil port scene by Lacroix, dated six

143

144

142 PIERRE-ANTOINE DEMACHY *The Louvre with the Colonnade Recently Cleared of Buildings* 1755–69

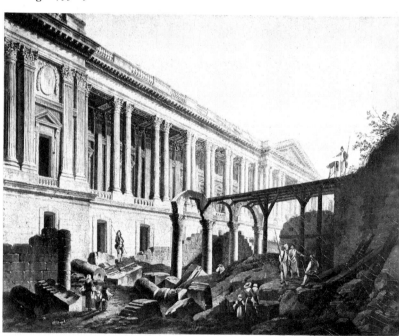

143 CLAUDE-JOSEPH VERNET *A Storm with a Shipwreck* 1754

144 LACROIX DE MARSEILLE *A Mediterranean Seaport* 1760

145 PIERRE-HENRI VALENCIENNES *Tivoli*

years later, seems to be an altered view of Genoa, and shows the application of the *capriccio* style to this particular branch of painting.

But the Italianate landscapes of Vernet, Lacroix and Robert were by no means the only kind being painted by French painters at this
142 period. Pierre-Antoine Demachy (1723–87) produced views of Paris and its suburbs which are both delicate and accurate: their documentary interest has led to the neglect of their artistic qualities. Demachy's
146 pupil, Louis-Gabriel Moreau, called Moreau l'Aîné (1740–1806), created paintings which have a more personal touch than his master's; occasionally they even seem to anticipate Corot, as do the oil-sketches
145 of Pierre-Henri Valenciennes (1750–1819), though these, like the similar sketches made by Desportes, were intended, not as finished works of art, but as preparations for larger (and much duller) paintings.

146 MOREAU L'AÎNÉ
Cabin on a Rising in a Wood

One other specialized department of painting flourished exceedingly throughout the eighteenth century in France, and that was portraiture. The reasons were twofold: the rise of the bourgeoisie, and the new interest in human individuality promoted by the writings of the *philosophes*. Curiously enough, French portrait painters produced few masterpieces (rather more were produced by the portrait sculptors, such as Houdon, Pajou and Pigalle). The mythological portraits of Jean-Marc Nattier (1685–1766), which continue the tradition of Mignard, are, as I have said, risible; but he did have the gift of making a pretty woman look her best, usually at the expense of telling us much about her character. The late portrait of the Comtesse de Tillières, *147* painted when the mythological vogue was at last over, shows him at his most attractive.

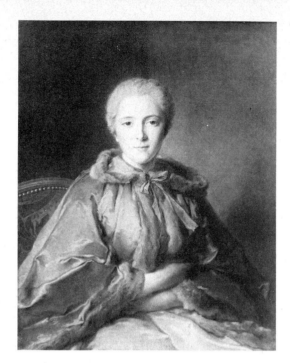

147 JEAN-MARC NATTIER
Comtesse de Tillières
1750

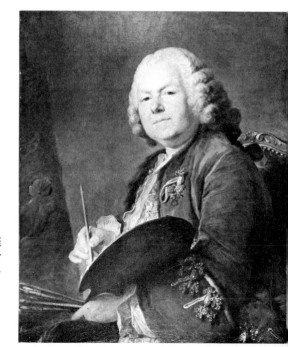

148 LOUIS TOCQUÉ
Jean-Marc Nattier
1762

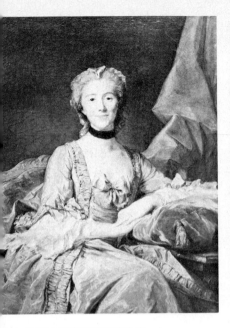

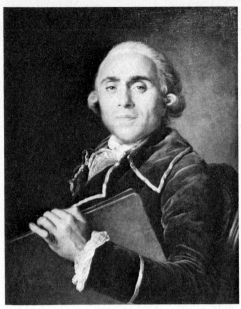

149 JEAN-BAPTISTE PERRONEAU
Madame de Sorquainville 1749

150 SIFFRED DUPLESSIS
Augustin de Saint-Aubin 1787

Nattier's rivals, such as his son-in-law Louis Tocqué (1696–1772) often have greater powers of insight. When we see Tocqué's portrait *148* of Nattier we are immediately convinced that the subject looked exactly thus, and we almost seem to see his gestures and catch the echo of his voice. The same is true of the men and women who appear in portraits by Siffred Duplessis (1725–1802), Jacques-André-Joseph- *150* Camelot Aved (1702–1766), the Swedish-born Alexandre Roslin (1718–93), and Jean-Baptiste Perronneau (1715–83). Perronneau, who *149* was probably the least known of the group during his own lifetime, was arguably the most gifted.

Yet, even in the hands of artists such as these, the sitters in French eighteenth-century portraits remain poised, sophisticated and very much on their guard. They give away nothing that they do not wish us to know; the painter never penetrates the armour of intelligence and worldliness. Though the fact that they often chose to be painted in informal dress reflects a new informality of manners, decorum triumphs all the same.

153

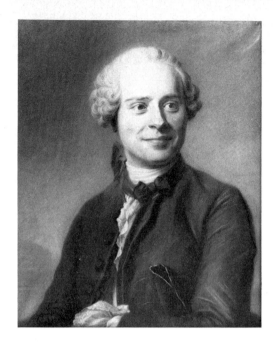

151 MAURICE QUENTIN
DE LA TOUR
D'Alembert 1753

 The most brilliant portraitist of the age does not really belong in this book, as he worked exclusively in pastel. This was Maurice Quentin de la Tour (1704–88). La Tour's sitters were no less guarded than those of his rivals, but he spices his portrayals with a revealing and sardonic wit. No respecter of persons, La Tour was especially favoured by the *philosophes*, who admired the quality of his intellect:
151 he made portraits of Voltaire, Rousseau, D'Alembert and Diderot. He was on friendly terms with Diderot, who recorded some of his comments:
 'He confided to me that the passion for embellishing and exaggerating nature grew weaker as one acquired more experience and skill; and that a time came when one found nature so beautiful, so whole, so inseparably one, even in its very defects, that one was inclined to show it as one found it: an inclination from which one could not be deflected save by contrary habit, and by the extreme difficulty which one found in being true enough to please while following this path.'
 La Tour's originality of mind sometimes allowed him, without shattering the portrait conventions of the time, to discover the hidden truths which eluded his contemporaries.

154

A Moral Climate

Diderot's greatest enthusiasm seems to have been divided between Jean-Baptiste-Siméon Chardin (1699–1779), and Jean-Baptiste Greuze (1725–1805). Both these painters were influenced by the Dutch and Flemish artists of the preceding century, and both produced genre scenes. In other respects, they could hardly be more different. Diderot's discussion of their work shows him trying to reconcile the claims of painting as a physical and sensual experience, and painting as a repository of valuable moral ideas.

Chardin was in many ways an 'outsider' in the art world of his time. His training and background were not the conventional ones of the successful artist of the day: in this he resembled Watteau. His father was a cabinet-maker who specialized in making billiard-tables. As a craftsman himself, Chardin *père* thought of his boy's chosen career as a craft. He refused to let his son study the humanities, thus debarring him from history painting for want of the necessary knowledge. And he put his son's name down for the Academy of St Luke, the successor to the old craft guild of painters, and now very much a second-best to the Academy itself. Chardin was later to regard this as a bad start, and to speak with bitterness of his father's error.

Chardin's training was not conventional: in particular it seems to have lacked the traditional academic emphasis on drawing. His first teacher, the uninspiring Pierre-Jacques Cazes, was too poor to pay for a model, and the young Chardin made do with copying his master's work. Later, he went as an assistant to Noël-Nicolas Coypel. A combination of lack of training and lack of money led the young Chardin to opt for still-life painting, a minor genre for which there existed a ready market. Only later, when he realized the restrictions which this put upon him, was he to try his hand at figure painting; even then, it was domestic scenes that he attempted: nothing in the grand manner.

The first thing he had to do was to remedy his father's mistake in putting him down for the wrong Academy. He had the opportunity to do so when, in June 1728, he exhibited some paintings in the Place

155

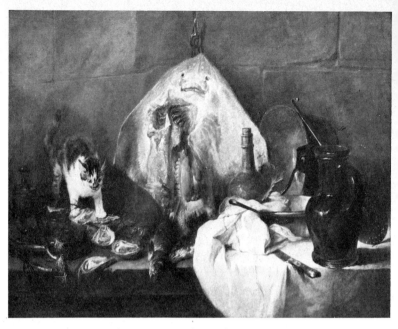

152 JEAN-BAPTISTE-SIMÉON CHARDIN *The Rayfish c.* 1727–28

Dauphine: it was the custom for young artists to show their efforts there, in the open air. Among the pictures which Chardin exhibited
152 was *The Rayfish.* Diderot was later to describe it thus: 'The object is disgusting, but it is the very flesh of the fish, its skin and blood; one would not be affected otherwise by the sight of the thing itself.'

Chardin's offerings impressed some of the Academicians who saw them at the Place Dauphine; he was invited to offer himself for membership of the Academy, duly presented himself, and was accepted. In 1729 he resigned his mastership at the Academy of St Luke.

Having made his reputation with his still-lifes, Chardin turned to painting genre scenes quite early, at least by the beginning of the 1730s. One practical reason for this seems to have been the fact that he thus opened up to himself the lucrative market in reproductive engravings of his work. A contemporary historian complained that 'engravings after Chardin are by way of becoming fashionable and, along with those of Teniers, Wouwerman and Lancret, have dealt a death-blow to the serious engravings of artists like Le Brun, Poussin, Le

Sueur and even the Coypels'. Thus far, at least, he was able to take his revenge on the history painters. After 1736, Chardin ceased to exhibit his still-lifes at the Salons; they reappear only in 1752.

The still-lifes were, nevertheless, appreciated from the very beginning of Chardin's career. It was not only his fellow Academicians who admired them. Collectors sought for them; critics praised them, though usually with the galling qualification that this was a 'low' form of art. Diderot's praise of *The Rayfish* tells us what contemporary connoisseurs appreciated: the dazzling virtuosity of Chardin's technique. Today, when Chardin's reputation again stands very high, this is still a reason for admiring his work. No painter has a keener sense of the interplay of colours, the way in which one tone affects the value of the tone set next to it. Every colour takes life from its neighbours.

This appears most clearly, perhaps, in Chardin's simplest compositions, such as the *Kitchen Still-life with Cooking-pots and Eggs* in the Louvre. But there is something else that impresses us, besides the sheer skill with which the paint is put on; and that is the stillness, the tranquillity that the artist has imposed. The objects on their stone ledge seem like offerings to the household gods, placed upon an altar.

153

153 JEAN-BAPTISTE-SIMÉON CHARDIN *Kitchen Still-life with Cooking-pots and Eggs* *c.* 1734

154 ANDRÉ BOUYS
The Kitchen Maid c. 1735

155
HENRI–HORACE–ROLAND
DE LA PORTE
The Rustic Meal

156 JEAN-BAPTISTE-SIMÉON CHARDIN *Vase of Flowers c.* 1760–63

Chardin is by no means the only still-life painter of the French eighteenth century, nor does he represent a sharp break in the development of the art. But he did to a surprising extent impose his personality
154 on his rivals. An older artist, André Bouys (1656–1740), was not immune, as can be seen from a painting exhibited in the Salon of 1737.
155 Juniors, such as Henri-Horace-Roland de la Porte (1724–93), and Anne Vallayer-Coster (1744–1818), seem to have been entirely under his spell. We do not have to search too far for the reasons, once we
156 have looked at a picture such as the miraculous *Vase of Flowers* in the National Gallery of Scotland. This, which was probably painted early in the 1760s, shows the unrivalled intensity of Chardin's powers of observation. It is a work of art before which the critic falls mute.

Our reaction to Chardin's genre scenes is not likely to be quite as intense or as unmixed as our reaction to his still-lifes. But this is hardly the painter's fault; it is inherent in the nature of genre painting. These remain probably the most triumphant representations of 'ordinary' life that have ever been painted. The name of the Le Nains is appropriate here: even contemporaries were quick to make the comparison.

There is one important difference, however: Chardin's subjects are
158 predominantly taken from the bourgeoisie. Even in *The Draughtsman* the young man, with his ragged coat, who is perhaps to be thought of as a reminiscence of Chardin's own early years, is visibly not a member of the proletariat which was to rise up with the Revolution. The alternative title which is given to *The Draughtsman* is *The Basis of The Arts*. This hints at an important aspect of Chardin's genre scenes which tends to divide them from his still-lifes. Chardin told Diderot that the painter needed a 'moral climate'. In still-life painting, the existence of such a climate had to be implied; in genre scenes the means of express-
157 ing it could become more explicit. A picture such as *The Morning Toilet*, which shows a mother preparing her child for church, hints subtly but definitely at the moral lesson which the scene embodies. We, unlike Chardin's contemporaries, are not on the look out for such things, and tend to miss the point which is being made. What appeals to us is the technical skill, transferred intact from the still-lifes, and the mixture of suppleness and rigour in the composition. Vermeer is the only artist who has rivalled Chardin as a painter of domestic interiors; only these two can take the commonplace facts of existence, and the banal objects with which we surround ourselves, and create from them the purest of harmonies.

160

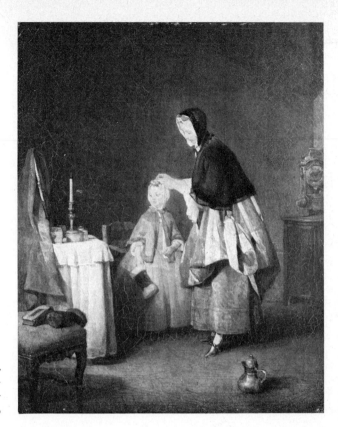

157
JEAN–BAPTISTE–SIMÉON
CHARDIN
The Morning Toilet c. 1740

158
JEAN–BAPTISTE–SIMÉON
CHARDIN
The Draughtsman c. 1738

With Jean-Baptiste Greuze, on the other hand, we are in no danger of missing the moral lesson. He rams it down our throats, to an extent which makes it difficult to echo the enthusiasm which his contemporaries felt for him. In part, they liked him because they were beginning to react against the laxness and grossness of the times. The society of *douceur de vivre*, for which Talleyrand was to breathe such a heartfelt sigh of regret, was also a corrupt society, sliding downhill towards revolution. But it did not have an easy conscience. Greuze, who scored his first success in 1755, arrived at the psychological moment. He became, in the visual arts, the representative of the contemporary 'cult of feeling'. The brilliant intellectual life of the French eighteenth century had always based itself upon a fundamental faith in mankind: Diderot once remarked that 'Mankind is the unique term, from which we must set out and to which everything must return.' Trust in man, as

159 JEAN-BAPTISTE GREUZE *A Father's Curse* c. 1775

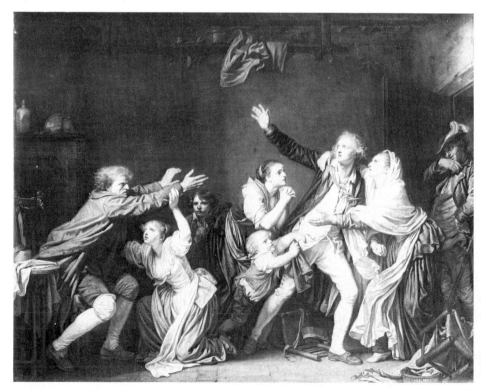

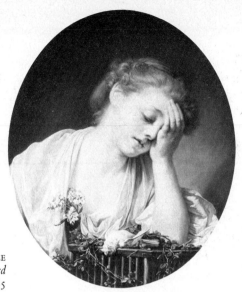

160 JEAN-BAPTISTE GREUZE
Girl with a Dead Bird
1765

people came to see, means trust not merely in his intellect but in his emotions. The decisive advocate of feeling was Jean-Jacques Rousseau, who came to prominence after 1750.

In his most celebrated paintings, Greuze established the rights of humble people, their lives and their values, in the world of art; even Chardin had not been able to do as much. His work filled a gap of which everyone was suddenly aware, intellectuals and broad public alike. But unfortunately there is something intensely self-conscious about these works, which now seems to rob them of artistic validity. A painting such as *A Father's Curse* in the Louvre seems to us now to be stagy, false and hollow. Staginess, indeed, was a quality which Greuze introduced into French painting thanks to his study of the theatre. David, too, was to take lessons from the actor, as Robert took them from the scene-designer. *159*

Besides his genre scenes, Greuze produced another type of picture. He was a specialist in ambiguous representations of innocence. The *Girl with a Dead Bird* in the National Gallery of Scotland is a typical example. It was exhibited at the Salon of 1765, where Diderot found it 'delicious'. But here, as elsewhere, he recognized the equivocal nature of Greuze's art: *160*

'The subject of this little poem is so subtle that many people have not understood it; their belief is that this little girl weeps only for her

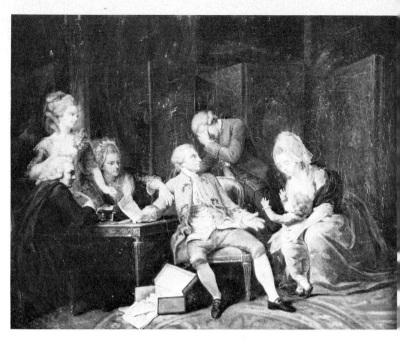

161 ÉTIENNE JEAURAT *The Broken Marriage Contract*

canary. Greuze has painted the same subject before: he placed a grown girl dressed in white satin before a cracked mirror – she is full of the deepest melancholy. Do you not think that it would be quite as stupid to attribute the tears of the former to the loss of a bird as the melancholy of the latter to her broken mirror?'

Greuze cannot escape the libertinism of the century; he pays tribute to it while condemning it.

The success of first Chardin and then Greuze raised up a host of imitators. Among them were Etienne Jeaurat (1699–1789) and Nicolas-Bernard Lépicié (1735–84), both of whom painted interesting repre-
161 sentations of contemporary life: Jeaurat's *The Broken Marriage Contract* is a representative example. Etienne Aubry (1745–81) produced
162 pastiches of Greuze which come deceptively close to the originals. A later and cooler exponent of story-telling genre is Louis Léopold
163 Boilly (1761–1845). In Boilly's paintings, which are technically very refined, we see a more thorough absorption of neoclassical ideas, and, once more, the pervasive influence of theatrical gesture.

164

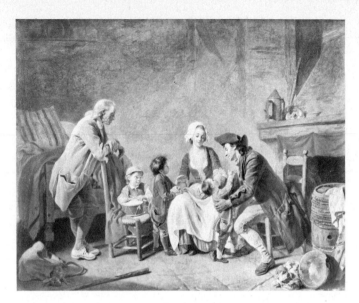

162 ÉTIENNE AUBRY
Paternal Love

163 LOUIS LÉOPOLD BOILLY *The Sorrows of Love c.* 1790

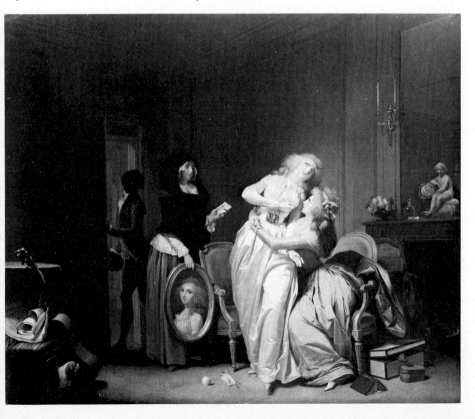

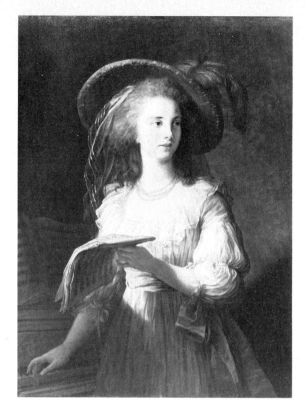

164
ÉLISABETH-LOUISE
VIGÉE-LEBRUN
Princesse de
Polignac 1783

The enormous popularity of Greuze's work saw to it that he had an effect upon other things besides genre painting. The fashionable portraitist Elisabeth-Louise Vigée-Lebrun (1755–1842) took his advice, and her carefully simple and artless portraits of fashionable people, *164* such as the Princesse de Polignac, demonstrate the effect which the cult of feeling had on Parisian society.

Nevertheless, both Chardin and Greuze outlived their own success. Genre painting might triumph for a time, but this triumph could not altogether suppress the desire to see the visual arts tackle more 'serious' and more innately heroic themes. Painting could not escape the reformist efforts of neoclassicism, a movement which dates its rise from the 1750s, just at the moment when Greuze himself was ready to burst upon the scene. Indeed, neoclassicism and the cult of feeling with which

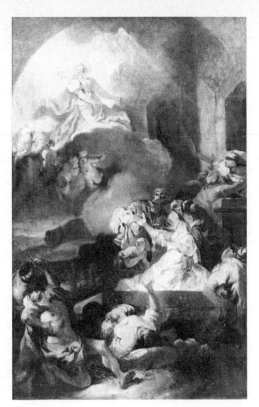

165
FRANÇOIS–GABRIEL DOYEN
St Genevieve
Interceding for the Victims
of the Plague 1767

Greuze was associated were by no means inimical to one another:
after all, they both attached a definite moral value to 'purity' and
'simplicity', and did not necessarily disagree in the meanings which
they attached to these words. Neoclassicism, however, was by its
nature systematic: it believed in rules. It was by following these rules
that artists could return to original principles.

Not that the story of the rise of neoclassicism in France is free from
paradox. Artists such as François-Gabriel Doyen (1725–1806) and
Jean-Baptiste Deshays de Colleville (1729–65), who treated classical
subjects more seriously than, for example, Boucher, could find no
better models than the Baroque painting of the preceding century.
Indeed, they represented the continuation of the true Baroque in the
age of the Rococo.

165

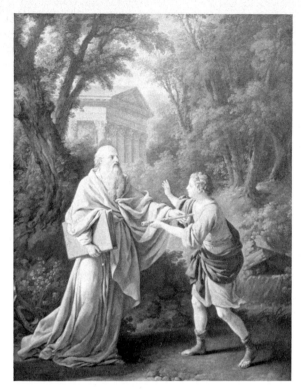

166
LOUIS-JEAN-FRANÇOIS
LAGRENÉE THE ELDER
Telemachus and
Terosiris 1770

 Even painters who are more clearly recognizable as early neo-
166 classicists, such as Louis-Jean-François Lagrenée the Elder (1724–
1805), and Joseph-Marie Vien (1716–1809), are affected both by the
tradition which they inherited and by the prevailing taste of their own
day. Both men show a curious unevenness of style.

 During the Revolution, Vien was to lay claim to the honour of hav-
ing regenerated the French school; but the quality of his work scarcely
supports his assertion. Like many men of secondary talent who are also
gifted with a certain originality of mind, he veers from one stylistic
167 experiment to another. When he paints *Lot and His Daughters*, a tradi-
tional subject in Baroque art, he produces a work which is in many
168 respects not far off from Vouet. When he depicts the *Apotheosis of
Winckelmann*, the great German theorist of neoclassicism is imagined
as the central figure in a composition which derives from Baroque
43 *Pietàs* and Entombments; compare, for example, the *Entombment* by
Caravaggio.

168

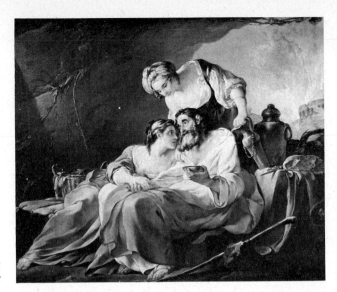

167 JOSEPH-MARIE VIEN
Lot and his Daughters 1747

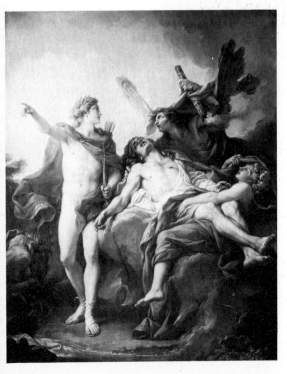

168
JOSEPH-MARIE VIEN
Apotheosis of Winckelmann

169 JOSEPH-MARIE VIEN
Greek Girl at the Bath
1767

170 JOSEPH-MARIE VIEN
The Merchant of Loves
1763

171 JEAN-BAPTISTE
GREUZE
*Septimius Severus
Reproaching Caracalla* 1769

Yet, in a different mood, Vien produced work which, if rather
170 bloodless, is recognizably neoclassical. *The Merchant of Loves* is adapted
from a celebrated Roman wall-painting at Herculaneum, just as the
furniture of the time was beginning to be an adaptation of the models
which contemporary cabinet-makers found in Greek vase-paintings.
Not being at the mercy of ideas about practicality and convenience,
Vien's work comes closer to its model than furniture was to do until
169 the 1800s. The *Greek Girl at the Bath*, signed and dated 1767 and a
famous picture in its own day, is less directly dependent upon the
antique; it shows the precise degree to which the art of the period was
ready to adopt the formulae of neoclassicism.

170

Things were on the move, however. Greuze himself sensed it, and *171* in 1769 produced *Septimius Severus Reproaching Caracalla* as his belated reception piece for the Academy. The fact that the unfortunate painter was lectured by his colleagues on the defects to be found in this work, and was informed by them that he would be received as a genre painter only, does not alter its historical significance. French painting here returns to seventeenth-century sources: antiquity and Poussin (the resemblance to some of the *Sacraments* by Poussin was unmistakable). The way would soon be open for another dictator of the arts, of a kind which had not existed in France since the days of Le Brun.

172 JACQUES-LOUIS DAVID *The Combat of Minerva against Mars* 1770

172

Roman Virtue

The new dictator was Jacques-Louis David (1748–1825). It is no accident that David is also the painter who links the eighteenth century in France to the nineteenth.

He was a distant relation of François Boucher, and the pupil of Vien. His earliest known work, curiously enough, seems to owe almost as much to the former as it does to the latter. *The Combat of Minerva* 172
against Mars, which David entered for the Prix de Rome in 1770, is a picture still full of Rococo influences, though it is somewhat lacking in spirit and lightness. It gives no idea of the kind of artist that David was to become.

He did not win the prize at his first attempt. He had to wait until 1774, the year of Louis XV's death. He left Paris for Rome in October 1775, in company with his master Vien, who had just been appointed Director of the French Academy in Rome. It was at this point that David's career as a painter really began. Though he had sworn not to change his manner under the impact of Italy, the place immediately overwhelmed him. He was to remain there until 1780. During this period he transformed himself from a callow student into a mature and original artist.

Yet he was also a child of his time. His first important picture, *St Roch Begging the Virgin to Intercede for the Plague-stricken*, shows affinities with the work of Doyen, who had already taken an interest in the young painter's career. The truly striking thing about it is the intensity with which the dead and dying are represented. Somewhat more chastened in style, but still very much within the Baroque tradition, was the painting which won for David his first success at the Salon, the *Belisarius* which he exhibited there in 1781. 173

Classical subjects were by this time solidly in fashion, and particularly those which related to Roman legend or history. Among those who showed paintings on Roman themes in the Salons of the period were painters such as Brenet, Hallé, and Lagrenée the Elder. Lépicié, whom we now think of as being primarily a genre painter, also

attempted subjects from Roman history: *The Courage of Porcia* in 1777, *Regulus Returning to Carthage* in 1779, the *Piety of Fabius Dorso* in 1781. Jean-François-Pierre Peyron (1744–1814), who won the Prix de Rome in competition with David, and François-André Vincent (1746–1816), who like David was a pupil of Vien, were keenly interested in Roman subjects. The new Court reacted against the licentiousness of Boucher, and Louis XVI's Directeur-Général des Bâtiments, the Comte d'Angivillier, was busy commissioning pictures of suitably moral and heroic subjects for the royal palaces. Needless to say, Roman virtue was well to the fore.

D'Angivillier had been a friend and patron of David's from the beginning. He now ordered a painting for the King from his newly 174 successful protégé. This, exhibited in the Salon of 1785, was *The Oath of the Horatii*. It was followed by another royal commission, *The* 175 *Lictors Bringing Brutus the Bodies of his Sons*, shown at the Salon of 1789. These two pictures have often been interpreted as a prophetic summons to revolution. A recent historian labels *The Oath of the Horatii* 'fully republican'. Clearly, however, it did not strike D'Angivillier

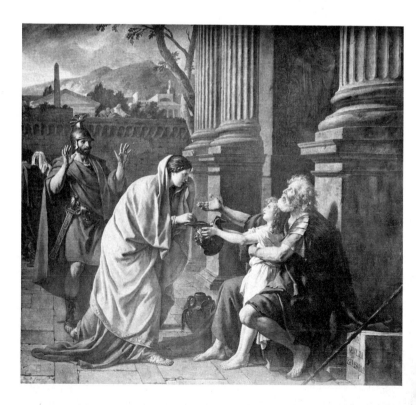

174 JACQUES-LOUIS DAVID *The Oath of the Horatii* 1785

like this, and it seems unlikely that David had at this point evolved a republican philosophy. His subsequent career, first as a member of the revolutionary Convention, and then as court painter to Napoleon, shows him to have been exceptionally sensitive to the climate of the times he lived through. It seems likely that both the *Horatii* and the *Brutus* were subconscious reactions to what many people were thinking and feeling. A new patriotism, a new impatience with pettiness and self-indulgence: these were familiar reactions in France in the decade before the Revolution, and the monarchy itself thought them healthy and encouraged them. David expressed these emotions with such force that they afterwards seemed to herald something else.

The Oath of the Horatii can, nevertheless, be described as revolution- *174* ary in another sense: it is a completely neoclassical picture, one in

175

173 JACQUES-LOUIS DAVID *Belisarius* 1781

175 JACQUES-LOUIS DAVID *The Lictors Bringing Brutus the Bodies of his Sons* 1789

which all the elements which contributed to neoclassicism fuse and be-
come incandescent. Particularly noticeable is the effort towards
175 archaeological correctness (to be seen again in the *Brutus*) and the
abandonment of Baroque compositional devices in favour of a new
system. Instead of employing the serpentine line of Baroque, and a
compositional axis which thrusts diagonally into the picture-space,
David places his figures parallel to the picture-plane. Their outlines are
clear, each occupies an unambiguously defined spatial position, the
underlying compositional framework consists of straight lines and
rigid angles. In fact, pictorial science has undergone a process of
simplification, a stripping away of unnecessary clutter.

But the *Horatii* and the *Brutus* would not have had the impact they
did have, if this were all. David puts abstract design at the service of a

176 JACQUES-LOUIS DAVID *The Death of Marat* 1793

subtle naturalism; he wanted every part of his composition to be free of 'mannerism', or wilful idiosyncrasy. In his own terms, he succeeded; yet there is a theatricality, a sense of strain, about these two paintings which in the end denies them the status of masterpieces. David and the Greuze whom David superseded were alike in at least one thing. They were both impassioned students of the theatre, and theatricality enters into their work by the directest route: it is a reminiscence of what they had already seen on stage. And both felt that the drama and painting must make an inescapable moral point. They agreed with Diderot that 'Every piece of sculpture, every painting, must be the expression of an important maxim, a lesson for the spectator; without which it remains mute.'

Events themselves rescued David from the stagnation into which, for all his gifts, he might soon have sunk. Swept up into the whirlwind of the Revolution, David found himself a member of the Convention, and voted for the execution of the King. There is a world of difference *174, 176* between the *Horatii* and the *Death of Marat* (1793). Here it was not Roman history which was being depicted, but the history of the time. The spectator stands, in relation to the figure of Marat, just at the spot which Marat's assassin, Charlotte Corday, has just quitted. The figure has an astonishing realism; it is meant to shock, and it does. But it is also a secular *pietà*, and a much more moving one than Vien's *Apotheosis of Winckelmann*. The immediacy of this work is also to be found *180* in the self-portrait which David painted soon afterwards, when imprisoned following the fall of Robespierre. In this, as in the *Marat*, one finds an impassioned scrutiny of an essentially inscrutable reality.

Though David was to continue to paint canvases with classical subjects during the Revolutionary period and afterwards (among them *The Sabines* of 1799, and *Leonidas at Thermopylae* of 1814), Napoleon, whose principal painter he soon became, had a forcibly expressed preference for national and contemporary subjects in painting. Thus it was that David found himself commissioned to paint, first of all the *Bonaparte at Mont-Saint-Bernard* (1800), and later the *Coronation* (1805–7), and the *Distribution of the Eagles* (1810). The Bonaparte is a memorable presentation of the subject's own image of himself, 'calm, upon a fiery horse', but is too schematic to count for much as a work of art. The two big ceremonial canvases remind me of Le Brun's *Tent of Darius*: they are immensely professional, and lukewarm. They do, however, contain a throng of interesting portraits.

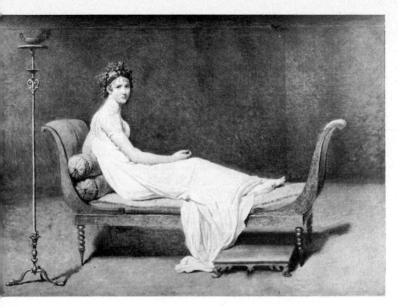

177 JACQUES-LOUIS DAVID *Madame Récamier* 1800

Throughout his career, David was a master portraitist. His subject paintings are important from a historical point of view, but it is chiefly upon the portraits that his claim to being a major artist must rest. He was able to penetrate the social surface, and reveal what lay beneath. His portrait of Madame Pécoul (the second wife of his father-in-law) *178* is wonderfully sympathetic without being in the least flattering. The famous unfinished portrait of Madame Récamier shows how bril- *177* liantly David met what is perhaps the supreme challenge for a portrait-ist: how to show character in a beautiful woman without diminishing or denying her beauty. But there is something more to it as well. This picture, above all, allows us to see how David himself had changed the dress, the furniture, even the manners of his time.

Another way in which David was able to exercise his influence was through his pupils. He had attracted large numbers of pupils to him ever since his return from Italy in 1780, and some of these became, after David himself, the most celebrated and successful painters of the day. They were subjected to a rigid system of instruction: under David's iron rule painting was fuller of 'do's and don'ts' than it had been under the pre-Revolutionary Academy.

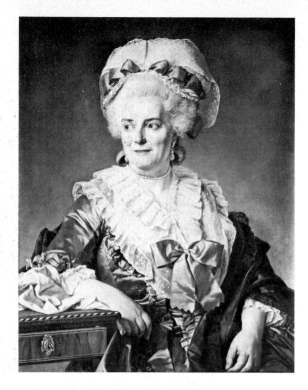

The most tragic and the most interesting of these pupils was Antoine-Jean, Baron Gros (1771–1835). It is in Gros's work that we see being fought out the battle between Romanticism and classicism. David considered him his heir, and, on going into exile in Brussels at the Restoration, left Gros his studio and asked him to continue to direct a new generation of pupils. This in spite of the fact that the master had previously condemned the pupil for 'still not having painted a real history picture', and for having contented himself with 'worthless' and 'topical' subjects. Torn between his respect for David's theories and his own violence of temperament, Gros eventually committed suicide.

It is Gros, rather than David, who is the poet of the Napoleonic epic. David's paintings invariably remind us of the authoritarian aspect of Napoleon's rule; Gros catches the heroism of the Empire, and the excitement which attended Napoleon's conquests. His
179 sketch-portrait *Bonaparte at the Bridge of Arcola*, painted in 1796, renders the atmosphere of the early Napoleonic days perhaps better

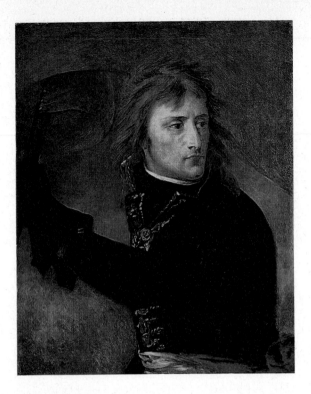

179 BARON GROS
*Bonaparte at the Bridge
of Arcola* 1796

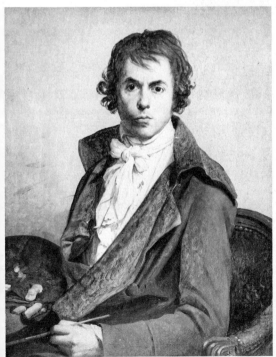

180 JACQUES-LOUIS DAVID
Self-portrait 1794

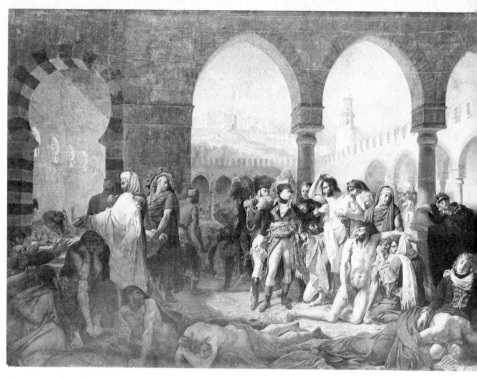

181 BARON GROS *The Plague at Jaffa* 1804

181 than any other painting; while *The Plague at Jaffa* creates a compelling image of courage and invulnerability, a new version of the Baroque altarpieces which show St Charles Borromeo ministering to plague-victims. Equally evocative of the Napoleonic Age are Gros's swagger-
182 ing military portraits, such as the *Comte Fournier-Sarlovèze* in the Louvre.

 A colder and less individual follower of David was François-Pascal-Simon, Baron Gérard (1770–1837), who first attracted David's attention in 1786. Yet even he moved gradually towards Romanticism, and away from the strict neoclassicism of David. We see from
183 Gérard's coquettish portrait of Madame Récamier (which the subject
177 herself probably preferred to David's) how the directness and classicism of the author of the *Horatii* were already being modified, by his followers, towards that mannerism which he detested.

182

182 BARON GROS *Comte Fournier-Sarlovèze* 1812

183 BARON GÉRARD *Madame Récamier* 1802

184 PIERRE–PAUL PRUD'HON *Empress Josephine* 1805

Another pupil of David's, Anne-Louis Girodet de Roucy-Trioson (1767–1824), supplies a case in point. Unlike Gros and Gérard, Girodet was not concerned with preserving the purity of Davidian doctrine. When he painted his *Ossian Receiving the Warriors of the Revolution into Paradise* for Malmaison in 1801, he boasted that the painting gave him more confidence in himself because it was altogether his own creation and 'not inspired by any model'. The bogus epic on which he based himself was a great favourite of Napoleon's, and Girodet's misty interpretation of it is indeed quite unlike anything which his master might have imagined. David openly disapproved of the picture, but the contemporary public liked it.

The real opposition to David under the Empire, however, was supplied by Pierre-Paul Prud'hon (1758–1823). Not that Prud'hon, compared to David, was outstandingly successful. He began in obscurity, and died in misery. In between, he knew a period of success, as official painter to the two Empresses, Josephine and Marie-Louise. Prud'hon's style is as far from that of David as can conveniently be imagined, within the boundaries of the neoclassical convention. He, like Boucher before him, was influenced by Correggio: he is all

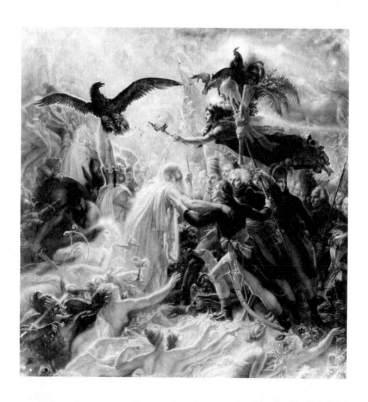

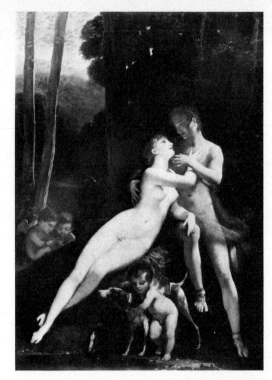

186
PIERRE-PAUL PRUD'HON
Venus and Adonis
1810

185 ANNE-LOUIS GIRODET
Ossian Receiving the
Warriors of the Revolution
into Paradise 1801

softness and *sfumato*, in contrast to the definite outlines of David and his pupils. He thus continues into the nineteenth century the loose, melting, mysterious manner favoured by Greuze and later by Frago-nard. Naturally, his pictures seem lacking in real content when put beside those of other painters of the time, just as his portraits seem to lack character. Yet this is, in a way, the clue to his originality. The portrait of the Empress Josephine which Delacroix afterwards *184* described as 'ravishing', and the large allegorical mythological paint-ings such as the *Venus and Adonis* in the Wallace Collection, are all of *186* a piece, part of a completely imagined and created world with its own rules: Prud'hon dealt, not in the *reproduction* of reality, but in the *transformation* of reality into paint. This is what makes him a true forerunner of the Romantics. It also explains how the legend could take root that Marie-Louise, Josephine's successor, sat for the Venus, and Neipperg, her lover in later years, for the Adonis. There would be small difference in the painting if this were true.

187

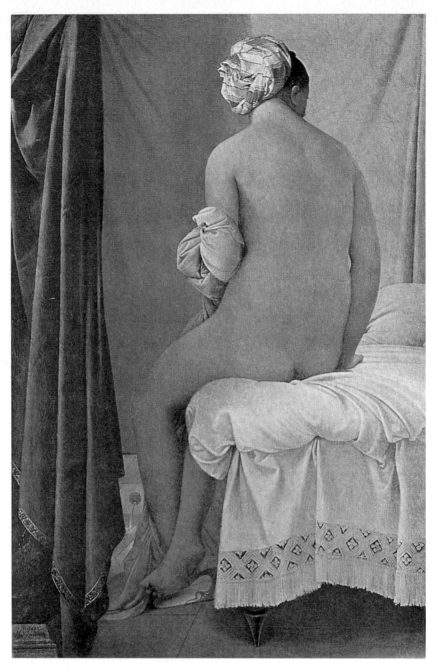

187 JEAN–AUGUSTE–DOMINIQUE INGRES *Grande Baigneuse* 1808

Romantic Passion

Neoclassicism did not give way to Romanticism without a struggle. But the Romantic spirit took a curious revenge upon the man who, as the Romantic movement progressed, came to be regarded as the true upholder of the classical spirit of David. This was that great but very strange painter Jean-Auguste-Dominique Ingres (1780–1867). Ingres, like the majority of the neoclassicists mentioned in the last chapter, was one of David's pupils. After studying at the Academy of Toulouse, Ingres entered David's studio in 1797. He underwent the rigorous course of instruction which all the master's pupils received, and seems to have made good progress. In 1800, he is said to have helped David with the accessories in the unfinished portrait of Madame Récamier. In 1801 he won the Prix de Rome, but public money was in such short supply that his departure had to be postponed. He did not reach Rome until 1806: he was not to leave Italy until 1824, some years after the Napoleonic adventure was over, and only a year before the exiled David's death in Brussels.

Because of the long interval before he was able to set off for Rome, Ingres had already established a personal style before he departed; it appears most clearly in the three portraits of members of the Rivière family, now in the Louvre. They were shown in the Salon of 1806, and, like Ingres's other submissions in that year, were severely criticized. Ingres was described as being 'Gothic', an adjective which he was felt to have earned upon several counts: the evident influence upon him of the Flemish Primitives and of the artists who preceded Raphael, the lack of chiaroscuro, and perhaps, most of all, the determination to establish his independence of his master. David's *Madame Récamier*, Gérard's portrait of the same person, and Ingres's *Madame Rivière* make a kind of sequence, in which we can see both the steady development of a 'mannerist' elegance and an increasing emphasis upon line, as opposed to volume. 177 183 190

When we look at Ingres's mythological compositions, which were an attempt to rival David in the genre with which the latter had made

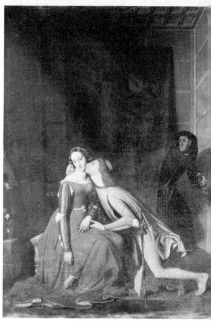

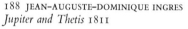

188 JEAN-AUGUSTE-DOMINIQUE INGRES
Jupiter and Thetis 1811

189 JEAN-AUGUSTE-DOMINIQUE INGRES
Paolo and Francesca 1819

his name, we are struck by the differences between the two artists,
rather than their similarities. Ingres's *Jupiter and Thetis* has nothing
of David's logic and measure. The figure of Thetis, in particular, has
a wilful elegance which is very far from the kind of thing which David
tried to achieve: it is compressed in space, so that it forms a kind of
shallow bas-relief rather than a fully rounded three-dimensional form,
and the head is forced back at an exaggerated angle (it seems possible
that Ingres borrowed this exaggeration from Girodet). The figure of
Jupiter is huge in proportion to that of his suppliant.

Ingres also tackled compositions whose subject-matter was very
different from that selected by David. In addition to painting classical
history pictures and portraits, changing taste led him, like Gros, to
paint the kind of costume picture which was to enjoy an immense
vogue throughout the rest of the century. But these costume pictures
are informed by an unchanged sense of design: the *Paolo and Francesca*
of 1819, for example, is very close to being the composition of *Jupiter
and Thetis* in reverse.

188

189

190

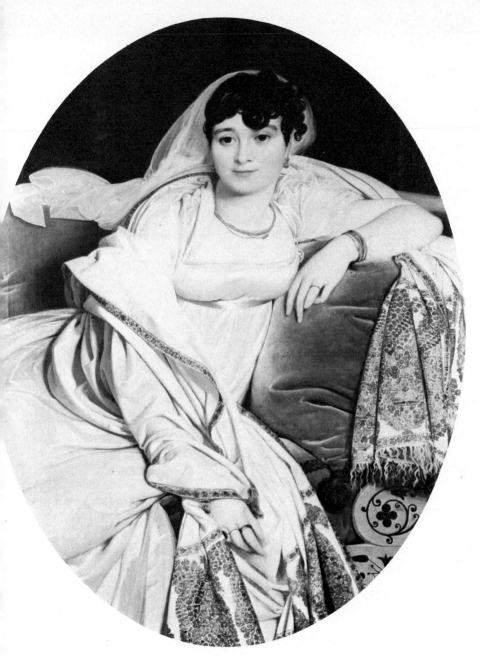

190 JEAN-AUGUSTE-DOMINIQUE INGRES *Madame Rivière* 1806

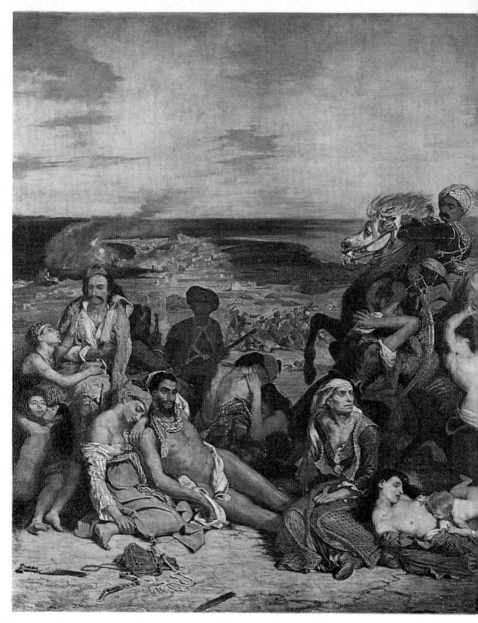

191 EUGÈNE DELACROIX *The Massacre of Chios* 1824

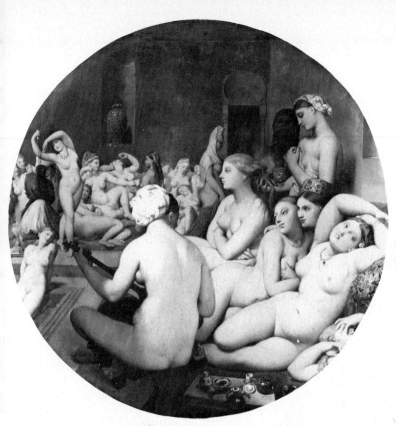

192 JEAN-AUGUSTE-DOMINIQUE INGRES *Le Bain turc* 1862

Some of Ingres's most personal, as well as his most beautiful pictures are the female nudes, with their marvellous cold sensuality. Ingres was to paint compositions of this type throughout his career, often using the same elements in a whole sequence of paintings of different dates. The *Grande Baigneuse* of 1808, for example, is the direct ancestress of the principal figure in *Le Bain turc*, which dates from 1862.

Yet, though one can detect certain obsessions in Ingres's work, he was not confined by those obsessions. His portraits of men are equal, if not superior to his portraits of women. And, conservative though he was, he was extremely sensitive to the nuances of social change. His portrait of Monsieur Bertin, editor of the *Journal des Débats*, which had been the organ of the constitutional opposition under the Bourbon Restoration, and which became the support of the liberal bourgeoisie after the July Revolution of 1830 which placed Louis-Philippe in

187

192

194

193

power, is the shrewdest possible characterization of the kind of man who was to dominate the France of the nineteenth century.

Though Ingres was to influence not only his pupil Degas, but Renoir, the main line of development in the French painting of the time does not run through his work. Rather, there is a direct succession from David to the Romantics, from the Romantics to Courbet, and from Courbet and the Barbizon painters to the Impressionists. The first link in the chain, after David himself, is the academic painter Pierre-Narcisse Guérin (1774–1833). Guérin was the pupil of Regnault,

193 THÉODORE GÉRICAULT *The Wounded Cuirassier* 1814

194 JEAN-AUGUSTE-
DOMINIQUE INGRES
Monsieur Bertin 1832

one of David's rivals, who was slightly (but only slightly) less rigid in his views on colour and technique than David himself. Guérin himself did not have the genius to trigger off the Romantic explosion. That honour belonged to two of his pupils, Géricault and Delacroix.

The short-lived Théodore Géricault (1791–1824) was by seven years the elder of the two, and in his work we see the Romantic spirit gradually breaking free of the past. Géricault was a child of the Napoleonic Age. His first paintings, done before the Emperor's fall, such as the *Chasseur Officer Charging*, or the *Wounded Cuirassier*, reflect *193* both the excitement and the strain of the declining Empire.

When Géricault made his way to Rome, as he did in 1816, these military pictures, which owed much to Gros, gave place to a more generalized depiction of energy; he was attracted, for example, by the riderless horse-race which was one of the events of Carnival in *195* Rome, an event which he made the subject of a number of sketches. He seems to have been less overwhelmed than his predecessors by the works of art which he found in Italy, perhaps because he had already had access to the vast accumulation of works of art which Napoleon had brought together in Paris as the spoils of his conquests.

195 THÉODORE GÉRICAULT *Start of the Riderless Horse-race in Rome* 1817

197 THÉODORE GÉRICAULT *The Raft of the Medusa* 1819

Returning to Paris, Géricault embarked on an ambitious project: *The Raft of the Medusa*. This was an attempt to give epic stature to a contemporary event, a shipwreck off the west coast of Africa. One hundred and fifty survivors were crowded upon an improvised raft; after a mutiny and many days of suffering, only a handful reached safety. In deciding to treat a subject of this kind, Géricault was not innovating: he was continuing the tradition of David (the projected painting of *The Tennis-Court Oath* and *The Death of Marat*), and that of Gros, who had already influenced the military pictures. The *Raft of the Medusa* is the successor of the *Plague at Jaffa*, although its motive force is not hero-worship but indignant compassion.

Géricault had a tireless curiosity about the nature of man. When he began to explore the terrible subject he had chosen, he also began to explore the extremes of experience and feeling. He made studies of executed criminals, and of the severed limbs he saw in mortuaries. Later, after the completion of the *Medusa*, he was to make studies of

<div align="right">

197

176

181

196

197

</div>

196 THÉODORE GÉRICAULT *Severed Heads* 1818

198 THÉODORE GÉRICAULT *The Plaster-Kiln* 1821-22

lunatics, in much the same spirit as Le Brun's study of the niceties of
human expression, but again breaking through the hitherto estab-
lished boundaries of decorum.

The *Medusa* completed, Géricault departed for England, and here,
in addition to coming into contact with the English national passion
for sport, and particularly for those sports which involve horseflesh,
he had the opportunity to observe the effects of the Industrial Revolu-
tion at first hand. This seems to have made as deep an impression upon
him as anything he encountered in Italy. A certain number of late
198 paintings, lithographs and drawings, notably *The Plaster-Kiln*, which
seems to have been painted after his return to Paris, sum up his
reactions to industrial occupations and landscape. Marxist critics have

198

rightly stressed the importance of these works in the history of painting. The realism which Géricault inherited from David is here put at the service of an entirely fresh and different kind of sensibility.

Eugène Delacroix (1798–1863) came into contact with Géricault after the latter's visit to Italy. If it was Géricault who, under pressure from his own demanding temperament, loosened the constrictions of academic classicism, it was Delacroix who now explored to the full the possibilities which were becoming available to French painting.

All the dominant concepts of Romanticism are to be found in the work of Delacroix: nature, liberty, the love of change for its own sake, the fascination with power, the search for emotion as an end in itself. Yet, at the same time, he remained profoundly rooted in the past, both as a man and as an artist. He faces both forward and back: he was the last great decorative painter in the French tradition, and arguably the last great religious painter also. Yet the technical freedom of his work leads directly to the innovations of the Impressionists, to those of Cézanne, and even to those of the Fauves with whom Modernism begins.

One of his earliest masterpieces, the *Massacre of Chios*, illustrates *191* many of his qualities. Like the *Death of Marat* and the *Raft of the Medusa* *176, 197* it depicts a contemporary incident, a Turkish atrocity committed during the Greek Wars of Independence. But this is made the pretext for what Baudelaire called a 'terrifying hymn in honour of doom and irremediable suffering'. Delacroix had been influenced, in his handling of paint, and especially in his treatment of the background landscape, by the work of the English painter John Constable, with which he had recently become acquainted.

Another English painter who influenced Delacroix at the same period was his friend Richard Parkes Bonington (1801/2–28). Bonington emigrated to France in 1817, and seems to have encountered Delacroix when both artists were sketching in the Louvre. His contact with Delacroix was at its closest in 1825, when he shared a studio with the Frenchman for a few months. Precociously gifted, Bonington painted small landscapes and costume pieces which interested Delacroix because of their freshness of colour and handling. The link appears very plainly if we compare a typical Bonington, such as his *François I and Marguerite de Navarre*, with the small cabinet-pictures which Delacroix was producing at this period. One of the most beautiful is the *Woman with a Parrot*, which is also a perfect illustration *199*

of the sensuality which illuminates much of Delacroix's work: a very different sensuality from the cool eroticism of Ingres. The same model appears in *Greece Expiring upon the Ruins of Missolonghi*.

Perhaps the greatest of Delacroix's political paintings, however, is the slightly later *Liberty Guiding the People*, painted to commemorate the Revolution of 1830. Delacroix here depicts the aspirations of his time as Ingres depicted its reality in the portrait of Monsieur Bertin. This is a political image to put beside David's *Marat*; the mixture of realism and allegory is made to work by the sheer energy and conviction which the painter puts into it.

In 1832, an extremely important event occurred in Delacroix's career: he visited Algiers and Morocco in the suite of the Comte de Mornay, who was Louis-Philippe's Ambassador to the Sultan of Morocco. Islamic Africa made a profound impression on him. Among the Moors he discovered a classical dignity and beauty which was the more impressive because, unlike the world of antiquity which academic painters taught their pupils to admire, it was still alive. The

200 EUGÈNE DELACROIX *Liberty Guiding the People* 1830

ketches which he made during this visit were to supply him with
deas for the rest of his life.

The authority of the famous *Algerian Women in their Apartment,* 201
which was one of the first and most beautiful results of this visit, lies
n the fact that it is a sober and factual record of experience. After 1832,
Delacroix achieves his mature style, which is less high-pitched and
restless than that which he had practised previously. He became
ncreasingly concerned with the traditional subject-matter of painting,
and intensified his efforts to achieve monumental form. The *Entry* 202
of the Crusaders into Constantinople, exhibited in the Salon of 1840, later
moved Baudelaire to say that 'No one, after Shakespeare, excels as
Delacroix does in mingling drama and reverie to create a mysterious

201

99 EUGÈNE DELACROIX *Woman with a Parrot* 1827

truth.' This phrase perfectly sums up the difference between the

191 *Entry of the Crusaders* and the earlier *Massacre of Chios*, which Baude laire also admired: the *Entry of the Crusaders* is reflective and poetic where the early work is impassioned and oratorical.

During the later part of his life, Delacroix painted a number of cycles of architectural decoration in Paris: for the Salon du Roi and the library of the Palais Bourbon, for the library of the Palais du Luxembourg, the Galerie d'Apollon in the Louvre, the Salon de la Paix in the Hôtel de Ville, and finally for the Chapelle des Saints-Anges in the Church of Saint-Sulpice. He succeeded in these tasks where most nineteenth-century decorative painters failed, because he was able to use colour as the very structure of his compositions; there was no separation of colour and design. Working on such a large scale encouraged him to still greater freedom and amplitude of technique; the freshness and brilliance of the sketches for these projects reappears in the finished projects. Few other artists of the time were to be offered Delacroix's opportunities: he rose to the challenge with inexhaustible energy.

202 EUGÈNE DELACROIX *Entry of the Crusaders into Constantinople* 1840

The minor Romantics who attended the two major luminaries of the school, Géricault and Delacroix, practised their art with varying degrees of success. Horace Vernet (1789–1863), grandson of the landscape painter Claude-Joseph Vernet, and a member of the first generation of Romantic painters, produced vast battle scenes for the

203

201 EUGÈNE DELACROIX *Algerian Women in their Apartment* 1834

historical museum which Louis-Philippe created at Versailles, and also a number of attractive pictures with Arab subjects; some of these, 203 such as the *Arab Tale-Teller* in the Wallace Collection, were in fact produced before Vernet's visit to Algiers in 1837. Oriental subjects of this type were also favoured by Alexandre-Gabriel Decamps (1803–60), and Edme-Alfred-Alexis Dehondecq (1822–82).

The Napoleonic legend, which had obsessed Géricault for a time, continued to exercise a powerful spell over artists: a favourite subject was the retreat from Russia, which had an appropriately romantic *terribilità*. Among the painters who tackled this theme were Joseph-Ferdinand Boissard de Boisdenier (1813–66), and Nicolas Toussaint Charlet (1792–1845): Delacroix admired the 'powerful unity' of 204 Charlet's version.

Genre pictures with military subjects eventually became one of the staples of the academic Salon painting of the mid nineteenth century: Jean-Louis-Ernest Meissonier (1815–91) produced some typical examples, including a tiny and wonderfully meticulous painting of 205 *Napoleon I and his Staff*. In fact, Salon painting in general owes much to the Romantic pioneers. The last flicker of romantic Orientalism

203 HORACE VERNET *The Arab Tale-Teller* 1833

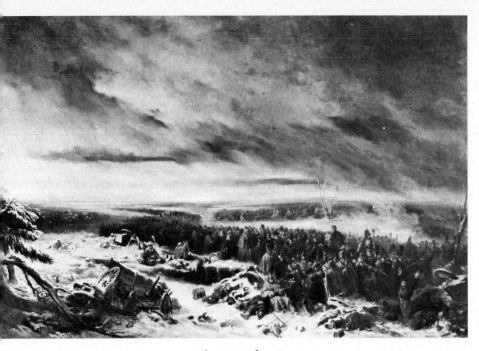

204 NICOLAS-TOUSSAINT CHARLET *The Retreat from Russia* 1836

205 JEAN-LOUIS-ERNEST MEISSONIER *Napoleon I and his Staff* 1868

206 THOMAS COUTURE *Romans of the Decadence* 1847

appears, for instance, in the work of Jean-Léon Gérôme (1824–1904), who also painted 'classical' genre scenes in the manner of Alma-Tadema, and lived to teach Vuillard and Léger. A painting such as the
206 immensely popular *Romans of the Decadence* by Thomas Couture (1815–79) shows the tendency of the Salon painters to borrow wherever they could, in the effort to satisfy public taste. Couture softens Davidian classicism by harking back nostalgically to Greuze; and yet the end-product remains very firmly within the Romantic orbit.

Two painters of a somewhat younger generation than that of Delacroix deserve particular mention. One is Honoré Daumier (1808–79), by profession a caricaturist, whose paintings and drawings were scarcely known until after his death, when they were acquired from his widow by a syndicate of dealers. Working in isolation, and influenced by the techniques of caricature, which call for radical simplification, Daumier produced work of extraordinary boldness, which has often been compared to that of Rembrandt in his last years. It is Daumier's brilliance of observation that allows him to generalize so successfully. Confident in his ability to pin down the essentials, he
208 has no need to search for an expressive subject: chess-players, or people in a railway carriage, are an adequate vehicle for what he has

207 HONORÉ DAUMIER *The Refugees* 1852–55

208 HONORÉ DAUMIER *Chess Players c.* 1863

209 THÉODORE CHASSÉRIAU *Arab Chieftains Challenging one another beneath the Ramparts of a City* 1852

to say. He is a realist not of the thing seen, but of the spirit. The paintings of ordinary life are an externalization of personal feeling just as
207 much as *The Refugees*, which is visionary rather than realistic. *The Refugees* bears comparison, in sheer intensity of expression, with the
197 studies which Géricault made for the *Raft of the Medusa*.

Less isolated than Daumier was the very gifted Théodore Chassériau (1819–56). Chassériau was drawn from a strict adherence to the principles of Ingres into an admiration for Delacroix. He visited Algeria in 1846, and, like Delacroix, thought that he had discovered among the Arabs a living equivalent of the world of antiquity. His
209 pictures with Arab subjects are the only ones which come close to challenging Delacroix upon his own ground: there is, indeed, something feverish and excitable about Chassériau's talent which gives his work a flavour of its own, a flickering, spangled quality of colour which was to attract Gustave Moreau. Towards the end of his brief life Chassériau came into contact not only with the young Moreau, but with Pierre Puvis de Chavannes. He thus forms the link between Romanticism and Symbolism in French painting.

208

The Triumph of Light

After the Romantic movement lost its impetus, French painters (those, at least, who were not content with the formulae of academic art) found themselves faced with two possible paths of exploration. Essentially, both of these involved the development of aspects of art which had interested the Romantics, and which had, indeed, been latent in French art since the middle of the eighteenth century. One path involved the exploration, the ever-closer questioning, of the idea of 'nature'. The real, the natural, the true, were to be defined and redefined by painter after painter, from Corot to Cézanne. The other choice was to see, in the visual arts, a means whereby the artist achieved an externalization of his own feelings, and imposed them upon his surroundings; this path led, via Symbolism and Gauguin, to the Nabis. The realist or naturalist movement has until very recently been seen as the more important of the two. But there is a growing realization that Symbolism was the parent, not only of modern poetry, but of Modernism as such, throughout Europe.

Even when Romanticism was at its height in France, the tradition of naturalism was never entirely broken. This was especially true in landscape, where a natural and informal treatment of the thing seen could also be an expression of the Romantic spirit. A continuous tradition links the naturalistic landscape painters of the latter part of the eighteenth century, such as Simon Mathurin Lantara (1729–88) and Lazare Bruandet (1755–1803) with those of the next century; and the painter who bridges the gap is Georges Michel (1763–1843).

Michel goes much further than his predecessors towards informality: he rejects the 'composed' landscape of the eighteenth century in favour of something which comes much closer to being a direct transcription from nature. The way in which he saw his chosen subject-matter, the landscape surrounding Paris, was undoubtedly influenced by what he found in the Dutch landscapes which he dealt in and restored for sale.

Of the landscape painters who were active during the first half of the century, the closest to the Romantics I have already discussed was

211

210 CAMILLE COROT *Ponte d'Augusto at Narni* 1827

211 GEORGES MICHEL *The Plain of St Denis*

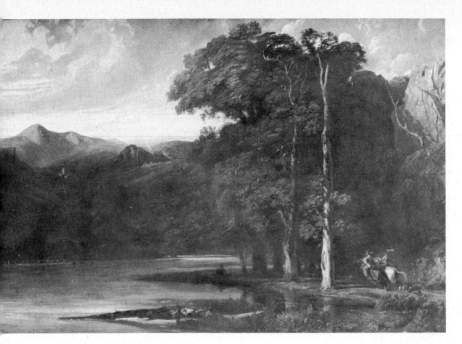

212 PAUL HUET *The Lake* 1840

Paul Huet (1803–69), who was a friend of both Delacroix and Bonington. His landscapes have a dramatic character which led the *212* poet Théophile Gautier to label them 'Shakespearean'.

Significantly, drama of this kind is not the characteristic of the other important landscape painters of the period. The most important of these, though his contemporaries were slow to realize it, was Jean-Baptiste-Camille Corot (1796–1875). It was only the fact that Corot's parents were fairly well off that enabled him to be a painter at all, and even then it was some time before he could overcome the opposition of his family. Once he had done so, he was able to embark on a long, tranquil, and in the end prosperous career.

The striking characteristic of Corot's early work is its simplicity and directness of approach. This is very nearly as true of the 'history landscapes' which he began to send to the Salon in 1827 as it is of the studies directly after nature which he made in preparation for them. The history landscapes, for example the *Ponte d'Augusto at Narni*, one *210* of the two paintings which marked Corot's début at the Salon, are a

deliberate attempt to continue the tradition of Claude and Dughet; the studies from nature, some of the most beautiful of which were made during Corot's first visit to Italy in 1825–28, show a classical concern with form, the forms themselves being articulated by means of carefully graded tonal values.

213

Early in the 1830s, he felt the influence from Dutch seventeenth-century artists, notably Jacob van Ruisdael, which was affecting other French landscapists at the time; later still, he veered towards a more idealized conception of landscape. He made a renewed study of Claude, and eventually began to produce the paintings which he entitled *Souvenirs*: nostalgic distillations of his experience, not only of the landscapes he had spent his life in observing, but of the opera and ballet performances which he loved. In 1856, for example, he wrote in one of his notebooks; 'Beauty in art consists in a truthfulness in the impression we have received from an aspect of nature. . . . The real is one part of art; the sentiment completes it.'

214

As sentiment gained the upper hand in Corot's work, the public began to flock to him. The crepuscular effects to be found in his late work appealed to the neo-Rococo taste which was prevalent in the reign of Napoleon III. But it is a mistake to try and sum up Corot too

213 CAMILLE COROT *S. Trinità dei Monti from the Villa Medici c.* 1826–28

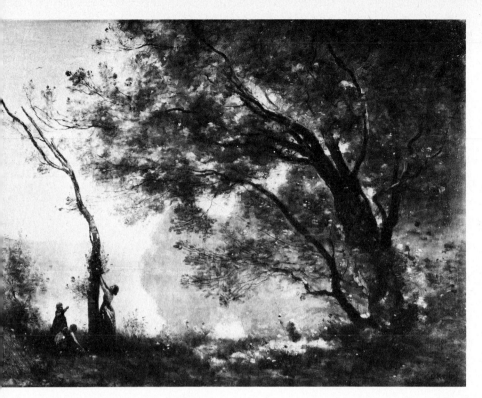

214 CAMILLE COROT *Souvenir de Mortefontaine* 1864

neatly; he was a paradoxical artist, paradoxical in the admirers he attracted (Monet was an enthusiast for his late work), equally paradoxical because he never quite abandoned one concept when moving on to another. The painter of the misty *Souvenirs* was at the same time producing monumental figure studies, such as *The Albanian Girl*, 216 which dates from 1872. The comparisons which spring to mind when we look at these studies of women – Delacroix and Manet – are the measure of Corot's gift.

A whole school of landscape painters shared Corot's attitudes to nature, without having his innate classicism of temperament. The tradition of Claude, Poussin and Dughet meant less to them than did the Dutch landscape painting of the seventeenth century. Their landscapes are on the human scale, and filled with the breath of the human spirit. They are, at the same time, exercises in close observa-

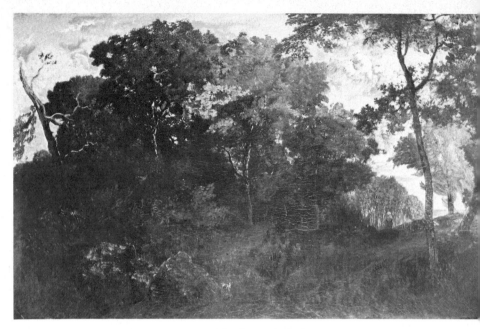

215 THÉODORE ROUSSEAU *The Forest of Clairbois*

tion: the invention of oil-paint in tubes enabled painters to work
directly from the motif, instead of making drawings which were later
worked up in the studio. Most of these painters were afterwards to be
grouped together as the Barbizon school.

The leading spirit at Barbizon, a forest village close to Paris, was
Théodore-Pierre-Etienne Rousseau (1812–67), who settled there in
1836. Rousseau was typical of his colleagues both in the detailed
analysis which he made of natural forms, and of effects of light and
atmosphere, and in his dramatic treatment of them. There is a similar
feeling for drama in the work of Charles-François Daubigny (1817–
78) and of Jules Dupré (1812–89), whose work sometimes recalls that
of Huet. A more tranquil naturalism appears in the painting of Henri
Harpignies (1819–1916).

The most significant painter of the Barbizon school was, however,
not primarily a landscapist. Jean-François Millet (1814–75) had
already established a manner of his own before he settled at Barbizon
in 1849. *The Sower*, later to be his most celebrated picture, was

215

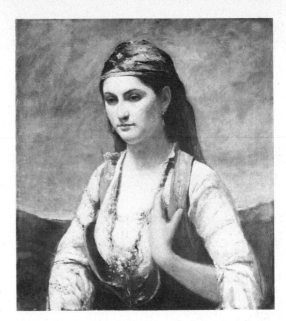

216 CAMILLE COROT
The Albanian Girl 1872

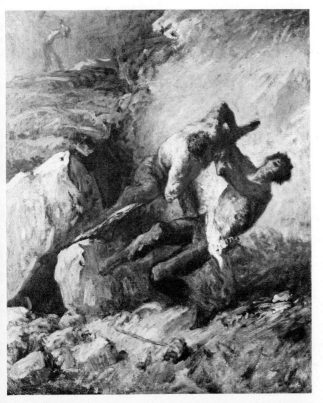

217 JEAN-FRANÇOIS MILLET
Quarrymen 1847–49

exhibited at the Salon of 1848, where Gautier saw and praised it. Millet's work marks the transition from Romanticism to the realism of mid-century. His subject is peasant life, which he sees as a matter of heroic toil and struggle: good reason why his work was later to attract the enthusiastic attention of Van Gogh. Neglected during his own lifetime, Millet achieved immense fame and popularity immediately after his death. The dimension of spirituality in his work was favourably contrasted with the lack of it to be found in the work of the Impressionists. Millet, perhaps even more than his fellow realist Gustave Courbet, lies at the end of a tradition: he takes the subject-matter of the Le Nains and infuses it with a Romantic afflatus, and at the same time he is a moralist, like Greuze. If some of his pictures disappoint, it is because, like those of Greuze, they preach too openly; what should be implicit is made explicit.

Gustave Courbet (1819–77) seldom makes this mistake, for all his loudly professed Socialism, for which he was driven into exile after the Commune (the specific charge was that he had been responsible for the destruction of the column in the Place Vendôme). Courbet was the son of a well-to-do farmer, and he came from the traditionally independent Franche-Comté. As an artist he owed his formation less to the masters under whom he studied than to what he found in the Louvre: he particularly esteemed Rembrandt and the Spanish masters who were also to have a decisive impact upon Manet.

218 GUSTAVE COURBET *The Funeral at Ornans* 1849

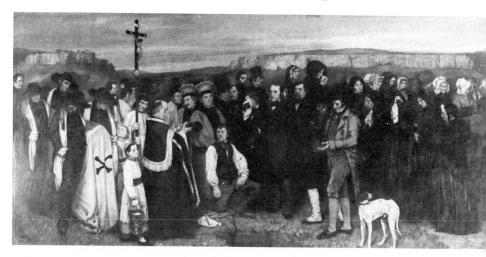

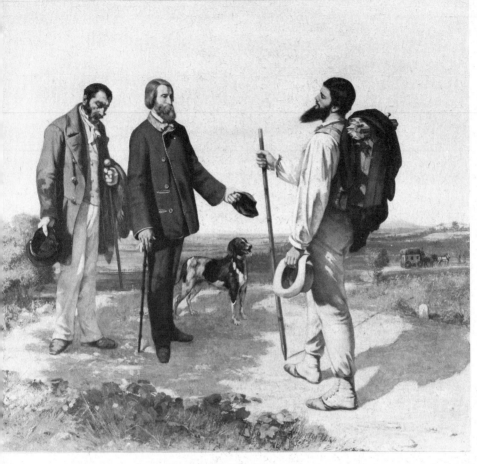

219 GUSTAVE COURBET *Good Morning, Monsieur Courbet* 1854

Courbet's first success was scored at the exceptional liberal Salon of 1849 (it was liberal because it came close on the heels of the Revolution of 1848). He was awarded a medal, which placed him *hors concours* for future exhibitions. In view of the hostility which he was later to evoke, this was a real piece of good fortune; his work might be abused, but no jury could prevent him from exhibiting it. Public and critics alike were outraged by *The Funeral at Ornans*, the large picture which Courbet exhibited in the Salon of the following year. Courbet was painting what he knew: Ornans was where he came from, and he

218

217

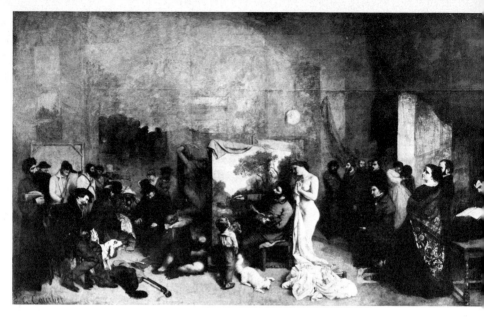

220 GUSTAVE COURBET *The Studio* 1855

chose to paint it without a hint of idealization. 'Never', cried the art
critic of the *Journal des Débats*, 'has the cult of ugliness been practised
more frankly.'

 Courbet was a naïvely self-centred man: many of his works, such
as the delightful *Good Morning, Monsieur Courbet* of 1854, are an
219 expression of his sense of the identity between the painter and his
works. He enjoyed his position as a *chef d'école*, even if he found him-
self frequently exposed to attack. In 1855, he painted a huge canvas
220 which was intended as a kind of manifesto: *The Studio*, which he sub-
titled 'a real allegory'. Here we see Courbet himself seated at his easel,
with a nude model standing beside him. To the left are the plebeian
models he used in his compositions; and to the right are various
friends and supporters, among them Baudelaire and the Socialist
writer Proudhon. When *The Studio* was rejected by the jury of the
Exposition Universelle of 1855 (on this occasion Courbert's Salon
privileges as a medal-winner did not apply), the artist decided to hold
a separate showing of his works. He put forty of his paintings on view,
including *The Funeral* and of course *The Studio*, with the word

218

'Realism' in bold letters at the door. He also issued a manifesto, in which he said:

'I have studied, without bias or prejudice, the art of the ancients and the art of the moderns. I have attempted neither to imitate the one nor to copy the other; nor have I striven for the idle goal of art for art's sake. No! I have simply tried, by searching the records of traditional knowledge, to arrive at a reasoned and independent consciousness of my own individuality.

'To know in order to do, such was my desire. To translate the manners, the ideas, the outward appearance of my age as I perceived them: in a word, to create living art; such is my aim.'

Courbet thus staked his claim to be regarded as the successor of the ageing Ingres and Delacroix. From 1855 until 1870, he was probably the most discussed artist in France. His appetite for reality was equalled by his appetite for work: his best paintings seem to be part of a gigantic effort to devour every experience available to the painter.

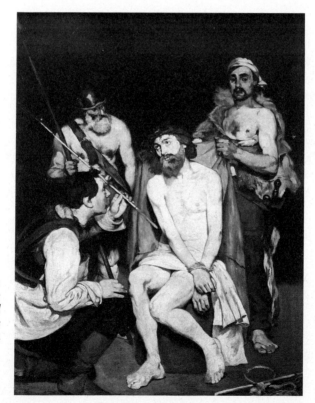

221
ÉDOUARD MANET
Jesus Insulted
by the Soldiers
c. 1864

Yet, as Edouard Manet (1832–83) was to demonstrate, an artist could be a realist and yet practise a very different kind of art from that of Courbet. Nevertheless, these two very different artists had something in common: Manet, like Courbet, was deeply impressed by Spanish painting, which became available to him, as it did to Courbet, through the exhibition of the paintings of the Spanish school confiscated from the Orléans Collection after the fall of Louis-Philippe's Orléanist monarchy in 1848. Manet came so completely under the influence of Spanish art that some of his early work, such as the *Jesus Insulted by the Soldiers*, come very close to pastiche. Other, more personal works – *Lola de Valence, Victorine in Espada Costume, The Balcony* – play original variations upon themes which Manet discovered in the painting of Velázquez and Goya.

221

Manet's parents were upper-middle-class Parisians, rich enough to make their son an allowance once he had overcome their objections to his choice of career. In many respects, Manet remained true to his

222 ÉDOUARD MANET *Le Déjeuner sur l'herbe* 1863

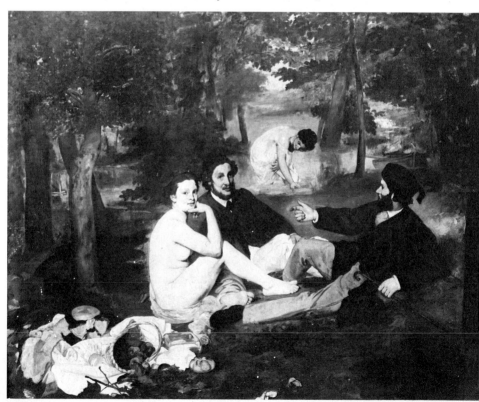

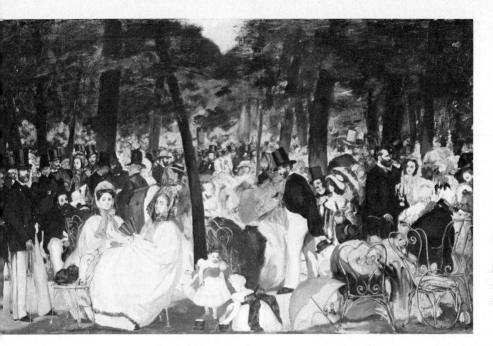

223 ÉDOUARD MANET *Music at the Tuileries* 1862

origins: he relished the Parisian scene and the amusements offered by
the Second Empire; unlike Courbet, he did not feel comfortable about
the admiration which eventually came his way from younger artists
because he did not whole-heartedly accept their view of him as a
pioneer and a rebel.

At the same time, he remained an experimentalist almost in spite of
himself, and was frequently attacked by contemporary critics. His
technique was novel; avoiding half-tones, he flooded his pictures with
light and used strong, dark outlines. But it was not merely this which
aroused the opposition; rather, it was the immorality which the critics
thought they discovered in his work. A well-known example is
Le Déjeuner sur l'herbe, which became the subject of an especially *222*
violent outcry. The picture, as art historians have been at pains to
point out, is merely a nineteenth-century version of Giorgione's
Concert champêtre, which had also inspired Watteau. The three figures
in the principal group are taken almost directly from a well-known
sixteenth-century engraving by Marcantonio Raimondi. Despite this,

the critics and even the public were horrified by the combination of clothed and nude figures, one good reason being the fact that the clothed figures were wearing contemporary dress, which suggested an equally contemporary context.

Before we dismiss this opposition as stupid and nonsensical, it is as well to remember the context in which the picture was shown. Ever since Chardin had complained to Diderot about the lack of a 'moral climate' for painting, French artists had tried, in their various ways, to create one. This is true of Greuze and David; it is also true of Courbet. Manet's work is a demonstration of the fact that he thought that moral notions of this sort were extraneous to the painter's task, which was essentially to paint: to find new ways of relating the process of putting paint upon canvas to the world of appearances. Manet omits the moral dimension in all his most beautiful and characteristic paint- *223, 224* ings, such as *Music at the Tuileries* and *A Bar at the Folies-Bergère*. Life itself was henceforth to be the painter's guide, not some ideal notion

224 ÉDOUARD MANET *A Bar at the Folies-Bergère* 1882

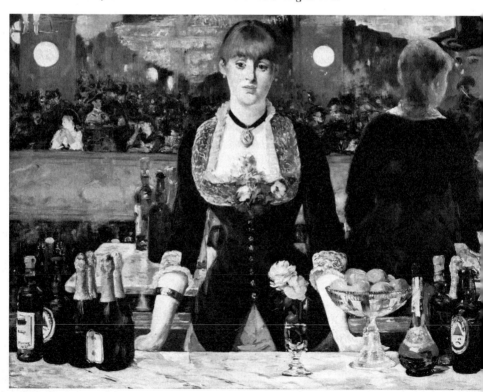

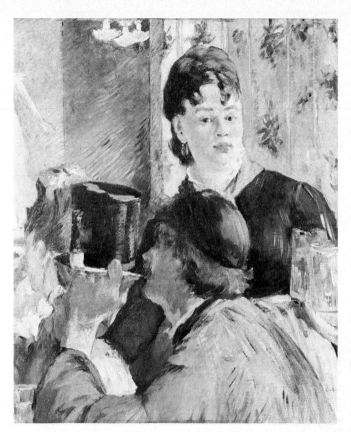

225 ÉDOUARD MANET
La Serveuse de bocks

of life, but simply that which presented itself to his eye. Painting was 225
to be practised for its own sake, and enjoyed on its own terms. It was
a considerable revolution; it is small wonder that the contemporary
public had difficulty in accepting it.

The painter upon whom Manet's work had the most decisive
impact was Claude Monet (1840–1926). It is not too much to say that
Monet forced Manet into the position of being a *chef d'école*. During
his long life, Monet saw the difficult beginnings of Impressionism, and
then its triumph. It was in his work that the implications of the
movement were worked out to their fullest extent, and his late
compositions are as extreme as anything in the whole history of
French painting. Son of a grocer at Le Havre, Monet made his first

contact with the professional art world when he met Eugène Boudin
226 (1824–98), whose little beach scenes anticipate Impressionist clarity
of colour without adopting Impressionist techniques. In 1862 Monet's
parents (who, like Manet's, had opposed his desire to become a
painter) sent him to study in the studio of the Salon painter Charles
Gleyre (1806–76). It was in Gleyre's studio that he met the artists
who were to form the core of the Impressionist movement: Pierre-
Auguste Renoir (1841–1919), Alfred Sisley (1840–99), and Frédéric
Bazille (1841–70).

Monet's god was light, and the thing which interested him most
was the movement of light. He therefore, by gradual stages, abandoned
the attempt to represent the forms which he observed, but confined
227 himself to trying to pin down the way the light changed as it passed
over the forms which happened to be in its path. In this obsession he
had been anticipated by the greatest of the English Romantic painters,
Turner, whose work he discovered when he was temporarily driven
from his home at Argenteuil-sur-Seine by the Franco-Prussian War,
and went to London. But Monet's attitude to light was basically very
different from Turner's because his object was not to arouse emotion,
but to explore matters scientifically. Colour, for Monet, is something

226 EUGÈNE BOUDIN *Empress Eugénie on the Beach at Trouville* 1863

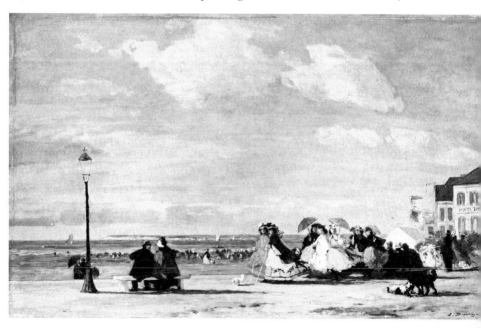

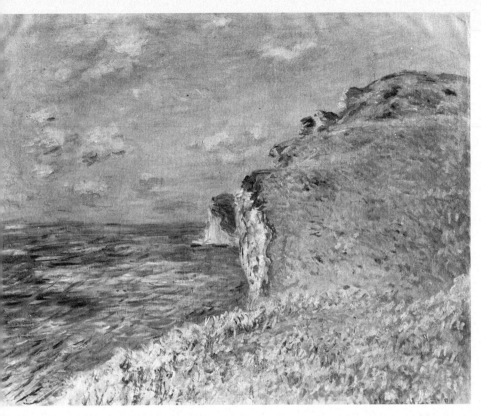

227 CLAUDE MONET *The Cliff at Fécamp* 1881

which can only be perceived in terms of light, and the pure colours which he puts upon the canvas are intended to blend together in the eye to create what is bright and what is shadowy.

The first Impressionist Exhibition of 1874, at which thirty artists exhibited, including Pissarro, Sisley, Renoir, Degas and Monet himself, was the first attempt at a public statement of new attitudes in painting. The label coined for the group was not invented by the artists themselves, but was accepted by them: it came from a picture by Monet entitled *Impression: Sun Rising*. Subsequent Impressionist exhibitions were held in 1876, 1877, 1879, 1881, 1882 and 1886, and varying numbers of artists took part. Monet, however, was the one who remained the truest to the central doctrines of Impressionism.

C. Pissarro. 1902

228 CAMILLE PISSARRO
The Louvre in the Snow
1902

229 AUGUSTE RENOIR *On the Terrace* 1881

Eventually he began to concentrate on producing long series of
paintings which showed the same motif under different conditions
of light and weather: a group of haystacks in a field, the façade of
230 Rouen Cathedral, the water-lilies in the beautiful garden which
Monet created for himself at Giverny. Many of the early pictures were
painted entirely in the open air: Monet thus continued a practice
which had been begun by Corot and the Barbizon painters.

228

230 CLAUDE MONET *Rouen Cathedral: Morning Sun* 1894

The huge and continuing popularity of the Impressionists with twentieth-century collectors and gallery-goers makes it perhaps difficult to accept the fact that some of them, although major painters in sale-room terms, occupy a relatively minor position in the story of French art. One such was the half-English Alfred Sisley; another, somewhat more considerable, was Camille Pissarro (1830–1903), the kindly 'father' of the group, who painted some beautiful pictures and many dull ones.

Undoubtedly in the first rank were Renoir and Edgar Degas (1834–1917), neither of whom remained faithful to Impressionism in its strictest interpretation. Renoir is a painter who sums up in his own development many of the most important tendencies of the nineteenth century: having begun as an Impressionist, he then felt the attraction of the severe manner of Ingres, and then, returning to colour again, produced work which seems like a revival, in terms that his contemporaries would understand, of the manner of Boucher and Fragonard. Like Boucher, Renoir developed an efficient formula for painting the female nude, and like Boucher's his hedonism can seem cloying. In fact, of all the important Impressionists, Renoir now seems to me the most uneven. He rebelled against the heavy, lifeless side of nineteenth-century taste, as represented by the academic Salon painting of his time, only to fall victim to the passion for the *dix-huitième* which came in with the Empress Eugénie. There is no denying,

231 EDGAR DEGAS *Young Spartans Exercising* 1860

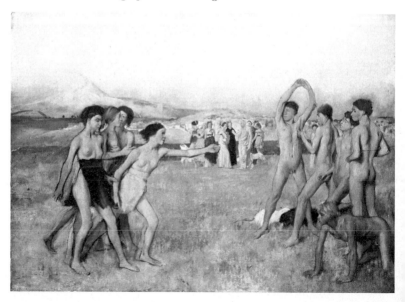

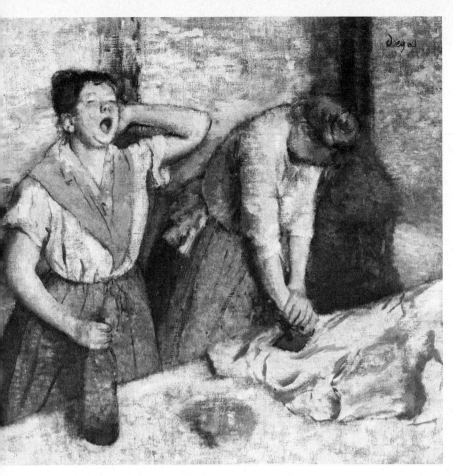

232 EDGAR DEGAS *Women Ironing c. 1884*

however, that Renoir offers a very beautiful vision of nineteenth- *229*
century life, a delicate compromise between realism and idealism, in
tenderer and more opulent versions of the subjects which already *234*
appear in some of Manet's paintings.

Degas was very different in background and temperament. Where
Renoir's origins were humble, Degas was the son of a banker. He
began as a disciple of Ingres, and it is interesting to see what he makes
of classical doctrine in an early history picture, such as the *Young* *231*
Spartans Exercising, which dates from 1860. Already Degas, while

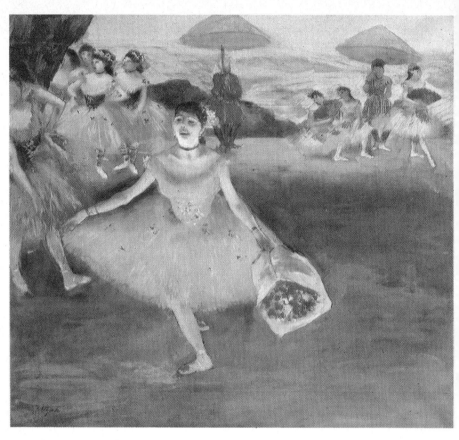

233 EDGAR DEGAS *Dancer with Bouquet, Curtseying* 1878

preserving classical rigour, is rejecting the classical tendency to idealize: these young bodies have the awkwardness of individuality. As he developed, it was not the play of light that interested Degas, but *233* the utterly characteristic gesture. His brilliant figures of dancers are representations of women at work, whether practising or actually on *232* stage: they are working as hard as the washerwomen, or women ironing, whom he also painted. Degas was not content to reject idealism in his figures, he also spurned the classical rules of composition. His apparently 'accidental' distribution of compositional elements owes much to his study of Japanese prints (which also attracted his fellow Impressionists) and photographs.

232

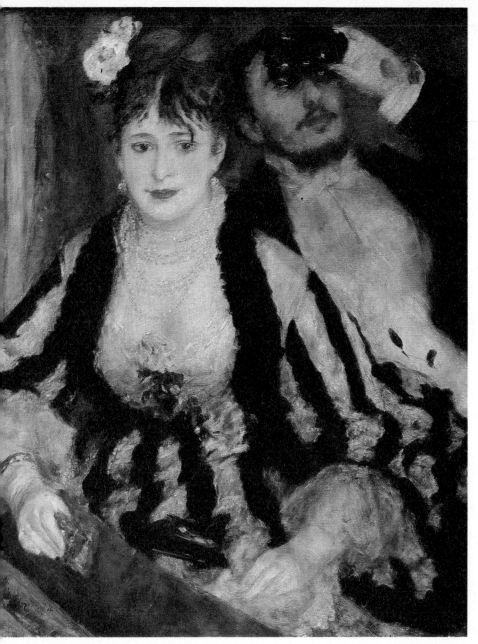

234 AUGUSTE RENOIR *The Box* 1874

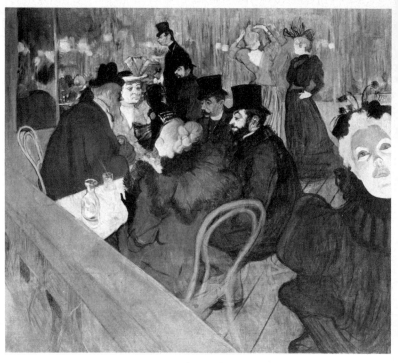

235 HENRI DE TOULOUSE-LAUTREC *At the Moulin Rouge* 1892

One thing which makes Degas important in the late nineteenth century is the fact that he continued to emphasize the importance of drawing. A brilliant draughtsman such as Henri de Toulouse-Lautrec (1864–1901) could find sustenance in Degas's work for this reason.
235 Cafés and theatres attracted them both; they developed the techniques which Manet had already pioneered for recording ordinary life. But in Lautrec we are aware of just that element of comment which Manet had decisively rejected. Where Degas is interested in theatrical performances as a specific kind of work, Lautrec is interested in them as projections of the soul: he has a sardonic eye for character which rivals that of Maurice Quentin de la Tour.

It is, however, not Lautrec but Cézanne and Seurat who mark the
236 rejection of Impressionism. Paul Cézanne (1839–1906) started his career as a follower of Courbet, then came into contact with the Impressionists, and was an exhibitor at the first Impressionist exhibi-

234

tion. He was never, however, a convinced follower of Manet and Monet; he wanted to find the way to a much more classical, architectural form of painting. Manet had been interested in the relationship between what the painter saw and the techniques he adopted to put it on canvas; Cézanne perceived that there was a further problem: how to unify the picture-surface so as to give the work of art an identity as an object at least as strong as the identity of the objects which surrounded it. The external morality which Manet had rejected was to be replaced in Cézanne's work by a morality of painting; art itself was to supply the moral canon.

236 PAUL CÉZANNE *Still-life with Plaster Cupid c. 1895*

This step, a decisive one in the history of art, because it lies at the very roots of Modernism, was also a step backward, a re-examination of problems which had passionately interested David and Chardin. David's anxiety to avoid mannerism is to be found again in Cézanne: the distinguishing mark of the large, late compositions, such as the

237 *Bathers* – which still seem radical today, so many years after they were painted – is that they have no 'handwriting', no distinctive personal touch. Every apparent distortion or departure from the norm reflects the desire, not to express some idea or feeling or observation, but to achieve the highest possible degree of pictorial unity. Cézanne thus returns to the impersonality of Poussin.

Poussin's influence is equally visible in the work of Georges Seurat (1859–91). Seurat tried to reduce Impressionism, which was already much influenced by scientific theories about light, to a fully worked-out scientific system. Where the Impressionists had used colour empirically, Seurat used pure colours, spot by spot, to create colour effects on a purely rational basis. This colour he applied to static, architectural compositions, as firmly classical in their relationships as

237 PAUL CÉZANNE *Bathers c.* 1900–5

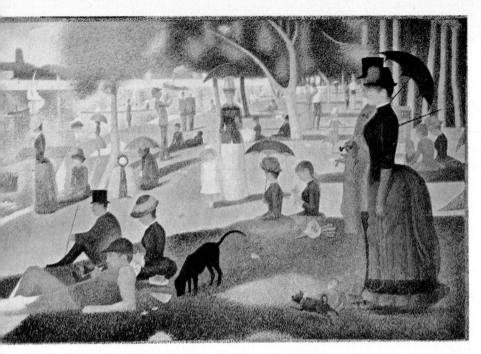

238 GEORGES SEURAT *A Sunday Afternoon at the Island of La Grande Jatte* 1886

Poussin's and David's had been in the past. The difference lies in the content of these compositions. Seurat makes us feel the solemnity and grandeur of ordinary life, not that of some climactic occasion. Parisians enjoying themselves beside the Seine are made the excuse for a composition as deliberate as *The Deluge* or *The Oath of the Horatii*. Thus Seurat, like Cézanne, rejects external morality in favour of a morality of painting.

238

73, 174

The great deliberate statements of Cézanne and Seurat bring the nineteenth century to a fitting close. Modern art owes much to both of them, and more essentially to Cézanne, who is the direct ancestor of Cubism. Yet Cubism no longer seems the only ancestor of modern art, and there is good reason for regarding Cézanne and Seurat alike as being essentially the conclusion of something. In their work is summed up the rationalism, the objectivity, the reticence, the professional feeling for the *métier*, which had been the distinguishing marks of French painting throughout its history.

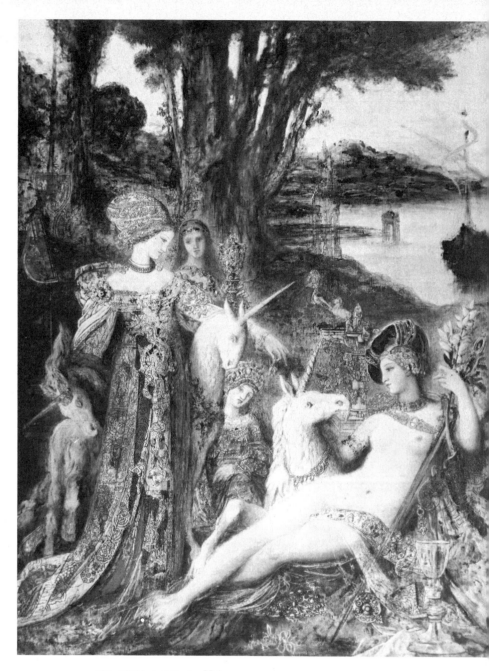

239 GUSTAVE MOREAU *Unicorns*

Symbolists and Modernists

If we are fully to understand the relationship between the French national school of the nineteenth century and the international Modernism which replaced and to some extent displaced it during our own, it is necessary to look backward a little in time, and to trace a path of development which runs through the work of painters who are for the most part a great deal less celebrated than the Impressionists.

While Impressionism and literary Symbolism were on cordial terms (Manet and Mallarmé were friends, and Manet's 'art for art's sake' attitude was certainly something that Symbolists could approve of), there was also in France a tradition of Symbolist painting. Romanticism for a moment retreated before the onslaught of realism, but it was by no means defeated. Gustave Moreau (1826–98) is one of the two important figures who form the link between Delacroix, at the beginning of the century, and Gauguin and the Nabis at the end of it. He was perfectly aware of his own position: 'I am a bridge which some of you will cross,' was what he said to his pupils.

Moreau's intricate compositions are the very antithesis of Impressionism. For its airy world of light and colour, of the life of the streets and the countryside, he substituted the claustrophobic world of dream, but a dream worked out in every detail. Nothing could be more revealing about the difference between his attitudes and those of the Impressionists, than Moreau's instruction to a disciple: 'You must think colour, imagine it. If you do not imagine it, you will never make a beautiful colour.' But Moreau could be yet more specific: 'I believe', he said, 'neither in what I touch nor in what I see. I believe only in what I do not see and solely in what I feel; my brain, my reason seem to me ephemeral and of doubtful reality; my inner feelings alone seem to me eternal and incontestably certain.'

Yet Moreau was still, in the detail of his pictures, the prisoner of nineteenth-century naturalism: his visions are cobbled together from innumerable meticulously observed details.

239

240 VINCENT VAN GOGH *Self-portrait with Bandaged Ear* 1889

241 PIERRE PUVIS
DE CHAVANNES
The Poor Fisherman
1881

Lack of unity is not the reproach which can be brought against the compositions of Pierre Puvis de Chavannes (1824–98). Puvis, though very different in style from Delacroix, was the latter's successor as a painter of vast decorations; as the tide of realism came in, he stood out for the epic and the monumental. But it was a peculiarly blanched and desiccated monumentalism. J.K. Huysmans, describing Puvis's *The Poor Fisherman* in an essay written in 1881, captures its quality exactly: *241* 'This is a twilight painting, a painting like an old fresco, eaten away by the light of the moon, drowned by floods of rain. . . .'

It is not difficult to see why the Symbolists liked Puvis, and some of his characteristics – 'unreal' colour, and a firm division between colour-areas – were to be the commonplaces of Symbolist painting.

A more conscious and genuine Symbolist than either of these two was Odilon Redon (1840–1914); but Redon first made his name, and fascinated the Symbolist writers, with his graphic work. His visionary and allegorical work in colour (some of it in oils, and some of it in his favourite medium of pastel) belongs very largely to the end of his life. His position in a history of French painting is a great deal more marginal than that of Moreau.

The artist who saw to it that Symbolism was to play a genuine role
in the history of French painting was undoubtedly Paul Gauguin
(1848–1903). Gauguin started his career in the Impressionist group. In
his early days, as a prosperous businessman interested in painting, it
was their works he collected. Later, he exhibited in the Impressionist
exhibitions of 1880 and 1881; and at the last Impressionist show, in
1886, he contributed no fewer than nineteen pictures. But he was not
yet a fully personal artist. The decisive events for Gauguin were his
discovery of Cézanne and his visits to Pont-Aven in Brittany.

His earliest truly characteristic pictures were painted in Brittany in
1888. One of the most significant of the works painted in this year is
the *Jacob Wrestling with the Angel*, where the artist tries to imagine the
Biblical episode as it might appear to the Breton peasant women after
they had heard it described to them in a sermon. The structure of the
picture shows Gauguin's attempt to achieve a pictorial unity like that
of Cézanne, and also the lessons he had learned from a recent study of
stained glass. But the colour is expressive rather than structural; it is
in fact the colour of the women's emotions.

242

243

242 PAUL GAUGUIN *Nevermore* 1889

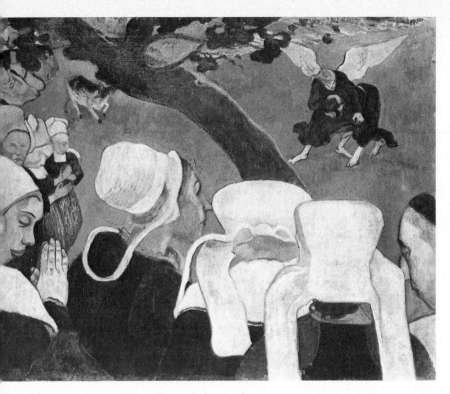

243 PAUL GAUGUIN *Jacob Wrestling with the Angel* 1888

Before turning to Gauguin's followers, it is necessary to take a look at the man who was a colleague rather than a disciple: the Dutch-born painter Vincent van Gogh (1853–90). Van Gogh's life-story, like Gauguin's, has been told many times, from his beginnings with the picture-dealing firm of Goupil at The Hague to his suicide at Auvers-sur-Oise. The Romantic painters meant much to Van Gogh, and so did the Romantic-realist Millet, but it was his personal contact with Gauguin, Lautrec and Seurat which helped him to form his style. His originality was the product, not so much of profound cogitation about the nature of painting as of an extreme violence of temperament which pushed him towards the use of arbitary and symbolic colour. *240* In the very numerous late works which Van Gogh painted at Arles and Auvers we see that total commitment to the dictates of the self which has come to be seen as one of the criteria of modernism in art.

On the occasion of the Exposition Universelle of 1889, Gauguin organized an exhibition of his own at the Café Volpini in Paris. The exhibitors were the painters who had worked with him in Brittany. Symbolist critics immediately realized the kinship between Gauguin's newly proclaimed 'Synthesism' and literary Symbolism. A deeper response to Gauguin's work was to follow; his followers were to perceive in him a successful attempt to bring together the two things which seemed to them most vital in contemporary art – the pictorial absolutism of Cézanne, and the subjectivity of Moreau and Redon.

Gauguin's followers called themselves the Nabis (after the Hebrew word for prophet), and their involvement with the Symbolist movement was far more complete than that of the man who originally inspired them. The founder of the Nabis was Paul Sérusier (1864–1927). Like many of his associates he was educated at the Lycée Condorcet, a school in Paris long famous for producing a sophisticated élite; his schoolfellows included the actor-producer Lugné-Poe, whose theatre was later to provide a home for the Symbolist drama, and the future editor of the important Symbolist publication *La Revue Blanche*, Thadée Natanson.

Sérusier came into contact with Gauguin at Pont-Aven in 1888, which was, as we have seen, a crucial year in the development of Gauguin's art. Almost instantly converted to Gauguin's way of thinking, Sérusier began to proselytize his friends. A man of systematic mind, he tried to codify what he felt he had learned. Sérusier believed that art must return to its sources in the remote past: to the Egyptians, the Greeks, the ancient Chinese, and the sculptors of the Gothic cathedrals. At the same time, he proclaimed doctrines which were essentially an extension of literary Symbolism, then very much in the public view (the poet Jean Moréas had published his Symbolist Manifesto in 1886). 'Nature', Sérusier declared, 'merely supplies us with inert materials. A human mind alone can arrange them in such a way that, through them, it can express its feelings by means of *correspondences*. That is how we arrive at style, the ultimate aim of all art.' The notion of 'correspondences', profound affinities between sense stimuli of different kinds, had made an early appearance in Symbolist literature with Rimbaud's sonnet about the links between vowels and colours.

But Sérusier is more important as a prophet and teacher than as an artist. There is something stiff and unrealized about his work, just as

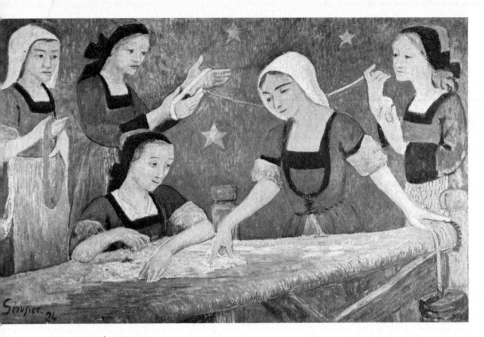

244 PAUL SÉRUSIER *The Tapestry*

there is about that of some of his closest associates, such as Maurice Denis (1870–1943).

The same reproach cannot be levelled against the two greatest members of the movement: Edouard Vuillard (1868–1940), and Pierre Bonnard (1867–1947). Vuillard and Bonnard have subsequently been linked together as 'Intimists', and their connection with the Nabis almost forgotten. Yet the Symbolist milieu is the one from which they sprang, and it is the Symbolist experience which divides them from the Impressionists, who painted subjects which were superficially similiar. The desire to unify the surface, so fundamental in Cézanne, makes its appearance in the early pictures of Bonnard and Vuillard in the use of a compressed and flattened picture-space. We find a similar compression in Degas, but these two painters of a much younger generation carry matters much further, to the point where we begin to see that the mark of the brush is as important as the representation which each successive mark builds up. Vuillard, in particular,

246
245

245

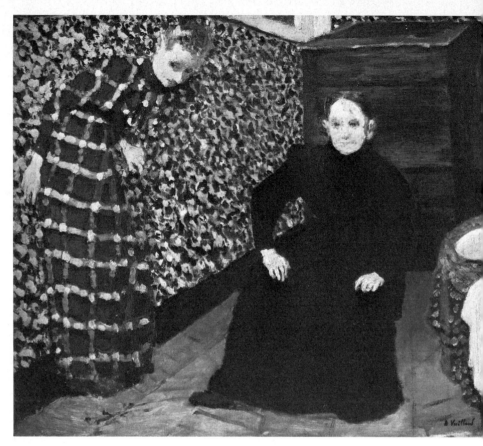

245 ÉDOUARD VUILLARD *The Artist's Mother and Sister c.* 1893

carries two-dimensional patterning to extreme lengths, and thus provides an equivalent for the word mosaic in Symbolist poetry.

The central idea of Symbolism, that it was possible to use the object as a nexus for ideas and feelings which could then be decoded from the clues provided in the work of art, was also to be a fundamental one in the history of the Modernism which succeeded Symbolism. It was Symbolism that taught young painters such as Henri Matisse (1869– 1954) and Pablo Picasso (b. 1881) how to reinterpret the legacy of Gauguin and Cézanne; although eventually they reacted against Symbolist idealism.

248
249

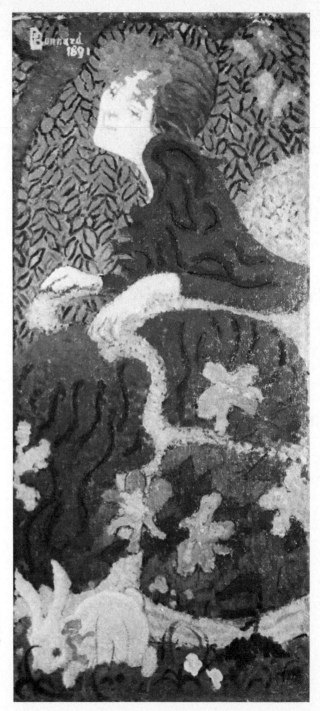

246
PIERRE BONNARD
Woman with a Rabbit
1891

The year 1905 saw the first great innovatory event of a period which was to be marked by so many innovations, and which was to see the transformation of French painting, as it had hitherto been understood, into the international manifestation now usually referred to as the Ecole de Paris. This event was the appearance of a new group of painters, quickly dubbed the Fauves or 'wild beasts', at the Salon d'Automne which had itself been founded only two years earlier. The acknowledged leader of the group was Matisse, and his colleagues included Albert Marquet (1875–1947), Georges Rouault (1871–1958), André Derain (1880–1954), Maurice de Vlaminck (1876–1958), Othon Friesz (1879–1949) and Kees van Dongen (b. 1877). The Fauves were interested in the power of colour, and, in particular, in its *constructive* power from the compositional point of view. They were, in adopting this point of view, anxious to stress their own links with what had preceded them.

In fact, Matisse and his colleagues saw themselves as restoring to painting qualities which were present in Gauguin, but which Gauguin's immediate followers had misunderstood or forgotten. Matisse was the pupil of Gustave Moreau, so he had every reason to know where he stood. Essentially, he agreed with Sérusier; 'Composition', he said, 'is

247
ANDRÉ DERAIN
Woman in a Chemise
1906

248 HENRI MATISSE
The Moroccan 1912

249 PABLO PICASSO
Woman Ironing 1904

the art of arranging in a decorative manner the various elements at the painter's disposal for the expression of his feelings.'

The revolutionary element in Fauvist theory came in the candid acknowledgment that nineteenth-century realism was dead. As Matisse's associate Derain remarked: 'The great thing about our experiment was that it freed painting from all imitative or conventional contexts.'

247

With that liberation came internationalization: Paris became the centre of an experiment whose effects were world wide. Young artists flocked to the city to participate in what was going on there, just as French artists had traditionally flocked to Rome to study the relics of antiquity. The arrival of Picasso in Paris, in the year 1900, was a first sign. He was to be followed by many other artists: Spaniards like himself; Germans and Italians; Futurists, Dadaists and Surrealists. Paris was the magnet which drew them all.

249

249　Picasso's earliest truly individual paintings, those of the Blue Period
250　are still Symbolist in style: they owe much to Redon, for example, as
well as to Degas and to Lautrec. In subject-matter, they are close to the
paintings which Rouault was producing at the same time, though
technically they are much suaver.

But Picasso could not be content to remain in a world of poetic
sadness. He already had an immense capacity for absorbing other
men's styles, and the things which now stirred him were primitive

250 PABLO PICASSO *Mountebanks* 1905

250

251 PABLO PICASSO *Les Demoiselles d'Avignon* 1907

(especially African) art, and the achievement of Cézanne. The Cézanne retrospective of 1900 was followed by an even more important memorial exhibition in 1907. Early in 1907, Picasso began work on a large figurative composition, which was to be a considered statement of his new position. This was the painting which, after many transformations, became *Les Demoiselles d'Avignon*. In the course of 251 working upon this, Picasso absorbed, much more thoroughly than he had been able to do before, Cézanne's method of analysing forms in order to release their true qualities and possibilities for pictorial order. *Les Demoiselles d'Avignon* thus led directly to a new pictorial adventure: Analytical Cubism.

Picasso's colleague in this adventure was a young Frenchman, Georges Braque (1882–1963). He had been introduced to Picasso by the poet Guillaume Apollinaire and by the dealer D.-H. Kahnweiler. In 1907 he visited Picasso's studio and saw the just completed *Demoiselles d'Avignon*; and by the summer of 1908 he was painting landscapes which showed an exaggeration of Cézanne's propensity to reduce everything to geometrical forms. Meanwhile, Picasso was applying much the same principle to still-life. It was inevitable that two painters working upon lines so similar should come together.

253 By 1909 both artists were painting pictures in which objects are dissected into facets. In constructing the picture, these facets are spread out over the surface, and are used to present successive yet simultaneous views of the reality which the painter experienced. At the same time, these facets are carefully related to one another in such a way that the surface itself is completely structured, and has the unity which Cézanne himself had continually striven to achieve.

Gradually, structural preoccupations began to oust descriptive ones, and Cubism entered upon a second phase: synthetic rather than analytical. Reality was now carefully coded into a new language of shapes and colour-harmonies. The facets are reduced to overlapping flat planes.

But the real world was not completely ousted from Cubist art. As 254 early as 1911 Braque had begun introducing letters into his pictures: immediately recognizable symbols which emphasized the deliberate 'unrealism' of the rest of the composition. From this it was but a short step to using scraps of newspaper, imitations of woodgrain, pieces of fabric. Cubism led to the invention of the collage, in which reality is re-created, not by means of elaborate illusionism, but through a cunning combination of symbol and sample, in which the oblique presentation of some particular object is played off against a passage of shocking literalism.

The whole tendency of Synthetic Cubism was, however, inexorably towards abstraction. The painting becomes a series of juxtaposed or overlapping areas. One plane may be transparent, in order to allow us to see another which lies behind it. So far as Picasso himself was concerned, this phase of the Cubist adventure lasted from 1912 until the 256 end of the war. By 1920 he was ready for a new and different approach.

The Cubist adventure undertaken by Picasso and Braque naturally attracted the attention of other young artists; soon a heresy developed,

252 HENRI MATISSE *Luxury* 1907

253 GEORGES BRAQUE
Still-life with Violin
1912

254 GEORGES BRAQUE
Musical Forms
1913

under the name of Orphism. The leading spirit in this rebellion was
Robert Delaunay (1885–1941). Delaunay's Cubism was contaminated
both by Symbolist ideas inherited from Sérusier, and by notions bor-
rowed from the new and noisy Italian movement in the arts, Futurism,
which had launched itself on Paris, Italy and the world (in that order)
with a manifesto published in *Le Figaro* on 20 February 1909. Symbol-
ism encouraged Delaunay not to scrutinize reality, as Picasso and
Braque had begun to do, but to think in terms of some ideal, and to
select aspects of reality which seemed to embody it. Futurism was
especially fascinated by the rhythms of modern life, the representation
of dynamism, simultaneity and speed.

Progressing through a study of three subjects which seemed to suit
his particular preoccupations – first the Eiffel Tower, then a tower
with a Ferris wheel, finally an almost abstract representation of the
movement, colour and light to be seen through an open window – 255
Delaunay arrived, in 1912, at a point where his pictures became en-
tirely abstract, demonstrations of the power of colour to impart move-

ment and rhythm. 'Everyone', said Delaunay, 'has sensitive eyes to see that there are colours, that colours produce modulations, monumental forms, depths, vibrations, playful combinations, that colours breathe. . . . Goodbye to Eiffel Towers, views of streets, the outside world . . . we no longer want apples in a fruit bowl, we want the heartbeat of man himself.'

Among the numerous foreign painters of the same generation working in Paris before and during the First World War there were some, such as Gino Severini (b. 1883) whose allegiance remained basically with already established national modes – in Severini's case, Italian Futurism. Others became more identifiably part of the French environment.

256 PABLO PICASSO *The Three Musicians* 1921

255 ROBERT DELAUNAY *Window on the City, No. 4* 1910–11

Amedeo Modigliani (1884–1920) and Juan Gris (1887–1927) moved to Paris in the same year, 1906, but their careers had very different patterns. Both owed something to Picasso. The Italian Jew Modigliani seems to have found his roots in the paintings of Picasso's Blue and Rose periods, to which he added influences drawn from Rodin and Matisse. Cézanne, too, had much to teach him, especially about the degree to which distortion or deformation of reality could actually lead the artist towards a deeper understanding of what was 'real' for himself. Modigliani is perhaps best thought of as another belated *258* Symbolist, who used the female nude in particular as a way of exploring his conquest of the ideal.

257 Gris is much more intimately connected with the development of French painting. Contact with Picasso led him towards Cubism; he had fully mastered the Cubist method by 1913. By 1915 he had abandoned Analytical for Synthetic Cubism, and it was Gris, indeed,

258

who pressed this aspect of the style to its furthest extreme, confessing candidly that for him the source of the painting was subjective – the imaginative faculty – and that he only moved towards the representation of objects as he proceeded.

Chaïm Soutine (1894–1943) was a friend of Modigliani's, and a much more Jewish artist. His characteristic achievement was to make the apocalyptic central European Expressionist strain part of the heritage of French painting. When we compare Soutine's work to that of the Fauves, even to that of the wildest of them, Maurice de Vlaminck (1876–1958), we see that the thing which he possesses, while they do not, is a sense of the transcendental. Soutine's anguished, emotional canvases sometimes seem like a direct challenge to the intellectuality of the Cubist adventure. The fact that Soutine and the Cubists could form part of the same milieu demonstrated the degree to which the French school had shed any kind of fixed national identity.

259

260 FERNAND LÉGER *The Mechanic* 1920

The School of Paris

The fullest period of internationalism only began after the conclusion of the First World War. Some artists came as exiles, among them Russians such as Marc Chagall (b. 1889). After spending four years in Paris Chagall returned to Russia at the outbreak of war, only to expatriate himself definitively in 1922, arriving again in Paris in the following year. For Chagall and others Paris provided the most sympathetic environment available to them, but on Chagall at least it made little stylistic impact.

The 1920s were a time of feverish activity in Parisian studios, and of very complex cross-currents in the development of painting. Immediately after the war, it seemed as if modern painting had paused to consolidate and draw breath. In 1920, Picasso entered upon his neoclassical phase; Gris, a classicist by temperament, was at the height of his powers; Braque moderated the austerities of Synthetic Cubism to make room for a richer, more painterly style; and the former Fauve André Derain also seemed to be pioneering a return towards a more traditional kind of 'painterly' painting.

One painter very much in tune with the atmosphere of the times was Fernand Léger (1881–1955), who had first made his reputation as a Cubist of a rather less stringent sort than were the creators of the movement. By 1918, he had achieved a more individual style, painting pictures which took literally Cézanne's idea that every natural form is capable of being reduced to a geometrical equivalent. Having served in an engineering unit during the First World War, Léger had become fascinated by technological imagery; and this preoccupation was linked, through his interest in geometry, to the lessons learnt from Cézanne and from the Cubists. At first Léger was included, in his search for hieratic anonymity, to identify the human figure with the machine. Later, he evolved towards a more traditional classicism, *260* seeking inspiration not only in Cézanne but in Poussin.

The paintings which Léger produced during the 1920s are linked to the work of the so-called Purists, such as Amedée Ozenfant (1886– *262*

261 MARCEL DUCHAMP *Nude Descending a Staircase, No. 2* 1912

262 AMÉDÉE OZENFANT *Composition* 1920

1966) and Le Corbusier (Charles-Edouard Jeanneret, 1887–1965).
These were men who tried to develop the clarity, precision and
rationality of Cubism into an all-embracing order, a kind of art com-
pletely congruous with the demands of modern technological civiliza-
tion. Purism resembled the Constructivism which flourished in Russia
during the early years of Soviet rule, in that its attitudes were those of
scientific experiment and investigation, so that the work of art be-
came a mere by-product of the exploration of general aesthetic ideas.
Perhaps for this reason it had a more fruitful impact upon architecture
than it did upon painting; Le Corbusier went on to become one of the
greatest of twentieth-century architects.

Though the classical strain seemed to triumph in French painting
during the decade that followed the war, the most important develop-
ments of the time were in fact profoundly anti-classical. The rise and
decline of the Surrealist movement was to dominate what happened
in French art between 1920 and 1940; and even after the Second
World War, Surrealism continued to make its influence felt.

Surrealism had its roots in Dada, the art movement which first manifested itself during the war in neutral Zürich and in New York, and which was in essence a revolt, not only against the horror and folly of the war itself, but against the massive stupidity of the bourgeois nationalism which had been responsible for its outbreak. Dada aimed to challenge all traditional values, all criteria for judging the worth of a work of art. It tried to shatter the accepted pattern of stylistic change by introducing the concept of anti-art.

The leading theoretician of anti-art was Marcel Duchamp (1887–1967), who had begun his artistic career as a member of the Section d'Or, which was, like Orphism, a somewhat heretical reinterpretation of Cubism. Duchamp's semi-Cubist, semi-Futurist painting *Nude Descending a Staircase* had been the sensation of the Armory Show in New York in 1913. During the war, Duchamp was in New York, together with another of the founders of Dada, the painter Francis Picabia (1878–1953). By this time, Duchamp had already invented the notion of the 'readymade' (the ordinary object selected from the surrounding environment and accepted by the artist as a work of art without further transformation), and was in the process of abandoning any kind of conventional career as a painter, though he continued to work on his large glass picture *The Bride Stripped Bare by Her Bachelors, Even* from 1915 to 1923. Picabia served as the link between New York and Zürich, and became the apostle of Duchamp's ideas.

261

The Parisian avant-garde had become aware, at least as early as 1917, that something important and interesting was going on in Switzerland. Tristan Tzara, one of the leading figures in Zürich Dada, was in touch with the poet-impresario Guillaume Apollinaire. Men who were later to become leading Surrealists, such as André Breton and Louis Aragon, were, by 1918, contributing to Dada publications in Zürich. But it was only when the war ended that the leading Dadaists were able to come to Paris.

In France, Dada made its first impact upon poets rather than artists. Tzara, a Romanian who had adopted French as his language of literary expression, became the star turn at a series of violent manifestations. And soon enough there began to be divisions between the ranks. By 1922, Breton had emerged as the leader of a powerful faction determined to systematize the lessons of Dadaist irrationality. In that year he and his colleagues broke formally with Dada. The first Surrealist Manifesto was issued in 1924.

263 JOAN MIRÓ *Painting on Masonite* 1936

264 NICOLAS DE STAËL *Les Martigues* 1954

What interested Breton especially was the inner realm discovered by Freud – the dark territories of the unconscious mind. The Surrealists aimed to liberate art by making it free of this realm. Aragon, speaking of early experiments with automatic writing (writing without conscious control, a characteristic literary technique of the Surrealists derived from Freud's own experiments with free association), described the creative euphoria which they induced: 'an incomparable freedom, a liberation of the mind, an unprecedented proliferation of images'. Obviously, it could not be long before painters sought to claim for themselves the freedom which the new Surrealist methods had already accorded to the poets.

The earliest work in a fully developed Surrealist vein was probably that of the German painter Max Ernst (b. 1891). Ernst had formed a Dada group in Cologne in 1919 – one of his collaborators there had been the Alsatian sculptor, painter and poet Jean Arp (1887–1966). In 1922 Ernst arrived in Paris and soon joined the Surrealist camp, collaborating with Paul Eluard, the poet, on a cycle entitled *Les Malheurs*

265 MAX ERNST
The Great Forest
1927

266 YVES TANGUY
The Sun in its Casket
1937

des Immortels. Ernst's contribution was a series of collages made from old book-illustrations, cut up and then pieced together in a new and fantastic order. By 1925, Ernst had invented the method of *frottage*, a pictorial equivalent of automatic writing. Tracings and rubbings of 'found' objects and materials – leaves, woodgrain, fabric and so forth – enabled him to develop new images by means of unconscious association, the rubbings being gradually transformed into whatever scene or thing they seemed to suggest as they evolved beneath the artist's hand.

What Ernst concerned himself with was a version – a hallucinatory paraphrase – of observed reality. Occasionally his work, too, can come close to that of Moreau or Redon. His brand of 'Veristic' Surrealism was also practised by other artists, among them Yves Tanguy (1900–55), and Salvador Dalí (b. 1904). 265

Tanguy was originally prompted to take up painting by the impact made upon him by one of the 'metaphysical paintings' of the Italian artist Giorgio de Chirico, in which objects take on an eerie presence.

As a painter, he evolved an inflexible but rather impressive composi-
266 tional formula. In a typical painting by Tanguy we are confronted
with a boundless desert, peopled with tumescent, amorphous shapes.
The spatial experience is preserved, but everything that governs the
articulation of space has been altered.

267 Dalí, on the other hand, specialized in the transformation and
deformation of familiar objects. His meticulous technique was put at
the service of an impulse towards pictorial rape. Dalí gives up all the
gains made by Cézanne; he reverts to traditional methods of represent-
ing space, traditional rules of perspective, but uses these to convince us
of the reality of the world of nightmare which he presents to us.

Some Surrealist painters, on the other hand, were dissatisfied by the
reversion to discarded pictorial conventions that was involved in the
pursuit of hallucinatory imagery in Veristic Surrealism. They began
to apply the freedom of automatic writing more literally to the
canvas in front of them, so that the painting became a series of calli-
graphic signs and arabesques. Among the artists on this wing of
269, 263 pictorial Surrealism were André Masson (b. 1896), Joan Miró

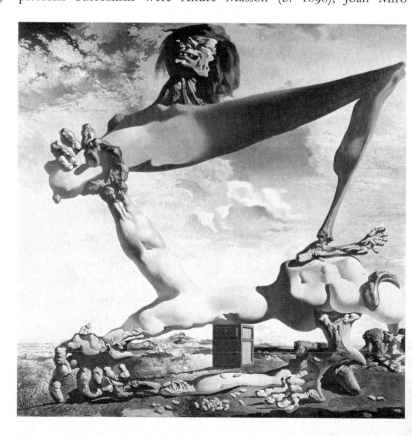

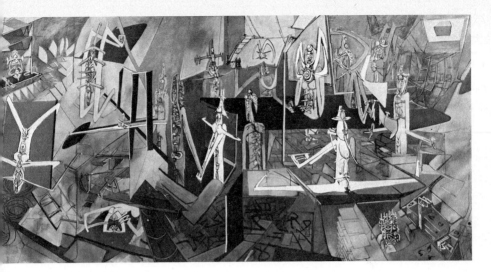

268 MATTA *Being With* 1945-46

(b. 1893), and Matta (Roberto Matta Echaurren, b. 1912). At the fall 268 of France, Masson and Matta, in company with other leading Surrealists, among them both Breton and Ernst, fled to the United States. The calligraphic method took root and flourished mightily among American painters, eventually transforming itself into the Abstract Expressionism of Jackson Pollock and Franz Kline.

Surrealism represents perhaps the most international phase in the whole history of French painting. Neither the International Gothic of the fourteenth century, nor the Mannerism of Fontainebleau, showed itself to be so entirely independent of political frontiers. Ernst was a German, whose art in many respects remained Germanic; Dalí and Miró were Catalans. Matta was born in Chile of French and Spanish parentage.

Despite its internationalism, the Surrealist movement was by no means united. Breton's dictatorial nature saw to it that his followers were continually rent by feuds and schisms. One expulsion followed another. But Surrealism deeply influenced the whole outlook of the avant-garde. Perhaps the most important Surrealist convert was Picasso. Never an orthodox member of the movement, he yet transformed his style under the impact of Surrealist ideas. In the 1930s he discovered, through Surrealism, a way of expressing his reaction to the desolation and violence which he saw descending upon the world, and

269

267 SALVADOR DALÍ *Soft Construction with Boiled Beans* (*A Premonition of Civil War*) 1936

his great masterpiece of this period, *Guernica*, would certainly have taken a very different form if Surrealism had never existed.

The Second World War administered a decisive check to the Ecole de Paris. Established masters, such as Matisse and Picasso, continued to paint under the Occupation, but stringent wartime conditions, and Nazi hostility to 'decadent art', made it difficult for painting and sculpture to maintain their forward impetus. Paris was robbed of many of its most important artists through emigration, and, though attempts were made to carry on much as before, once the war came to an end, it gradually became apparent that world leadership in the visual arts had passed from Paris to New York.

This is not to say that there were no developments of any interest in French painting during the period from 1945 until the present day – or, rather, in the kind of international painting which continued to base itself upon Paris.

The attention of those who were looking for convincing successors to the Surrealists, and continuators of the pre-war tradition of the Ecole de Paris, was at first directed towards a group of 'middle genera-tion' painters. The most prominent of these were Jean Fautrier (b. 1898), Maurice Estève (b. 1904), Edouard Pignon (b. 1905) and Jean Bazaine (b. 1904), all scarcely, if at all, younger than some of the leading Surrealists. In the work of these artists, we see an eclectic recapitula-tion of many tendencies which had already made themselves felt in the painting of the Ecole de Paris. The most original aspect of their

269 ANDRÉ MASSON *The Demon of Incertitude* 1943

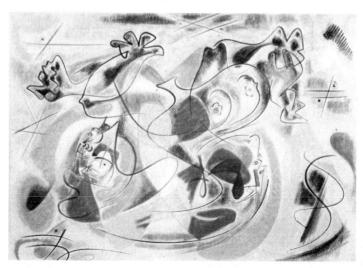

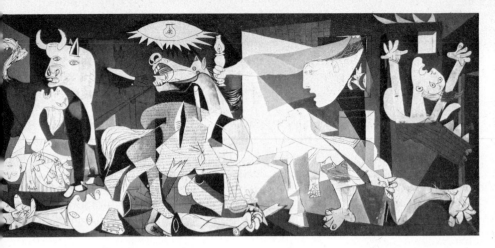

270 PABLO PICASSO *Guernica* 1937

work – and this is especially true of Fautrier – lay in the emphasis which *272*
had begun to be placed upon tactility, and the evocative quality of the
surface. French art was already moving towards its own, less vigorous
version of Abstract Expressionism, a style which was to be christened
art informel, or 'art without form'.

By the mid 1950s this evolution was complete, and artists such as
Pierre Soulages (b. 1919), and Georges Mathieu (b. 1921) were highly
fashionable. Mathieu, though in many respects a flashily trivial artist, *271*
is interesting because he represents the nearest approach in France to

271 GEORGES MATHIEU *The Capetians* 1954

true Abstract Expressionism, and some of his stunts (as when, in 1956, he painted a large canvas on stage at the Théâtre Sarah Bernhardt, in the presence of a large audience) recall the antics of the Dadaists.

An important contribution to the development of this calligraphic style was made by two German artists who had expatriated themselves to France. One was Wols (Wolfgang Schulze, 1913–51), who had been an associate of the Surrealist group before the war. The other was
273 Hans Hartung (b. 1904), whose vigorous brushwork, in bundled sheaves of lines, has an undoubted, if somewhat monotonous, energy.

Not all French, or French-domiciled, artists were content to follow the path marked out for them by *art informel*. There were various attempts to re-establish the prestige of figurative painting. The most convincing of these attempts was probably to be found in the work of Balthus (Balthazar Klossowski de Rola, b. 1908). Balthus is not merely a figurative painter; he is a realist. Cézanne has influenced him, but so have Courbet and Piero della Francesca. He combines these influences
274 in meticulously planned works, often with a strong erotic overtone.

Another distinguished figurative painter, though in a minor key, was the sculptor Alberto Giacometti (1901–66), whose spare portraits and still-lifes seem to convey the bleak mood of the Existentialists,

272 JEAN FAUTRIER
Hostage 1945

273 HANS HARTUNG
T. 1951–52 1951

some of the most prominent of whom were his friends. Giacometti was, however, never guilty of the vulgarity of Bernard Buffet (b. 1928), who achieved an immense success by popularizing Existentialist *misérabilisme*.

A significant rejection of abstract art in favour of figurative painting was made by the Franco-Russian painter Nicolas de Staël (1914–55). De Staël became dissatisfied with abstraction, but he did not abandon it; he tried, instead, to reconcile its demands with the world he saw about him. The result was a series of paintings (the most characteristic are landscapes and still-lifes) which can be read either as representations of reality, or as abstract designs in sonorous colours. These works achieved immense success in the painter's lifetime, and just after his death, because they were regarded as the latest flowering of the French tradition of *belle peinture*, so successfully pursued in their various ways by artists such as Matisse and Braque. At some years' distance they now seem less the products of genius than of refined sensibility, tact and taste. They lack the creative force of Whistler's *Nocturnes*, but belong to very much the same artistic genre. *264*

Utterly opposed to ideas of tact and taste, and, perhaps because of this, the most important artist of the post-war period in France, was Jean Dubuffet (b. 1901). Dubuffet achieved prominence comparatively *275*

late. His first one-man show was held in 1945, when he was already in his forties. One reason for the delay was probably that both his attitudes and his art are extremely complex, and belong firmly within the tradition of Surrealism. Interested in whatever escapes the formalities of art history – child art, graffiti, the art of madmen, the accidental markings to be found on any surface – and prepared to use any material – lumps of coal, twigs, or butterfly wings – Dubuffet is a master of indirection.

'I have always had recourse', he says, 'to one never varying method. It consists in making the delineation of the objects represented heavily dependent on a system of necessities which itself looks strange. These necessities are sometimes due to the inappropriate and awkward character of the material used, sometimes to the inappropriate manipulation of the tools, sometimes to some strange obsessive notion (frequently changed for another). In a word, it is always a matter of giving the person who is looking at the picture a startling impression that a weird logic has directed the painting of it, a logic to which the delineation of every object is subjected, even sacrificed.'

During the 1950s, the reigning orthodoxy of *art informel* began to be challenged by other tendencies. One of these was the so-called 'new

274 BALTHUS *Sleeping Girl* 1943

275
JEAN DUBUFFET
Vache la belle allègre
1954

realism', sponsored by the critic Pierre Restany. The most interesting member of the group was Yves Klein (1928–62), a wild neo-Dadaist whose conceits sometimes have a real poetic beauty. Klein's most cele- 276 brated works are probably his blue and gold monochromes, unvaried expanses of colour which challenge the spectator's notion of what a painting is or should be. Many of Marcel Duchamp's ideas were revived by Klein, in a new form which perhaps owed something both to his mystical studies – he was a Rosicrucian – and to his contact with Zen Buddhist philosophy – he was a judo expert, and wrote a book on the subject which is still a standard text.

Klein's associate Arman (Fernández Arman, b. 1928) perhaps gives a clearer idea of what 'new realism' was really supposed to be about. His most characteristic works consist of random accumulations of objects – but objects all of the same sort – encased in clear plastic. These seem to be a kind of illustration of Restany's remark that 'the new realism registers sociological reality without any controversial intention'.

1

276 YVES KLEIN *ANT 143 'The Handsome Teuton'* 1960

Realism of a different kind also attracted a following in Paris, thanks to the impact upon Paris-domiciled artists of American Pop art. While there might be some reason to claim that the United States, in embarking upon the Abstract Expressionist adventure, was still under the spell of French ideas, Pop art was a more purely native product, a response to the phenomenon of American consumerism. Britain, whose culture was in many respects intimately linked to what was going on in America, successfully bred its own variety of Pop, and indeed British artists in some respects anticipated American ones in making use of material drawn from mass culture. France responded more sluggishly, and we can see, from the work of artists such as Martial Raysse (b. 1936), and Alain Jacquet (b. 1939), the degree to which the Pop phenomenon was misunderstood and travestied in France. It is significant that Raysse and Jacquet tend to use other works of art – Gérard's *Cupid and Psyche*, Manet's *Le Déjeuner sur l'herbe* – as their source material, rather than the advertisements and newspaper photographs which interest their American colleagues. French painting remains firmly locked within the circle of the 'fine art bit' which American Pop painters were determined to get away from.

277

Significantly, the liveliest tendency in Paris during the 1960s was that represented by kinetic art in its various manifestations. I say 'significantly' because, in the first place, kinetic art showed a determination (which also manifested itself elsewhere) to break down the distinction between painting and sculpture, and to create works of art which fitted into no accepted traditional category. In the second place, though many kinetic artists now live and work in Paris, the movement is again clearly an international one, rather than specifically French. It merely benefits from the long-established French curiosity about the visual arts and the traditional hospitality of the Parisian milieu to foreign artists.

The senior figure in Paris-centred kinetic art is Victor Vasarely (b. 1908), a Hungarian who has lived and worked in France since the 1930s. Essentially the tradition he belongs to is alien to French art as it has been described in this book. He was trained at the Mühely Academy in Budapest, sometimes known as the Budapest Bauhaus, and his work in two dimensions bears the stamp of Bauhaus ideas. Though *278* Vasarely sometimes uses the third dimension in his work, he can still be described as a painter. This is not true of his colleagues and asso-

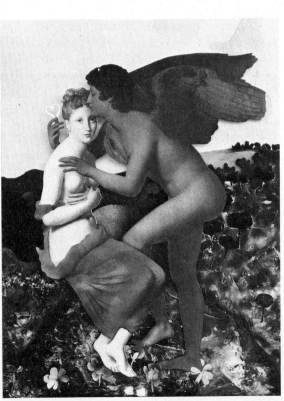

277
MARTIAL RAYSSE
*Tableau simple et
doux* 1965

278 VASARELY *Vega* 1957

ciates, such as the Argentinian Julio Le Parc (b. 1928) and the Venezuelan Jesús Rafael Soto (b. 1923), both of whom use metal elements suspended in real space.

Indeed, with the 1960s I have reached a point where it no longer makes sense to talk in terms of a national 'school', even if that school is as central to the whole tradition of European art as the French one has been. Nor does it make sense to confine my explorations to painting alone. The breakdown of the commonly accepted artistic categories which we have witnessed since 1945 has made it impossible to discuss contemporary art in such terms. It thus might be argued that a history of French painting that spans, as this one does, the six centuries between the late fourteenth century and our own day, has a more than fortuitous completeness. During those six centuries French painters produced some of the chief monuments of European culture, and the French school has a continuity of achievement which no other nation can rival.

278

Bibliography

List of Illustrations

Index

Bibliography

GENERAL WORKS

Béguin, Sylvie, *L'Ecole de Fontaine-bleau*, Paris 1960.

Blunt, Anthony, *Art and Architecture in France, 1500–1700*, 2nd edn, London 1970.

Chassé, Charles, *The Nabis and their Period*, London and New York 1969.

Diderot, Denis, *Salons*, 4 vols, Oxford 1957–67.

Dimier, Louis, *Histoire de la peinture de portrait au XVIe siècle*, 3 vols, Paris 1924–26.

Dimier, Louis, *Peintres français du XVIIIe siècle*, 2 vols, Paris and Brussels 1928–30.

Duthuit, Georges, *The Fauves*, New York 1950.

Goncourt, Edmond and Jules de, *French 18th-Century Painters*, London 1948.

Isarlo, Georges, *La Peinture en France au XVIIe siècle*, Geneva 1965.

Janneau, Guillaume, *La Peinture française au XVIIe siècle*, Geneva 1965.

London, Royal Academy of Arts, 'Landscape in French Art, 1550–1900', exhibition catalogue, London 1949.

London, Royal Academy of Arts, 'The Age of Louis XIV', exhibition catalogue, London 1958.

London, Royal Academy of Arts, 'France in the 18th Century', exhibition catalogue, London 1968.

Meiss, Millard, *French Painting in the Time of Jean de Berry: the Late 14th Century and the Patronage of the Duke*, 2 vols, London 1967.

Paris, Musée de l'Orangerie, 'Les Peintres de la réalité', exhibition catalogue, Paris 1934.

Rewald, John, *The History of Impressionism*, 2nd edn, New York 1955.

Ring, Grete, *A Century of French Painting, 1400–1500*, London 1949.

Sterling, Charles, *Still Life Painting*, Paris and New York 1959.

Stone, Joseph C., *French Painting between the Past and the Present, 1848–70*, Princeton 1951.

Sutter, Jean, ed., *The Neo-Impressionists*, London and Greenwich, Conn. 1970.

INDIVIDUAL ARTISTS

Boilly: Henri Harisse, *L.L. Boilly*, Paris 1898.

Bonnard: Annette Vaillant, *Bonnard*, London and New York 1966.

Boucher: D. Ternois, *François Boucher*, London 1966.

Boudin: G. Jean-Aubry, *Eugène Boudin*, London and Greenwich, Conn. 1969.

Bourdichon: R. Limousin, *Jean Bourdichon – peintre et enlumineur*, Lyons 1954.

Braque: N.S. Mangin, *Catalogue de l'œuvre de Georges Braque*, Paris 1959–; John Richardson, *Georges Braque*, London 1961.

Caron: J. Ehrmann, *Antoine Caron, peintre à la cour des Valois*, Geneva and Lille 1955.

Cézanne: Meyer Shapiro, *Cézanne*, 3rd edn, New York 1965; Lionello Venturi, *Cézanne, son art, son œuvre*, 2 vols, Paris 1936.

Champaigne: André Mabille de Poncheville, *Philippe de Champaigne, sa vie et son œuvre*, Courtrai 1953.

Chardin: Georges and Daniel Wildenstein, *Chardin, catalogue raisonné*, revised edn, Oxford 1969.

Charonton: M. Marignane, *Le Maître de la Pietà de Villeneuve . . . révélé*, Paris 1938.

Chassériau: Paris, Musée de l'Orangerie, 'Exposition Chassériau', exhibition catalogue, Paris 1933.

Claude: Marcel Rothlisberger, *The Paintings of Claude Lorraine*, 2 vols, London 1961.

Corot: François Fosca, *Corot*, Paris 1930.

Courbet: Marcel Zahar, *Gustave Courbet*, London 1950.

Daumier: K.E. Maison, *Catalogue Raisonné of the Paintings, Watercolours and Drawings of Honoré Daumier*, 2 vols, London and New York 1967–68.

David: L. Hautecœur, *J.L. David*, Paris 1954.

Degas: Paul-André Lemoisne, *Degas et son œuvre*, 4 vols, Paris 1946–49.

Delacroix: René Huyghe, *Delacroix*, London and New York 1963.

Fouquet: P. Wescher, *Jean Fouquet and his Time*, London and Zürich 1947.

Fragonard: Georges Wildenstein, *The Paintings of Fragonard*, London 1960.

Gauguin: Georges Wildenstein, *Gauguin, sa vie, son œuvre*, Paris 1958.

Géricault: Klaus Berger, *Géricault and his work*, Lawrence, Kans. 1955; Charles Clément, *Géricault*, Paris 1868.

Greuze: Camille Mauclair, *Greuze son temps*, Paris 1926.

Gros: Raymond Escholier, *Gros, s. amis et ses élèves*, Paris 1936.

Ingres: Georges Wildenstein, *Ingre* 2nd edn, London 1956.

Lancret: Georges Wildenstein, *Lancret*, Paris 1924.

La Tour, Georges de: Marcel Arlan *Georges de la Tour*, Paris 1953.

La Tour, Maurice Quentin de Alfred P.A. Leroy, *Maurice Quenti de la Tour*, Paris 1933.

Le Brun: Versailles, Château, 'L Brun', exhibition catalogue, Par 1963.

Léger: André Vernet, *Fernand Lége le dynamisme pictural*, Geneva 195?

Le Nain: Paul Fierens, *Les Le Nai* Paris 1933.

Master of Moulins: Madelein Huillet d'Istria, *Le Maître a Moulins*, Paris 1961.

Manet: Pierre Courthion, *Mane* London 1962 and New York 196?

Matisse: Alfred H. Barr, Jr, *Matisse his Art and his Public*, New Yor 1951.

Monet: Raymond Cogniat, *Mone and his World*, London and Nev York 1966.

Moreau, Gustave: Ragnar vo Hulten, *L'Art fantastique de Gustav Moreau*, Paris 1960.

Moreau l'Aîné: Georges Wilden stein, *Un peintre de paysages a XVIIIe siécle: Louis Moreau*, Pari 1923.

Picasso: Christian Zervos, *Pabl Picasso*, 22 vols to date, 1932–.

Pissarro: John Rewald, *Camill Pissarro*, London 1963.

Poussin: Anthony Blunt, *Nicola Poussin*, 2 vols, New York 1967.

Primaticcio: Louis Dimier, *L Primatice*, Paris 1928.

Prud'hon: Jean Guiffrey, *Musée d Louvre: P.P. Prud'hon, peintures pastels et dessins*, Paris 1924.

Puvis de Chavannes: Arsène Alexan dre, *Puvis de Chavannes*, Londo 1905.

Renoir: François Fosca, *Renoir, hi Life and his Work*, London 1961.

Robert: Paris, Musée de l'Orangerie 'Exposition Hubert Robert' exhibition catalogue, Paris 1933.

Rosso: Kurt Kusenberg, *Le Rosso* Paris 1931.

Seurat: John Russell, *Seurat*, Londoi and New York 1965.

Soutine: Marcellin Castaing and Jear Leymarie, *Soutine*, London 1965.

List of Illustrations

281

155 *The Rustic Meal.* 36¼×29½. Louvre, Paris.

LARGILLIÈRE, NICOLAS DE (1656–1746)
107 *The Artist with his Wife and Daughter,* c. 1700. 58¾×78¾. Louvre, Paris.
108 *Elizabeth Throckmorton as a Dominican Nun,* 1729. 32×25⅞. National Gallery of Art, Washington, D.C., Ailsa Mellon Bruce Fund 1964.

LA TOUR, GEORGES DE (1593–1652)
49 *The Penitence of St Jerome,* c. 1620–25. 59⅞×42⅞. National-museum, Stockholm.
50 *Nativity.* 29⅞×35⅞. Musée des Beaux-Arts, Rennes.
51 *Job taunted by his Wife.* 57×39. Musée Départemental des Vosges, Epinal.
52 *Magdalen with the Lamp.* 50⅞×37. Louvre, Paris.
53 *St Joseph in the Carpenter's Shop,* c. 1645. 59½×40. Louvre, Paris.

LA TOUR, MAURICE QUENTIN DE (1704–88)
151 *D'Alembert,* 1753. Pastel, 21⅝×18⅛. Louvre, Paris.

LE BRUN, CHARLES (1619–90)
91 *Hercules and the Horses of Diomedes,* 1638–39. 114⅝×74. Museum and Art Gallery, Nottingham.
92 *Tent of Darius,* 1660–61. 117⅜×178⅜. Musée National de Versailles.
93 *The Brazen Serpent,* c. 1649–50. 39¾×52¾. City Art Gallery, Bristol.
94 *Moses defending the Daughters of Jethro,* 1686–87. 44½×48. Galleria Estense, Modena.
101 *Chancellor Séguier,* 1661. 116×137⅞. Louvre, Paris.
102 *Marshal Turenne,* 1663–65. 26⅞×20½. Musée National de Versailles.

LÉGER, FERNAND (1881–1955)
260 *The Mechanic,* 1920. 45½×34½. National Gallery of Canada, Ottawa.

LE MOYNE, FRANÇOIS (1688–1737)
126 *Time Revealing Truth,* 1737. 71×56⅞. Wallace Collection, London.

LE NAIN, LOUIS (1593–1648)
54 *The Traveller's Rest.* 22×28⅞. Louvre, Paris.
57 (with assistant) *Nativity*

43⅛×54⅞. National Gallery, London.
58 (with Mathieu Le Nain) *Venus at the Forge of Vulcan,* 1641. 57×45¼. Musée des Beaux-Arts, Rheims.

LE NAIN, MATHIEU (1607–77)
55 *Travellers at an Inn.* 49×66¼. The Minneapolis Institute of Arts, John R. Van Derlip Fund.
56 *Reunion of Amateurs.* 45⅞×57¼. Louvre, Paris.
58 *See* Le Nain, Louis.

LE NAIN, SCHOOL OF
61 *Overturned Wheelbarrow,* c. 1640–50. 26¾×21⅞. Louvre, Paris.

LE SUEUR, EUSTACHE (1616–55)
96 *Clio, Euterpe and Thalia,* c. 1647–49. Wood, 51⅛×51⅛. Louvre, Paris.
97 *Death of St Bruno,* c. 1648. 76×51⅛. Louvre, Paris.

LIMBOURG, POL, HENNEQUIN AND HERMANT (d. before 1416)
3 *January, from the 'Très Riches Heures',* c. 1416. Vellum, 8½×5⅛. Musée Condé, Chantilly.

LORRAIN *See* CLAUDE LORRAIN

MALOUEL, JEAN (d. 1419)
5 (attributed) *Large Circular Pietà,* c. 1410. Gilt ground. Diameter 25¼. Louvre, Paris.

MANET, ÉDOUARD (1832–83)
221 *Jesus Insulted by the Soldiers,* c. 1864. 56⅜×74⅜. The Art Institute of Chicago.
222 *Le Déjeuner sur l'herbe,* 1863. 81⅛×104⅛. Louvre, Paris.
223 *Music at the Tuileries,* 1862. 30×46⅛. National Gallery, London.
224 *A Bar at the Folies-Bergère,* 1882. 37½×51. Courtauld Institute Galleries, London.
225 *La Serveuse de bocks.* 29¼×25½. Louvre, Paris.

MARMION, SIMON (active 1449, d. 1489)
18, 19 *St Bertin Altarpiece: Soul of St Bertin carried up to God; Choir of Angels.* Wood, each 22½×27⅞. National Gallery, London.

MASSON, ANDRÉ (b. 1896)
269 *The Demon of Incertitude,* 1943. Pastel on canvas, 29½×39¼. Galerie Louise Leiris, Paris.

MASTER OF FLORA (16th century)
29 *Birth of Cupid,* c. 1540–60. Wood, 41½×51⅞. The Metropolitan

Museum of Art, New York, Roge Fund 1941.

MASTER OF MOULINS (active c. 148 c. 1499)
15 *Portrait of a Child,* 1498–9 Wood, 12⅞×9. By courtesy of t Robert Lehman Collection, Ne York.
16 *Cardinal Charles de Bourbo* 13¾×10⅞. Alte Pinakothek, Munic
17 *The Moulins Triptych,* 1498–9 Wood, 61⅞×111⅜. Cathedr Moulins.

MATHIEU, GEORGES (b. 1922)
271 *The Capetians,* 1954. 112⅛×236 Musée National d'Art Modern Paris.

MATISSE, HENRI (1869–1954)
248 *The Moroccan,* 1912. 57½×37 State Hermitage Museum, Leni grad.
252 *Luxury,* 1907. 82⅞×54 Musée National d'Art Modern Paris.

MATTA (Roberto Matta Echaurre b. 1911)
268 *Being With,* 1945–46. 179¼×87⅞. Pierre Matisse Galler New York.

MEISSONIER, JEAN LOUIS ERNEST (181 79)
205 *Napoleon I and his Staff,* 186 Wood, 6×7⅛. Wallace Collectic London.

MERCIER, PHILIPPE (1689–1760)
122 *Conjurer,* c. 1720–25. 10⅞×13 Louvre, Paris.

MICHEL, GEORGES (1763–1843)
211 *The Plain of St Denis.* 18⅛×26 Musée des Beaux-Arts, Besançon.

MIGNARD, PIERRE (1612–95)
104 *Marquise de Seignelay and h Children,* 1691. 76½×61. Nation Gallery, London.

MILLET, JEAN-FRANÇOIS (1814–75)
217 *Quarrymen,* 1847–49. 29⅛×23 The Toledo Museum of Art, Ohi Gift of Arthur J. Secor 1922.

MIRÓ, JOAN (b. 1893)
263 *Painting on Masonite,* 1936. O casein, tar and sand on masonit 30¼×39⅞. Aimé Maeght, Paris.

MODIGLIANI, AMEDEO (1884–1920)
258 *Seated Girl,* c. 1917. 76¼×5 Courtauld Institute Galleri London.

DILLON, LOUISE (1609/10–96)
Nectarines, 1674. Wood, ×20½. Musée des Augustins, Toulouse.

ONET, CLAUDE (1840–1926)
27 *The Cliff at Fécamp*, 1881. ×25¾. Aberdeen Art Gallery.
30 *Rouen Cathedral: Morning Sun*, 1894. 37⅞×24¾. Louvre, Paris.

OREAU, GUSTAVE (1826–98)
39 *Unicorns*. Oil and watercolour on canvas, 45⅝×35⅜. Musée Gustave Moreau, Paris.

OREAU L'AINÉ (Louis Gabriel Moreau, 1740–1806)
16 *Cabin on a Rising in a Wood*. 8¼×21¼. Louvre, Paris.

ATTIER, JEAN-MARC (1685–1766)
27 *Comtesse de Tillières*, 1750. ⅞×25. Wallace Collection, London.

UDRY, JEAN-BAPTISTE (1686–1755)
39 *The White Duck*, 1753. 1¼×24¾. The Marchioness of Cholmondeley.
40 *Count Tessin's Dachshund*, 1740. 8¼×43. Nationalmuseum, Stockholm.

ZENFANT, AMÉDÉE (b. 1886)
62 *Composition*, 1920. 31⅞×39⅝. Solomon R. Guggenheim Museum, New York.

ARROCEL, JOSEPH (1646–1704)
12 *Cavalry Officer Resting, c.* 1685–8. 73½×57¼. Musée des Beaux-Arts, Lyons.

ATEL, PIERRE THE ELDER (*c.* 1605–76)
2 *Landscape with a Goatherd*. 3×21. Musée des Beaux-Arts, Orleans.

ENNI, LUCA (1500–56)
5 (attributed) *Diana, c.* 1550 (detail). 25¾×52½. Louvre, Paris.

ERRÉAL, JEAN (*c.* 1455–1530)
1 *Louis XII, c.* 1514. 11×7. By gracious permission of Her Majesty the Queen. The Royal Collection, Windsor.

ERRONEAU, JEAN-BAPTISTE (1715–83)
49 *Madame de Sorquainville*, 1749. 9⅞×31½. Louvre, Paris.

ICASSO, PABLO (b. 1881)
49 *Woman Ironing*, 1904. 45¼×28⅜. Tannhauser Collection, New York.

250 *Mountebanks*, 1905. 40¼×86¼. National Gallery of Art, Washington, D.C.
251 *Les Demoiselles d'Avignon*, 1907. 96×92. The Museum of Modern Art, New York.
256 *The Three Musicians*, 1921. 80×74. Philadelphia Museum of Art, A. E. Gallatin Collection.
270 *Guernica*, 1937. 138×300. On extended loan to the Museum of Modern Art, New York.

PISSARRO, CAMILLE (1830–1903)
228 *The Louvre in the Snow*, 1902. 25¾×32. National Gallery, London.

POUSSIN, NICOLAS (1593/4–1665)
65 *Dido and Aeneas, c.* 1634. 62×74¾. The Toledo Museum of Art, Ohio. Gift of Edward Drummond Libbey 1954.
66 *Parnassus*, 1626–27. 57½×77⅞. Prado, Madrid.
67 *Martyrdom of St Erasmus*, 1628–29. 126×73¼. Gallerie e Musei Vaticani.
68 *Shepherds of Arcady, c.* 1630. 39¾×29½. Devonshire Collection, Chatsworth, reproduced by permission of the Trustees of the Chatsworth Settlement.
69 *Childhood of Jupiter, c.* 1637. 37⅞×46½. Dulwich College Picture Gallery, London.
70, 71 *The Eucharist; Ordination*, 1647. Each 44¼×67¾. National Gallery of Scotland, Edinburgh, on loan from the Duke of Sutherland Collection.
72 *Diogenes Throwing down his Bowl*, 1648. 63×87. Louvre, Paris.
73 *Winter, or the Deluge*, 1660–64. 46½×63. Louvre, Paris.

PRIMATICCIO, FRANCESCO (1504/5–70)
24 *Ulysses and Penelope, c.* 1560, 44×48. The Toledo Museum of Art, Ohio. Gift of Edward Drummond Libbey 1969.

PRUD'HON, PIERRE-PAUL (1758–1823)
184 *Empress Josephine*, 1805. 96×70½. Louvre, Paris.
186 *Venus and Adonis*, 1810. 94½×66. Wallace Collection, London.

PUVIS DE CHAVANNES, PIERRE (1824–98)
241 *The Poor Fisherman*, 1881. 61×75⅝. Louvre, Paris.

RAYSSE, MARTIAL (b. 1936)
277 *Tableau simple et doux*, 1965. Assemblage with neon light, 76×51. André Mourges, Paris.

RENÉ MASTER (15th century)
11 *Amour Takes Away the King's Heart*. Miniature, 11⅝×79¼. From the *Livre au Cuer d'Amours espris*. Österreichische Nationalbibliothek, Vienna, Cod. 2597.

RENOIR, AUGUSTE (1841–1919)
229 *On the Terrace*, 1881. 24×20¼. The Art Institute of Chicago.
234 *The Box*, 1874. 31½×25. Courtauld Institute Galleries, London.

RIGAUD, HYACINTHE (1659–1746)
105 *Jan Andrzej Morsztyn and his Daughter*. 80¼×61⅞. Musée des Beaux-Arts, Cherbourg.
106 *Double Portrait of the Artist's Mother*, 1695. 32×39¾. Louvre, Paris.

ROBERT, HUBERT (1733–1818)
141 *Architectural Composition with Temple and Obelisk*, 1768. 41¾×54¾. Bowes Museum, Barnard Castle, County Durham.

ROHAN MASTER (15th century)
9 *Man before his Judge*, 1420–25. Miniature, 11½×8⅛. From the *Grandes Heures de Rohan*. Bibliothèque Nationale, Paris, MS. Lat. 9471.

ROSSO, IL (Giovanni Battista di Jacopo, 1494–1540)
22 *Pietà*, 1530–40. 49¼×56. Louvre, Paris.
23 *Venus Chiding Love*. Fresco. Galerie François Premier, Château de Fontainebleau.

ROUSSEAU, THÉODORE (1812–67)
215 *The Forest of Clairbois*. 25⅝×42¾. Glasgow Art Gallery.

SÉRUSIER, PAUL (1864–1927)
244 *The Tapestry*. 31⅞×51¼. Musée du Petit Palais, Paris.

SEURAT, GEORGES (1859–91)
238 *A Sunday Afternoon at the Island of La Grande Jatte*, 1886. 81×120⅞. The Art Institute of Chicago, Helen Birch Bartlett Memorial Collection.

SOUTINE, CHAIM (1894–1943)
259 *Portrait of a Boy*, 1928. 36¼×25⅝. National Gallery of Art, Washington, D.C., Chester Dale Collection.

STAËL, NICOLAS DE (1914–55)
264 *Les Martigues*, 1954. 38⅛×57½. Private collection, Oslo.

Photographic Acknowledgements

ACL, Brussels: 6, 176. Archives Photographiques: 4, 5, 7, 12, 13, 17, 35, 82, 102, 146, 151, 178, 183, 184, 185, 193, 194, 195, 199, 207, 208, 213, 222, 244. Archivio Fotografico, Gallerie e Musei Vaticani: 43. Arts Council of Great Britain: 248. Bulloz: 42, 97, 128, 159, 179, 180, 197, 206, 218, 220. Giraudon: 1, 2, 3, 8, 10, 23, 31, 32, 54, 59, 98, 99, 114,

115, 170, 171, 173, 174, 175, 190, 191, 192, 200, 225, 230. Walter Klein: 253. Galerie Maeght, Paris: 263. Mansell-Alinari: 44, 46, 67, 175. Mas, Barcelona: 66, 83. Musées Nationaux: 22, 25, 30, 37, 39, 47, 52, 53, 56, 60, 61, 63, 72, 73, 75, 85, 92, 100, 101, 106, 107, 110, 113, 119, 123, 133, 138, 141, 149, 152, 155, 165, 172, 182, 187, 198, 201, 209, 232, 239, 241. By

Courtesy of the Trustees of t⬚ National Gallery, London: 18, 19, ⬚ 57, 74, 76, 90, 104, 228, 231, 2⬚ Royal Academy of Arts, London: ⬚ 79, 111. Reproduced by permissi⬚ of the Trustees of the Wall⬚ Collection: 103, 118, 121, 124, 1⬚ 126, 132, 134, 136, 137, 143, 147, 1⬚ 203, 205. Dietrich Widmer, Bas⬚ 38.

Index *Italic figures are illustration numbers.*